Audubon

Audubon

A Biography by
JOHN CHANCELLOR

A Studio Book

The Viking Press · New York

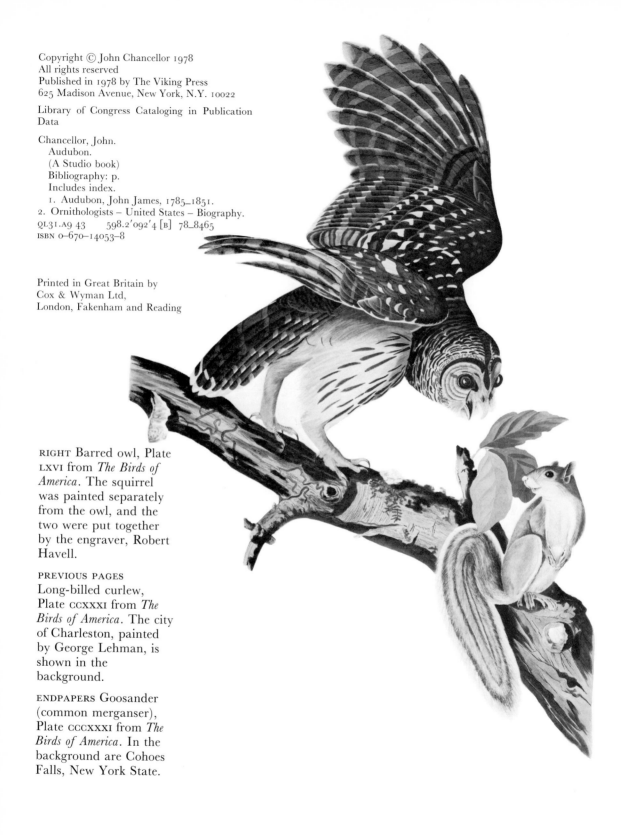

Published in 1978 by The Viking Press
625 Madison Avenue, New York, N.Y. 10022

Library of Congress Cataloging in Publication
Data

Chancellor, John.
 Audubon.
 (A Studio book)
 Bibliography: p.
 Includes index.
 1. Audubon, John James, 1785–1851.
 2. Ornithologists – United States – Biography.
QL31.A9 43 598.2′092′4 [B] 78–8465
ISBN 0–670–14053–8

Printed in Great Britain by
Cox & Wyman Ltd,
London, Fakenham and Reading

RIGHT Barred owl, Plate LXVI from *The Birds of America*. The squirrel was painted separately from the owl, and the two were put together by the engraver, Robert Havell.

PREVIOUS PAGES Long-billed curlew, Plate CCXXXI from *The Birds of America*. The city of Charleston, painted by George Lehman, is shown in the background.

ENDPAPERS Goosander (common merganser), Plate CCCXXXI from *The Birds of America*. In the background are Cohoes Falls, New York State.

Contents

	Foreword	7
1	West Indian Background	10
2	Revolutionary Childhood	22
3	Marriage and the Louisville Venture	36
4	Failure in Business	56
5	Birth of the Great Idea	82
6	Mississippi Wanderings	98
7	An Odd-fish in England	114
8	The Biographer of Birds	150
9	The Wild Coasts of Labrador	172
10	America, My Country	196
	Bibliography	219
	Acknowledgements	220
	Index	221

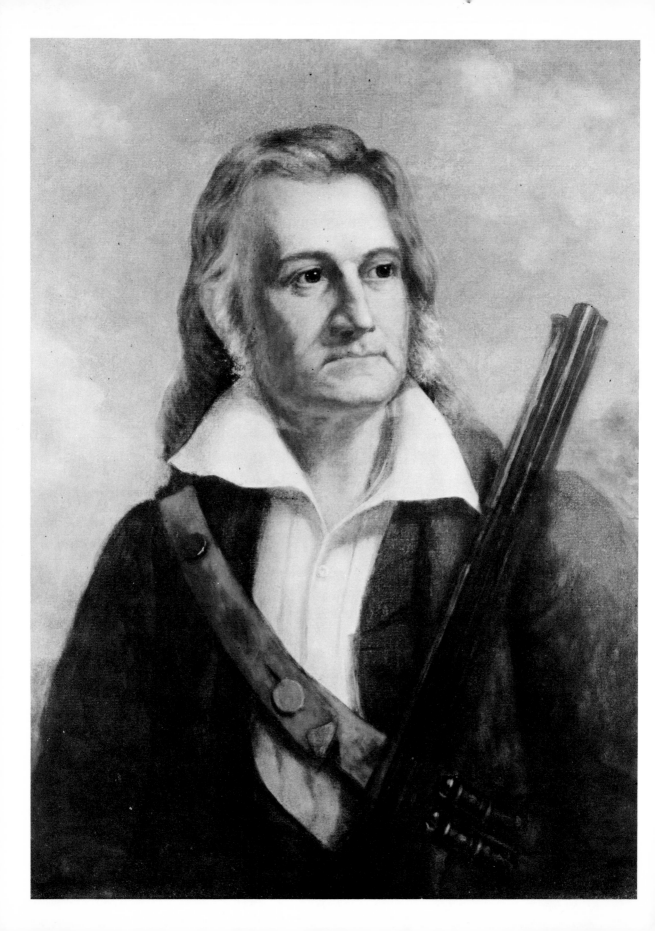

FOREWORD

o millions of people in America John James Audubon is the patron saint of birds. His name has taken on certain romantic attributes, to which he is not altogether entitled. Many 'lives' of Audubon written since his death in 1851, with a youthful readership in mind, paint a picture of him as a fearless frontiersman who penetrated hitherto unexplored territories attended only by his dog; who lived with Indians and who drew the birds and animals he loved so well. But as this biography will show, Audubon was not a latter-day St Francis of Assisi and he indulged in what appears to us today to be revolting and wantonly indiscriminate slaughter of birds; he would sometimes kill up to a hundred birds of a certain species to use them as models for a single drawing. He was also a curious character, with good and bad points. Readers will find that he becomes steadily more unattractive as the book progresses; then they will notice a change in the man, dating from the year 1826 when he landed in Liverpool and went on to Scotland, 'that land made famous', as he put it, 'by the entrancing works of Walter Scott'. When they finish the book they will

OPPOSITE Portrait of John James Audubon.

almost certainly say to themselves that he was a most extra-ordinary character – indomitable, exhibitionist, imaginative and artistic.

It is on his much-debated qualities as an artist that Audubon's reputation ultimately rests. He had the grandiose idea of painting birds life-size. This fact alone has brought fame to his monumental book, *The Birds of America*. He never drew from stuffed specimens – only from the recently killed bird or birds. Some people find his drawings of birds the greatest of all time; others, particularly scientists, complain that they are melodramatic, that the expressions and attitudes of Audubon's birds are human rather than avian, a consequence of his emotional nature.

Sportsmen, we are told, are the best conservationists. For this reason alone it is appropriate that America's greatest ecological and conservationist organization should be called the National Audubon Society. 'Audubon' is now synonymous with the protection and preservation of wildlife. The name has, perhaps deliberately, been detached from the man, whose record as a protector of wildlife was not a good one. This is why millions of Americans know that 'Audubon' means 'conservation', while having only a hazy idea that a person of that name existed. Audubon, although addicted to blood sports, saw clearly the outcome of orgies of senseless killing, whether of buffaloes or of passenger pigeons; his description of a scene of passenger pigeon butchery, quoted in this book, has become a classic of conservationist literature. Audubon's picturesque personality emerges vividly from his writings; indeed, he created a new *genre* of descriptive-anecdotal 'nature' literature.

In New York, in November 1977, I was present at a Christie's auction at their rooms in Park Avenue when a copy of Audubon's *The Birds of America* went for $400,000; the original subscribers paid $1,000. Before the auction Stephen Massey, Christie's book man in the United States, slowly turned over the splendid plates before a privileged little throng.

My book was largely written in the library of the American Museum of Natural History; the librarian, Nina Root, and her

assistant, Janina Gertner, know full well the extent of my gratitude to them for innumerable kindnesses. The same may be said of Hubert and Geneviève Faure who, at weekends, left their Fifth Avenue apartment for one of those spacious white houses near the little town of Millbrook in Dutchess County, nearly two hours' drive north of New York City. There I frequently joined them and carried on writing in a room with a magnificent view of the Catskill Mountains.

The greatest of the many treasures of the New York Historical Society are the original watercolours of *The Birds of America*, which they bought for about $4,000 from Audubon's widow in 1863. Some of these are reproduced in this book. I am grateful to Mary Alice Kennedy for arranging the reproduction of these and of other interesting pieces of Auduboniana belonging to the Society. Let me also mention my friend and neighbour in New York, Jeffery Brinck, the walls of whose apartment are hung with some of the finest of Audubon's plates, which I was wont to admire when the day's work was over.

American and English readers alike should be reminded of the indispensable part which England played in laying the foundations of Audubon's fame. Without his admirable wife Lucy and his brilliant engraver Havell, his great book would never have been brought to its triumphant completion.

J.P.C.
New York
January 1978

The box in which the prints of *The Birds of America* was sent to subscribers.

9

1
West Indian Background

't seems that my father had large properties in Santo Domingo, and was in the habit of visiting frequently that portion of our Southern States called, and known by the name of, Louisiana, then owned by the French Government. During one of these excursions, he married a lady of Spanish extraction, whom I have been led to understand was as beautiful as she was wealthy, and otherwise attractive, and who bore my father three sons and a daughter, – I being the youngest of the sons and the only one who survived extreme youth. My mother, soon after my birth, accompanied my father to the estate of Aux Cayes, on the island of Santo Domingo, and she was one of the victims of the ever-to-be-lamented period of the negro insurrection on that island.'

John James Audubon wrote this account of his birth in *Myself, J. J. Audubon*, a short autobiographical sketch for the benefit of his two sons. The manuscript of *Myself* was found inside an old book in a barn on Staten Island and published in *Scribner's Magazine* in 1893, many years after his death. Audubon was only marginally literate and was indifferent to the

OPPOSITE Great black-backed gull, watercolour painted on the Atlantic coast, probably in 1832, for Plate CCXLI in *The Birds of America*. Audubon was not averse to letting injured birds suffer while he drew them.

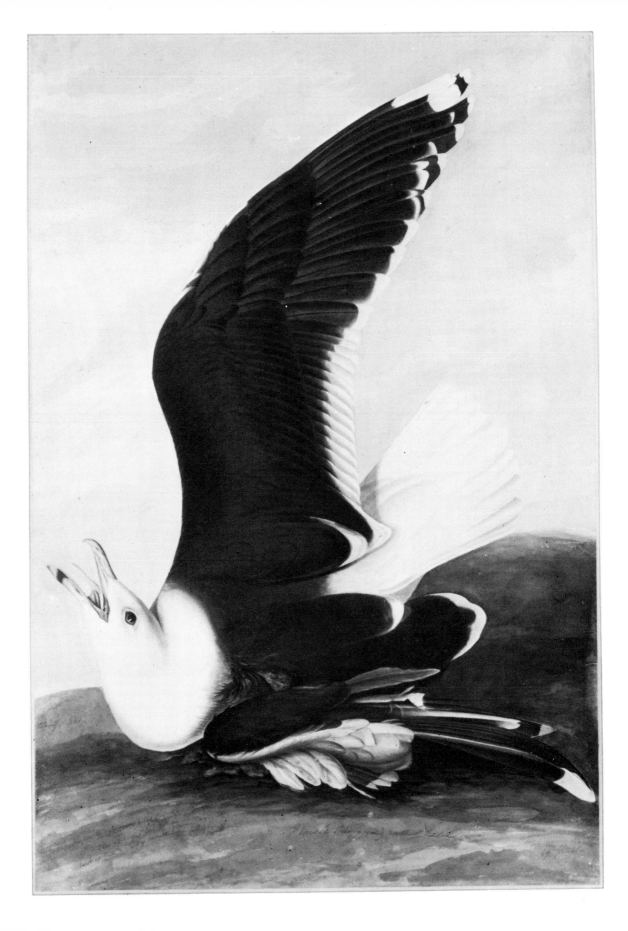

truth; he was vain and vulgar, infatuated with the carefully
nurtured image of himself as the exotic woodsman, the artist-
naturalist with a French accent, in flowing ringlets and leather
frontier clothes, a likeness which he recorded in a number of
self-portraits. This harsh judgment is true, but unimportant;
Audubon's paintings of American birds, even if at times too
grandiose and florid for certain 'scientific' tastes, are still, in the
words of the astonished Georges Cuvier when he saw them in
Paris, 'the most magnificent monument which has yet been
raised to ornithology'.

Cuvier, that great naturalist called the 'dictator of biology',
was, in fact, admiring not the drawings but some of the early
plates of *The Birds of America*, that extraordinary contribution to
the history of science, literature and art, a monument not only
to ornithology but to the genius of John James Audubon. As a
companion to the plates Audubon, assisted by William Mac-
Gillivray, published in 1831–9 his five-volume *Ornithological
Biography*; in it technical descriptions of the birds were varied
with what he called 'Delineations of American Scenery and
Manners'. These 'Delineations' or 'Episodes', sixty in number,
together with his various journals, with their vivid accounts of
American frontier life, of his encounters with Indians, lum-
bermen and runaway slaves, of his hair-raising adventures in
forests and on prairies, aboard flatboats on the Mississippi, in
the dunes and lagoons of Texas, in the palmetto groves of
Florida and on the stormy Labrador coast make, at times,
stirring reading and form with his drawings an essential part of
the Audubon legend. Out of these pages steps our hero with the
indispensable knapsack, dog and gun.

The intrepid explorer-artist-huntsman-naturalist roman-
ticized his origins and sometimes let vanity obscure his
presentation of facts. His account of his birth, quoted above, is
quite untrue. These untruths persisted, with variations, in all
biographies of him for a very long time. For instance, his own
granddaughter, Maria Audubon, tells us that her grandfather
was born on a plantation at Portchartrain near New Orleans
belonging to the Marquis de Mandeville de Marigny, 'the

A page of the doctor's
bill showing a record
of Audubon's birth.

Marquis having lent his home, in the generous southern fashion, to his friend Admiral [*sic*] Jean Audubon, who, with his Spanish Creole wife, lived here some months'. She quotes a member of the Marquis's family as saying that this lady was 'a woman of incomparable beauty and great pride'. She thinks that Audubon was born somewhere between 1772 and 1783 and that his father, the 'Admiral', died at the age of ninety-five.

In 1913 Francis H. Herrick stumbled upon a collection of vital documents such as certificates of birth, baptism and adoption at Les Tourterelles in the village of Couëron, just south of Nantes, where Jean Audubon lived. These papers enabled Herrick to write a definitive biography, *Audubon the Naturalist*, which established once and for all the facts of his early life. The French had, by the Treaty of Ryswick in 1697, acquired from Spain that part of the island of Hispaniola or San Domingo, discovered by Columbus in 1492, corresponding to the present republic of Haiti. Fougère or Jean Rabin was born on 26 April 1785 in the port of Les Cayes on the southern coast of San Domingo, the illegitimate son of Lieutenant Jean Audubon and a certain Mlle Rabin, 'a Creole woman of Saint-Domingue'. Audubon was sometimes referred to in documents as '*Jean Rabin, Créole de Saint-Domingue*'. Herrick wrote:

For every lover of birds and nature this semi-tropical island, and especially Les Cayes, upon its South-Westerly verge in what is now Haiti, will have a peculiar interest when it is known that there, amid the splendour of sea and sun and the ever-glorious flowers and birds, the eyes of America's great woodsman and pioneer ornithologist first saw the light of day.

Who was Lieutenant Jean Audubon and what was he doing on the island of San Domingo? The fathers of great men often have characters more straightforward than those of their more complex sons. Jean Audubon would never have indulged in fantasies about his own origins and he would almost certainly have told his son the unvarnished truth about the circumstances of his birth. Jean Audubon was a rough seaman

Lieutenant Jean Audubon, after a portrait painted about 1789. 'An ingenious man', wrote his son later, 'to whom I owe all.'

from the marshes of La Vendée in western France. He was born in 1744 and married in 1772 at Paimboeuf on the Loire estuary Anne Moynet, a widow nine years older than himself. He died in 1818, not 'at the great age of ninety-five', but at the less remarkable age of seventy-four.

This honest, matter-of-fact sailor lived during a disturbed period of European history, when the enmity between England and France, far from being settled by the Seven Years' War, revived during the American War of Independence; when the *ancien régime* was wiped away by the French Revolution and Napoleon, shortly afterwards, started his career of conquest. Jean Audubon was what we call a 'child of his time'; he hated the British, who seized and imprisoned him for several years, and he rejoiced in the downfall of the Bourbons and later in the victories of Napoleon. He came from Les Sables d'Olonne, then a small fishing village on the Bay of Biscay, fifty miles south-west of Nantes. He was one of twenty-one children, three of whom reached old age; his father was a seaman with his own boat in which he made many voyages between French ports in the Old World and the New. In 1757, aged thirteen, Jean Audubon went as a cabin-boy on his father's boat, *La Marianne*, bound for Louisburg. The fierce struggle between France and England for supremacy in the New World was just beginning. It was feared that Louis xv was about to launch an invasion of England and the Prime Minister, the weak Duke of Newcastle, instructed the inhabitants of the southern counties to drive their cattle inland. In November 1757 Pitt took charge of overseas operations, determined to destroy French power at sea; he succeeded beyond his expectations. The collapse of the French navy and the ruin of French merchant shipping later left the field open to enterprising French privateers. Meanwhile, the Audubons, father and son, were on their way to help strengthen the great fortress of Louisburg, France's most powerful base on the American continent; it fell to the British the following year and was left a heap of ruins. *La Marianne* was captured by the British; Jean Audubon was wounded in the left leg, taken to England as a prisoner and kept there until his

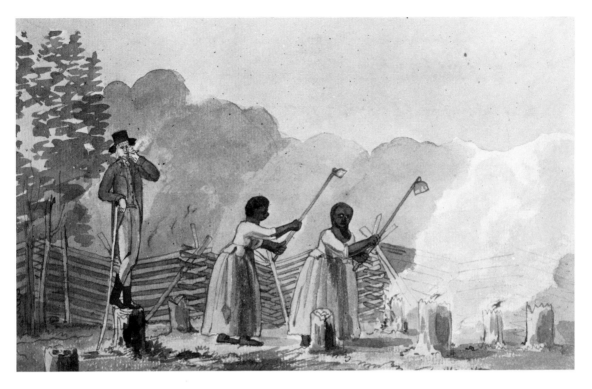

Negro slaves on a plantation – *Overseer Doing his Duty*, painted by Benjamin Henry Latrobe.

release after the Treaty of Paris in 1763, an experience which left him with an undying hatred of the British. At the end of the war France had lost all her possessions in the New World except a few islands in the West Indies, among them her part of San Domingo. John James Audubon was later brought up to share his father's aversion to anything British.

The war over, Jean Audubon, now aged nineteen, returned to France from captivity and re-entered the greatly weakened French merchant marine. He sailed between Les Sables d'Olonne and nearby La Rochelle and Rochefort, and sometimes further afield to Bordeaux and Marseilles; in 1770 he began a series of regular voyages to the French part of the island of San Domingo. The purpose of these voyages was to bring sugar, coffee and cotton back to France. The cultivation of these three commodities, which provided half the wealth of what remained of the French colonial empire and half the needs of the European market, was based upon the labour of half-a-million black slaves who worked for twenty thousand

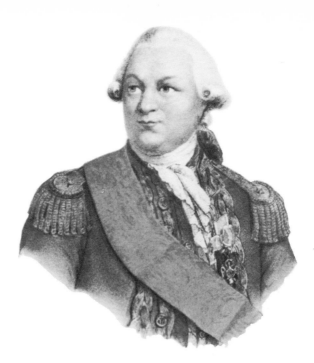

Admiral the Comte de Grasse, the famous naval figure under whom Lieutenant Jean Audubon served.

whites. Perspicacious people could see that there was a dangerously small ratio of whites to black; black backs furrowed with scars, missing ears and hands on black bodies, and disciplinary, studded iron collars around black necks testified to the lack of trust between the two communities. At the time of Jean Audubon's voyages, the colony was enjoying an unprecedented degree of prosperity as the richest sugar-producing area in the world. There were enormous temptations for Frenchmen to get rich quickly in this fabulous, semi-tropical island; to delight, before returning to their families, not only in the accumulation of wealth, but in the attention of some of the five thousand Negro women classified as mistresses of white men or, indeed, in some of the unclassified white mistresses.

Jean Audubon undoubtedly entertained such thoughts during his many trading voyages between 1770 and 1779. In 1772 he married the amiable and cultured widow Anne Moynet, and in 1775 war broke out between England and her American colonies. The later American victory was largely due to the help given the rebels by the French. Jean Audubon hoped to have an opportunity of avenging his wrongs at the hands of the British. Instead, the British struck first; in 1779 his ship, *Le Comte d'Artois*, bound for Nantes with a valuable cargo, was

16

attacked by four British corsairs and two galleys soon after leaving Les Cayes. Jean Audubon was captured and his boat destroyed; he was held as a prisoner-of-war in New York for thirteen months. His moment came with his release from captivity in June 1780. He rejoined the navy and was put in command of the corvette *Queen Charlotte*, under Admiral the Comte de Grasse, an important figure in the naval operations of the war, and had the satisfaction of witnessing the surrender of Cornwallis at Yorktown on 19 October 1781. He stayed in America for a while and commanded one or two merchant ships sailing between the United States and France, on one occasion sinking a British privateer outside Brest.

When the war was over, Jean Audubon accepted the agency of Coirond Frères, colonial merchants of Nantes, at Les Cayes. He arrived there towards the end of 1783. For the next six years he lived more or less continuously in San Domingo, building up a fortune as a merchant, planter and slave-dealer. His wife, Anne, remained patiently behind in Nantes. The French

The surrender of Cornwallis at Yorktown, 1781. Jean Audubon was a witness to this significant military and political event.

17

Revolution, which sparked off the bloody rebellion in San Domingo, was still some way off. Jean Audubon dealt extensively and profitably in slaves; in addition he had sugar plantations, a sugar refinery and stores in and around Les Cayes and Saint Louis, a port rather further to the east. His bills-of-sale show that a great many slaves passed through his hands. He kept about forty for his own use and sold the others which he imported for prices ranging between $300 and $450. He is said to have treated his slaves humanely and, while accepting the moral standards of his day in regard to mistresses, illegitimate children and slave-trading, to have shown kindness and integrity in his dealings with people. He was short and stocky, with red hair and blue eyes, in no way resembling his son who chose, however, later to say that, 'in personal appearance my father and I were of the same height and stature [the father was 5 feet 4 inches and the son 5 feet 10 inches], say five feet ten inches ... and with muscles of steel ... in temper we much resembled each other also, being warm, irascible, and at times violent; but it was like the blast of a hurricane, dreadful for a time, when calm almost instantly returned.'

Jean Audubon, then, threw in his lot with a luxurious, colonial society, as yet unaware of the coming horrors. Like every rich white in his cool, hillside villa, ministered to by slaves and mistresses, Jean Audubon was to lose the entire fortune which he had amassed during the years he had spent in San Domingo. He at least got out in 1789 when the boom ended with his two children, Jean by Mlle Rabin, and Muguet (or Rosa), born in 1787 to a Catherine Bouffard. Within eighteen months of their departure San Domingan history had become 'an intricate and disquieting detail of conspiracies, treacheries, murders, conflagrations and atrocities of every description'.

Was Mlle Rabin a serving girl or a noble Creole beauty? Nothing is known of her antecedents apart from the occasional cropping-up of the names 'Rabin', 'Fougère' (in English 'fern') and 'La Forêt', all San Domingan Creole names. Her son sometimes called himself 'John James Laforest Audubon'.

That she was a Creole appears to be undisputed. There is a certain amount of confusion as to the exact meaning of the word Creole. Some take it to mean a half-caste, others a European whose family have lived for several generations in Latin America. The word does not officially have any connotation of colour and simply means a person born or naturalized in the West Indies and other parts of America, but of European (usually French or Spanish) or of African Negro races. It is often supposed that a Creole woman must be a beauty, her blood warmed by the West Indian sun and her skin of texture and quality which can only be properly described by poets. The Empress Josephine was a Creole beauty *par excellence*. Whether Mlle Rabin came into this class must be left to conjecture. Audubon certainly thought so.

Was Audubon, instead of being the illegitimate son of Lieutenant Jean Audubon and Mlle Rabin, in reality the Dauphin, son of Louis XVI and Marie Antoinette, who became titular king of France as Louis XVII when his father was guillotined on 21 Janury 1793? This extraordinary theory was encouraged by Audubon in occasional cryptic utterances at odd moments of his life. 'My own name I have never been permitted to speak; accord me that of Audubon, which I revere, as I have cause to do.' Audubon, born in 1785, was only adopted by his father and stepmother in 1794, nine years later. Where the boy was during this time is a question asked by one or two biographers of Audubon. The answer they provide is that Jean Audubon returned to France from San Domingo without his son, that the Dauphin was entrusted to his care, and that he gave him the name of the little boy he had left behind in Les Cayes. Maria Audubon herself believed, on the strength of passages in her grandfather's private journals and in letters to his wife, that Audubon was, or might have been, the Dauphin. Unfortunately, no evidence of any kind can be adduced in support of this romantic theory; in refutation of it is the official declaration that the Dauphin died in the Temple prison on 7 June 1795 (he had been born on 27 March 1784). Perhaps the taint of illegitimacy was more painful to Audubon

Toussaint L'Ouverture, the Negro leader of the ill-starred revolt in Haiti in the wake of the French Revolution.

than he cared to admit, for he resorted to one smokescreen after another to conceal it; his friends taunted him with having as many birthplaces as Homer. When he was in Paris with some of the plates of *The Birds of America*, he wrote:

Patient, silent, bashful, and yet powerful of physique and of mind,

20

dressed as a common man, I walk the streets. I bow! I ask permission to do this or that! I follow the publication of a work on natural history that has apparently absorbed my whole knowing life. *I, who should command all*.

For Frenchmen in the eighteenth century the new colony of San Domingo offered the prospects of untold wealth and of sybaritic living. The Spaniards had exterminated all the two million Indians, replacing them by Negroes from the African coasts. The French continued this practice and turned it into one of the richest and most desirable colonies in the world. It was not the slaves but the twenty-five thousand free mulattoes who threatened to become a social and political problem; oppressed by the whites, they took their revenge on the blacks whom they were allowed to keep as slaves. There was continual tension between blacks and mulattoes. There was also tension between the Creole whites and the French, generally merchants like Jean Audubon, who benefited from existing trading conditions to a far greater extent than did the local planters. The French government monopolized the trade of the colony and fixed the prices for Negroes and other commodities. The political wind from France caused stirrings amongst the Creole whites; they petitioned for representation in the Estates General which Louis XVI had been forced to convene. More unrest was caused by *Les Amis des Noirs* in France, a society of fanatical abolitionists preaching hatred of the planters and urging the mulattoes to insist upon their political rights. By 1789, when Mlle Rabin had been dead four years and Jean Audubon decided to take his two children back with him to France, the colony was ready for the conflagration; the whites were divided against each other and hated by the mulattoes and the blacks, who in their turn despised each other. In 1790 the first battle between whites and mulattoes broke out at Les Cayes. The following year the mulattoes and blacks, temporarily in alliance, burnt the canefields and plantation houses and murdered their white owners. The colony became a scene of unbridled butchery until the appearance in 1793 of Toussaint L'Ouverture, that heroic and unfortunate black leader.

2
Revolutionary Childhood

I n Pennsylvania a beautiful state almost Central on the line of our Atlantic Shores, my Father in his constant desire to prove my friend through life gave me what Americans denominate a beautiful plantation refreshed from the Summer heat by that clear Stream the Scuilkill River as well as traversed by a Creek named Perkioming fine arable and wood land.'

Thus Audubon described many years later, in his quaint and imperfect English, the farm of Mill Grove near Philadelphia, which his father had bought towards the end of 1789. Jean Audubon, uncertain what would be awaiting him in France and anxious not to lose the money which he had made in San Domingo, decided to invest in property in America. In the Quaker city of Philadelphia he offered a cargo of sugar to Henry Augustus Prévost, a retired Swiss mercenary in the British army, in part exchange for his two-hundred-acre farm, Mill Grove; he was also attracted by a vein of lead that ran beneath the property. The deal concluded, Jean Audubon promptly leased it to the original owner and set sail for France.

OPPOSITE American white pelican, Plate cccxi from *The Birds of America*.

22

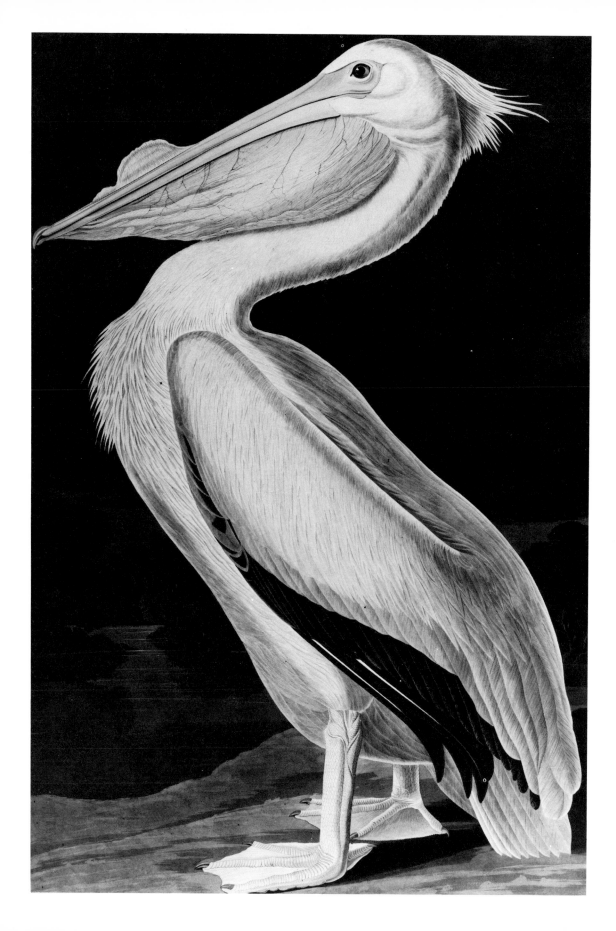

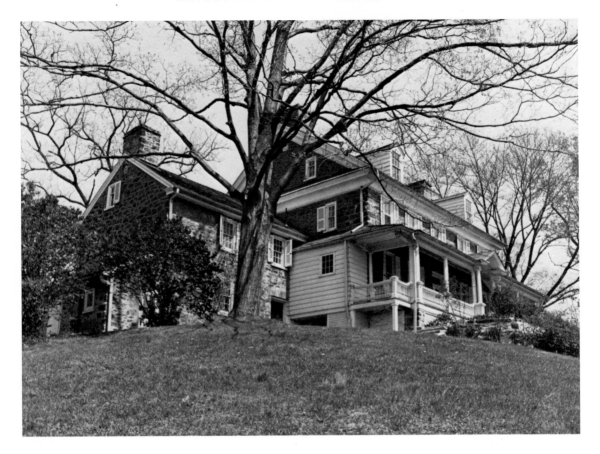

'Mill Grove', Audubon was to write in his journals, 'was ever to me a blessed spot.' He was to move into the house in 1804.

This handsome house, built in 1762 and once the home of Governor John Penn, was, fifteen years later, to become Audubon's home and the scene of the happiest experiences of his early manhood.

Captain Jean Audubon, his two children and a couple of slaves, arrived at Nantes shortly after the storming of the Bastille, which took place on 14 July 1789. The French Revolution had not yet got into its bloody stride. Audubon later wrote:

The first of my recollective powers placed me in the central position of the city of Nantes, on the Loire River, in France, where I still recollect particularly that I was much cherished by my dear stepmother, who had no children of her own, and that I was constantly attended by one or two black servants, who had followed my father from Santo Domingo. . . .

24

Jean Audubon, upon returning to France, became a zealous and committed Revolutionary. It is surprising to find a plantation owner and slave-trader carried away by Revolutionary sentiments in the strongly Royalist Vendée; supporters of the Dauphin theory would probably say that he had assumed a political mask for the greater safety of his royal charge. At the time of their arrival, the city of Nantes was in a state of high political excitement. The members of the third estate, which included many rich and influential citizens who were determined to be represented in parliament, formed a permanent Committee of Public Safety. Jean Audubon became an official Revolutionary by joining the National Guard of Nantes, which was soon to witness many scenes of fanaticism and carnage. The loyalists of La Vendée under Charette tried to storm the city; the National Guard, amongst them, perhaps, Jean Audubon, took them on outside the walls, while the citizens, rejoicing in their new Republicanism, rose to the occasion by digging up coffins for their lead and by turning church bells into cannons. In July 1792 Nantes accepted the Constitution of the Republic and a couple of months later there followed a

Audubon lived through some of the bloodiest years in French history. 'To think of these dreadful days', he wrote later, 'is too terrible....'

25

short but particularly bloody reign of terror under the ruthless Jean Carrier. The Vendéans were shot, guillotined and drowned in such numbers that both the town and the Loire were congested with fetid corpses. The plague spread through the streets; this did not assuage the blood lust of the Revolutionary maniac Carrier, and young Audubon, so he said later, had the misfortune of seeing one of his aunts dragged through the streets to the scaffold. All this did not exactly provide a serene background to the boy's education.

The thunders of the Revolution still roamed over the land, the Revolutionists covered the earth with the blood of man, woman and child. But let me forever drop the curtain over the frightful aspect of this dire picture. To think of these dreadful days is too terrible, and would be too horrible and painful for me to relate to you, my dear sons.

Thus wrote Audubon in later years about his experiences of the French Revolution. He was probably indulging his propensity for autobiographical licence and it is more likely that his efficient and doting stepmother kept him well away from all these horrors.

At about this time the Audubons decided to live in a safer part of the world; they moved into a small farmhouse, La Gerbetière, at Couëron, five miles downstream from Nantes on the Loire, where Jean Audubon after his retirement kept a fruit and vegetable garden and one or two animals. But he was not quite ready to withdraw to a life of quiet husbandry. In the early 1790s Jean Audubon was a naval lieutenant in command of a coasting vessel, a Republican lugger called the *Cerberus*. In July 1793 he was engaged in a desperate three-hour battle with a British privateer of fourteen cannon which had just captured an American ship laden with flour. Jean Audubon, after being wounded in the left thigh, forced the ship to surrender its prize, which he towed in triumph into the port of La Rochelle. As a civil commissioner, Citizen Audubon had less heroic assignments of visiting towns in the Nantes area whose loyalty to the Revolutionary cause was somewhat suspect, and on reporting to his superiors on the civil, moral and political health of those

areas. For these services he was promoted to *lieutenant de vaisseau*, one grade below that of captain. He retired from active service on 1 January 1801, aged fifty-seven. He had served in the French merchant marine and navy, on and off, for nearly twenty years, for which he was rewarded with a meagre annuity. In the meantime, the Negro revolt in San Domingo had meant the loss of Jean Audubon's entire fortune. With his small annuity and an indemnity of thirty thousand francs for the loss of his San Domingo property, he was able to lead a tranquil life in his new home at Couëron and to see something, at long last, of his wife and children. He died in 1818, in the words of his son, 'regretted most deservedly on account of his simplicity, truth, and perfect sense of honesty'.

Due partly to his father's active commitment to the Revolutionary cause and to the relative poverty of the family, young Audubon's education was on the rudimentary side. He had no training in his native tongue and he was never, in fact, able to write with grammatical accuracy in French or in English. Nevertheless his doting stepmother, Anne Moynet Audubon, arranged for him – her husband being frequently away on naval duties – to receive the sort of general education suitable for a well-to-do young bourgeois. He had private lessons in mathematics, geography, music and fencing. His stepmother did her best to keep him at home, perhaps wishing to protect him against the uncertainties and brutalities of the time. She was devotedly attached to him –

... far too much so for my good, [she] was desirous that I should be brought up to live and die 'like a gentleman', thinking that fine clothes and filled pockets were the only requisites needful to attain this end. She therefore completely spoiled me, hid my faults, boasted to everyone of my youthful merits, and, worse than all, said frequently in my presence that I was the handsomest boy in France ... let no one speak of her as my stepmother; I was ever to her as a son of her own flesh and blood, and she was to me a true mother.

Jean Audubon had had his doubts whether his son was benefiting to the full from his private tuition in the pampered atmosphere of La Gerbetière. He had clear ideas about the

value of knowledge. His son quoted him as saying, 'Revolutions too often take place in the lives of individuals, and they are apt to lose in one day the fortune they before possessed; but talents and knowledge, added to sound mental training, assisted by honest industry, can never fail, nor be taken from any one once the possessor of such valuable means.' He therefore insisted that his son's private tuition was accompanied by school lessons.

The school I went to was none of the best; my private teachers were the only means through which I acquired the least benefit. My father, who had been for so long a seaman, and who was then in the French navy, wished me to follow in his steps, or else to become an engineer. For this reason I studied drawing, geography, fencing, mathematics etc., as well as music for which I had considerable talent. I had a good fencing-master, and a first-rate teacher of the violin; mathematics was hard, dull work, I thought; geography pleased me more. For my other studies, as well as for dancing, I was quite enthusiastic; and I well recollect how anxious I was then to become the commander of a corps of dragoons.

Like Darwin, Audubon felt at an early age the urge to observe the workings of nature – only Darwin had more the eye and mind of the scientific naturalist. Audubon's first and last love was birds. His wife Lucy once said, when writing to her sister Eliza, 'I have a rival in every bird'. He would constantly slip out of La Gerbetière and take to the fields, returning home at night with his lunch-basket laden with the spoils of the day – birds' nests, eggs and other curiosities for his museum. When he returned to France from the United States in 1805, he met Charles d'Orbigny, also from San Domingo and a neighbour at Couëron, whose son, Alcide Charles d'Orbigny, was to be one of the greatest paleontologists of the nineteenth century. Audubon regarded d'Orbigny as his father in natural history. 'Together we searched the woods, the fields and the banks of the Loire, procuring every bird we could, and I made drawings of every one of them – very bad, to be sure, but still they were of assistance to me.' D'Orbigny seems to have provided him with

his only serious training in natural history. This is, however, to anticipate a few years.

Jean Audubon's disquiet about the shortcomings of his son's education grew; although he approved of his interest in natural history and drawing, they were not, in his view, adequate substitutes for more serious studies. In later years his son wrote:

La Gerbetière at Couëron in France, Audubon's boyhood home.

My father being mostly absent on duty, my mother suffered me to do much as I pleased; it was therefore not to be wondered at that, instead of applying closely to my studies, I preferred associating with boys of my own age and disposition, who were more fond of going in search of birds' nests, fishing, or shooting, than of better studies. Thus almost every day, instead of going to school where I ought to have gone, I usually made for the fields, where I spent the day; my little basket went with me, filled with good eatables, and when I returned home, during either winter or summer, it was replenished with what I called curiosities, such as birds' nests, birds' eggs, curious lichens, flowers of all sorts, and even pebbles gathered along the shore of some rivulet.

One day Jean Audubon, returning from one of his frequent sea journeys, asked his son what progress he had made in his studies. 'I, like a culprit, hung my head.' His father left the room without a word. Later that evening he asked his children to play to him; Rosa gave an accomplished performance on the pianoforte, but her brother, alas, had to admit that he had not touched his stringless violin for over a month. Once again his father made no comment. He asked to see his son's drawings, but they were indifferent.

My good father looked at his wife, kissed my sister, and humming a tune left the room. The next morning at dawn of day my father and I were under way in a private carriage; my trunk, etc., were fastened to it, my violin-case was under my feet, the postilion was ordered to proceed, my father took a book from his pocket, and while he silently read I was left to my own thoughts.

Thus Audubon described the long journey to the naval base of Rochefort, where he was enrolled in the military academy under the care of his future brother-in-law, Gabriel du Puigaudeau.

29

Audubon's stay at Rochefort lasted about a year. He was fourteen and the year was 1800. The wilful, ardent, artistic boy found the restraints of a naval training school intolerable and once attempted to escape. After a short cruise as a midshipman, he was back at Couëron. His father now began to recognize his son's genius; he gave up steering him towards a career which the boy found repugnant and, to his great credit, began to encourage his passion for drawing birds. Jean Audubon, as a man of the world, wanted his son to receive a thorough training in the art of draughtsmanship from the best available teachers. So he sent him in 1802 – so goes, at any rate, the persistent legend – to the *atelier* of Jacques Louis David in Paris. David was the acknowledged leader of French art during the Revolutionary period; he had earlier visited Nantes, whose citizens gave him a hero's welcome. Audubon found the discipline of David's studio almost as irksome as that of the naval school at Rochefort. 'David had guided [earlier he wrote "forced"] my hand in tracing objects of large size. Eyes and noses belonging to giants, and heads of horses represented in ancient sculpture, were my models. These, although fit subjects for men intent on pursuing the higher branches of the art, were immediately laid aside by me.' He had hoped to draw studies of animate, animal life and, instead, found himself having to transfer to paper, in black chalk, the features of these inanimate, classical casts. Nearly twenty years later, after being bankrupted and gaoled for debt in America, Audubon managed to pay off his creditors by drawing likenesses of the citizens of Shippingport and Louisville at five dollars a time. Once again he used black chalk and he may have spared a thought for David and his bleak technique of portraiture.

Back at Couëron, Audubon was free to roam the fields and draw the winged creatures of the meadows, woods, ponds and hedges. He began, at this time, to make a collection of his drawings of French birds. Audubon was a true child of the age of Rousseau and of the scientific enlightenment of Buffon and Lamarck. At this period the atmosphere was suffused with a revival of interest in nature. Rousseau's *Rêveries du promeneur*

OPPOSITE In 1802 Jean Audubon sent his son to Paris to study in the *atelier* of the famous artist David. This painting of the death of the Revolutionary leader Marat is perhaps David's best-known work.

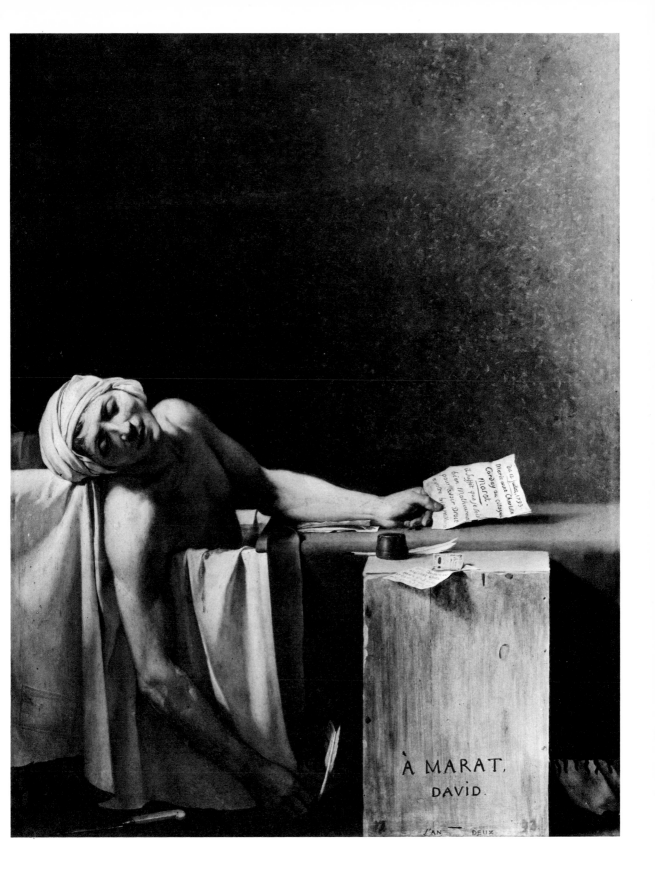

À MARAT.
DAVID.

solitaire, with its ecstatic descriptions of nature and of man's feelings for nature, had been published in the late 1770s. Every child must surely have responded willingly to his teachings that happiness can only be found with nature, far away from the brutish, artificial and stultifying rules and conventions of 'civilized' society.

The great Buffon, who made the study of natural history respectable in aristocratic circles, must certainly have shed some of the rays of his influence upon the unsuspecting head of young Audubon. His *Histoire naturelle des oiseaux* (1771–86) was the most splendid and sumptuous monument of its day to ornithological art, only to be superseded by Audubon's *The Birds of America*. Buffon's chief illustrator, F. N. Martinet, France's foremost bird painter, foreshadowed Audubon in his dramatic presentation of large species such as hawks, parrots and macaws. For all his great learning, Buffon's attitude to birds and indeed to every animal was unashamedly human or anthropomorphic. He divided birds into social rather than scientific classes; the eagle, being the 'royal eagle' or 'king of the birds', and his other warlike brethren enjoyed pride of place in the opening volume. Audubon was later to be accused by the scientists of unwarrantedly humanizing his birds by drawing them in anatomically impossible positions – a result of his passion for representing them in violent action. While the scientists were to find his drawings too emotional and impressionistic, the artists were sometimes to complain that they were too photographic. Audubon was, in fact, to alternate between two artistic techniques. When he was interested in a certain bird, he portrayed it in microscopic detail, to the displeasure of the 'artists'; when he was interested in a certain split-second pose of a bird, he would tend to portray it impressionistically, thus displeasing the 'scientists'. His drawings were to be judged by the double standards of art and science.

The drawings of the fifteen- to seventeen-year-old Audubon have not survived; the earliest drawings that have come down to us are those which he did at the time of his friendship with

Charles d'Orbigny in 1805 and 1806, when he was twenty. These drawings, done at Couëron, show the birds drawn life-size in a combination of crayon and watercolour on a thin, inexpensive paper. In these early efforts of the fledgeling painter there is no trace of David's classical discipline. And yet, years later, as the mature bird artist, Audubon was to succeed in giving his paintings of birds a rigid, Davidesque sense of classical composition. In his *Ornithological Biography* Audubon expresses his dissatisfaction with his early bird drawings.

My pencil gave birth to a family of cripples. So maimed were most of them, that they resembled the mangled corpses on a field of battle, compared with the integrity of living men . . . the worse my drawings were, the more fruitful did I see the originals. To have been torn from the study would have been as death to me. My time was entirely occupied with it. I produced hundreds of these rude sketches annually; and for a long time, at my request, they made bonfires on the anniversaries of my birth-day.

Audubon's love for nature came to him early in life. The joyful intensity of his first acquaintance with nature should earn him a place in romantic literature.

I received breath and life in the new World [his only consistent contribution to the mystery of his birth], and my Parents say, under the dark foliage of an Orange Tree, with a load of Golden Fruit and blossoms upon which fed that airy Silph the Hum Bird, whilst I received the tender cares of a Mother ever since kind to me . . . when I had hardly yet learned to walk, and to articulate those first words always so endearing to parents, the production of Nature that lay spread all around, were constantly pointed out to me. They soon became my playmates; and before my eyes were sufficiently formed to enable me to estimate the difference between the azure tints of the sky, and the emerald hue of the bright foliage, I felt that an intimacy with them, not consisting of friendship merely, but bordering on phrenzy, must accompany my steps through life.

As a boy he was 'fervently desirous of becoming acquainted with nature'. He wanted to perpetuate the joys of first seeing the nests, the eggs, the plumage of birds – to possess them, if

that were possible. He could find, however, absolutely no way of gratifying these fiercely covetous desires.

The moment a bird was dead, however beautiful it had been in life, the pleasure arising from possession of it became blunted; and although the greatest cares were bestowed on endeavours to preserve the appearance of nature, I looked upon its vesture as more than sullied, as requiring constant attention and repeated mendings, which, after all, it could not be said to be fresh from the hands of its Maker. I wished to possess all the production of nature, but I wished life with them. This was impossible. Then what was to be done?

The answer to the problem was provided by his father, 'an ingenious man to whom I owe all'. Jean Audubon gave him a book of 'Illustrations'. What they were we are not told, but from that moment, 'a new life ran in my veins. I turned over the leaves with avidity; and although what I saw was not what I longed for, it gave me a desire to copy nature'. In these words Audubon describes the beginnings of his artistic awareness.

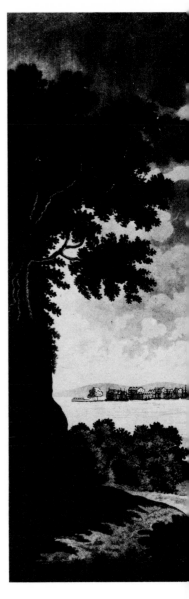

On 23 October 1800 Jean Jacques Fougère was baptized at Nantes. His stepmother had hopes that he might become a priest. He neither became a priest nor did he remain a Catholic; in later life, in fact, he gave up all formal religious beliefs and made many uncomplimentary remarks about his former religion. He did, however, like going to Protestant churches.

In 1803 Jean Audubon made another of his quiet decisions; he decided to send his son to America. Events in San Domingo had shown that he had no hope of recovering his lost fortune. Napoleon had extinguished a momentary ray of light on that unhappy island by blackguarding the heroic black leader Toussaint l'Ouverture, thereby intensifying the Negro revolt, and it was clear that French policies were about to lead to a long conflict with the British in that area. Napoleon's agents were combing France in search of cannon fodder for his campaigns and there was every likelihood that Jean Audubon's son would be conscripted. Although a passionate supporter of the First Consul, he did not wish his son to follow Napoleon's victorious eagles. He wished him instead to learn about trade and also the English language. 'Little could the father have

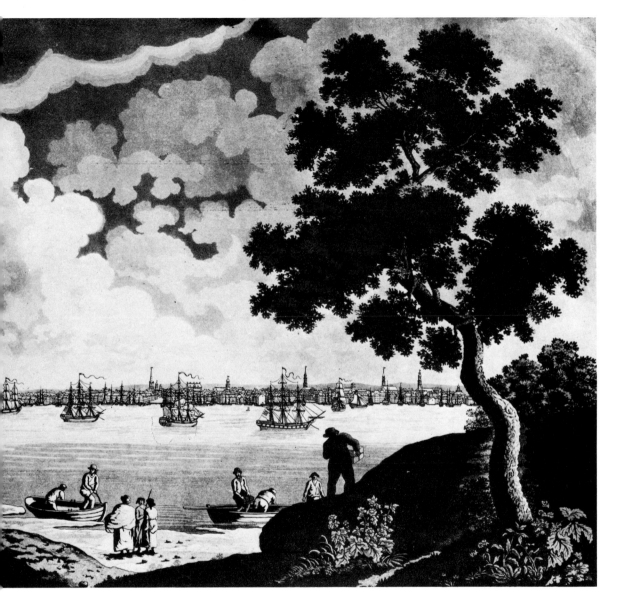

New York from Long Island, aquatint engraving by William Rollinson, 1801. The young Audubon sailed for New York in the autumn of 1803.

thought,' in the words of one biographer, 'that by following other eagles of his own choice, his son was destined to add a far greater lustre to the family name.'

In late August or early September 1803 Audubon sailed for New York. Although his stepmother sobbed to see him go, his own feelings upon leaving for the United States of America were of 'intense and indescribable pleasure'.

35

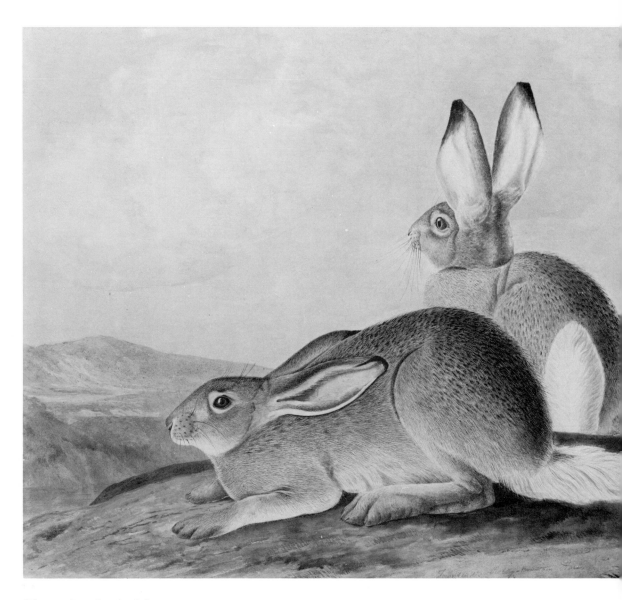

Watercolour by Audubon
of Townsend's hares.

3

Marriage and the Louisville Venture

fter landing in New York, Audubon did not make straight for Mill Grove. Instead, he walked thirty miles to Greenwich, Connecticut, to cash a letter of credit. On the way he succumbed to yellow fever, which he must have caught in New York; the captain of the ship in which he had sailed took him to Morristown, New Jersey, where he was put in the care of two Quaker ladies who, Audubon was later to say, saved his life.

On recovering from his illness, Audubon was taken over by another Quaker, Miers Fisher of Philadelphia. 'A rich and honest Quaker of Philadelphia,' was how Audubon described him. There were many such persons in that prosperous city which, since the arrival of William Penn at the end of the seventeenth century, had been growing steadily richer and more serious-minded. As the birthplace of their newly won independence, Philadelphia was, at the time of Audubon's arrival, the most distinguished and important city of the United States. The year 1804 was the third year of Thomas Jefferson's presidency.

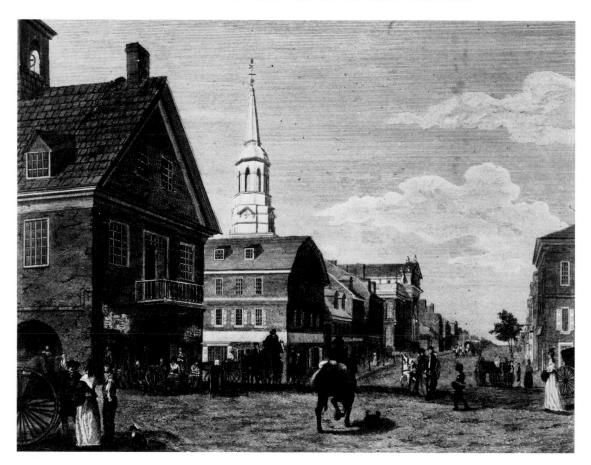

Engraving of
Philadelphia,
published in 1799.

Audubon did not take to the severity of the Quaker Fisher
household. His father, at the time of purchasing Mill Grove,
had placed his American business interests in the hands of the
worthy Miers Fisher, who, in having young Audubon to stay,
thought he was carrying out the father's wishes 'to procure him
a good and healthy place where he might learn English'.
Audubon soon suspected that Miers Fisher hoped to make him
a permanent member of his austere household by marrying
him to his daughter, a young lady 'of no mean appearance'.
Determined that this should not happen, he appealed to the
honest Quaker to help him establish himself in Mill Grove, his
own family property.

In the spring of 1804 Audubon moved to Mill Grove and a
short period of pure, unclouded happiness opened up before

38

him. William Thomas, another Quaker, was living there as Jean Audubon's tenant-farmer; Audubon joined him and his family and was given a quarterly allowance that 'was considered sufficient for the expenditure of a young gentleman'. At Mill Grove the image of Audubon, the American woodsman, began to emerge; he was not yet the frontier pioneer of his middle period, but the dandified young hunter, roaming the placid Pennsylvania landscape in satin pumps and silk breeches. It was at this time that he started to shoot birds in earnest; he was to be for the rest of his life a hunter – a fact which does not fully accord with the National Audubon Society's projection of him as a passionate protector of wildlife. And yet he shot the birds partly for sport and partly because he loved them and wished, as we have seen, to record their likenesses.

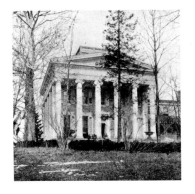

Fatland Ford, the home of Audubon's neighbours and future relations by marriage, the Bakewells.

During these carefree, pleasure-filled months at Mill Grove Audubon began to display certain qualities which never left him. These were hunting skill, an undisciplined curiosity, a latent artistic power and an unfailing energy – qualities which impressed his English neighbour, William Bakewell, who with his family had just moved into Fatland Ford, a large, porticoed, colonial house a quarter of a mile from Mill Grove. At first, Audubon let his hostility to the British stand in the way of developing an acquaintance with his new neighbours. He snubbed Mr Bakewell by failing to return his call. He could not forget his father's long imprisonment in England and the incessant harassment of French ships by British privateers. At the same time, he admired his neighbour's expert marksmanship and his well-trained dogs; when, both on the lookout for grouse, they accidentally met in a wood one autumn day in 1804, Audubon, forgetting his anglophobia, warmly greeted his neighbour and apologized for past discourtesies. From then on Audubon was a frequent visitor at Fatland Ford. Bakewell's daughter Lucy, the eldest of his six children and three years younger than Audubon, may well have been another reason for the rapid disappearance of his anti-British predudices. Audubon later described his first meeting with Lucy Bakewell:

Well do I recollect the morning, and may it please God that I never forget it, when for the first time I entered Mr Bakewell's dwelling. It happened that he was absent from home, and I was shown into a parlour where only one young lady was snugly seated at her work by the fire. She rose on my entrance, offered me a seat, and assured me of the gratification her father would feel on his return, which, she added, would be in a few moments as she would despatch a servant for him. Other ruddy cheeks and bright eyes made their transient appearance but, like spirits gay, soon vanished from my sight; and there I sat, my gaze riveted, as it were, on the young girl before me, who, half working, half talking, essayed to make the time pleasant to me. Oh! may God bless her! It was she, my dear sons, who afterward became my beloved wife, and your mother.

The Bakewells came from Leicestershire; William Bakewell inherited a fortune from his bachelor uncle Thomas Woodhouse Bakewell, and his interest in chemistry and natural philosophy led him into the circle of Joseph Priestley and Erasmus Darwin. His unorthodox political and religious views made him unpopular in county circles, which determined him to emigrate to America with his family. With his brother Benjamin he started brewing English ale in New Haven in 1798; when this business was destroyed by fire in 1804, he bought Fatland Ford, where he spent most of the time in his library and laboratory.

His daughter Lucy, born in Burton-on-Trent in 1787, became one of history's great wives; without her courage, loyalty and faith, Audubon would not have emerged triumphant from the many vicissitudes which lay before him, and the world would never have been presented with *The Birds of America*. She was to leave without a murmur her prosperous Pennsylvania home and suffer his tribulations as a bankrupt Kentucky store-keeper; she also shared his own confidence in the ultimate success of his artistic mission. Lucy and Audubon became engaged towards the end of 1804 – despite her father's opinion that Audubon was too unbusiness-like to marry – and the joys of courtship, sport and society filled his days. 'Not a ball, a skating match, a house or a riding party took place

without me.' Whatever the sport, he made certain that he had the best horses, the best guns and the best fishing-tackle and, whatever the occasion, he was sure to be seen in black satin breeches and silk stockings and wearing the most expensive Philadelphia shirts.

Audubon's diet and the hours which he kept contrasted with his flamboyant lifestyle. He rose at dawn to devote himself to his bird studies; he lived on fruit, vegetables and milk and seldom allowed himself a glass of wine: 'Pies, puddings, eggs, milk and cream, was all I cared for in the way of food.' Very occasionally he ate some game or fish. His first studies of American bird life date from this period. Mill Grove and the surrounding country with 'its fine woodlands, its extensive fields, its hills crowned with evergreens, offered many subjects to my pencil. It was then that I commenced my simple and agreeable studies, with as little concern about the future as if the whole world had been made for me'. He began to shoot and paint those birds which were new to him, rather than to shoot for shooting's sake.

In the spring of 1804 Audubon made the first 'banding' experiment on the young of an American wild bird. He was studying the habits of some peewees or phoebes which nested in a cave on the Mill Grove estate on the banks of the Perkioming, and he decided to test their migratory behaviour by tying silver thread to the legs of the nestlings. 'I fixed a light silver thread on the leg of each, loose enough not to hurt the part, but so fastened that no exertion of theirs could remove it.' In doing this he was anticipating by one hundred years the practices of the Bird Banding Society of the United States in establishing data for migratory movements. Audubon was not to turn into a good theoretician and sometimes his experiments led him to erroneous conclusions, as when, for example, years later in 1832, he tried to show that the turkey vulture could locate its food by smell.

Audubon was not, alas, destined to become the squire of Mill Grove and to perpetuate his idyll on that attractive piece of property. Later, in his reminiscences, he invested the place

Exploring the landscape,
hunting and studying
birds were Audubon's
chief preoccupations at
this time. *Sunny Morning
on the Hudson River*, by
Thomas Cole.

with imagined episodes and associations; he said that his father had met George Washington there and, even more surprising, that his mother lived nearby. The old house stood above the banks of the Perkioming Creek, where it emptied its waters into the Schuylkill River, and had a fine view over the valley to the distant Reading Hills. Audubon often made the twenty-four-mile journey to Philadelphia on foot. The caves in the banks of the Perkioming were rich in minerals, particularly sulphide of lead; early conveyances had referred to 'Mill Grove Mines Farm'. At the end of 1804 Francis Dacosta, an immigrant Frenchman from Nantes who became Audubon's guardian and had replaced Miers Fisher as Jean Audubon's agent, bought a one-half interest in Mill Grove and started to mine some rediscovered lead deposits. Should the mining be successful, the plan was that Audubon would be taken into the business.

Dacosta was intended to teach me mineralogy and mining engineering, but in fact he knew nothing of either; besides which he was a covetous wretch, who did all he could to ruin my father, and indeed swindled us both to a large amount. I had to go to France to expose him to my father to get rid of him, which I fortunately accomplished at sight of my kind parent. A greater scoundrel than Dacosta never probably existed, but peace be with his soul.

The reason for this diatribe against Dacosta was that he had objected, following Jean Audubon's instructions, to the proposed marriage and had cut off Audubon's annuity from the estate. Audubon decided to sail forthwith to France and expose the 'swindler'. He walked in three days from Philadelphia to New York, with what he thought was a letter of credit from Dacosta to pay for his trip. It was no letter of credit, but a note saying that the bearer should be arrested and shipped to Canton. Benjamin Bakewell, a New York merchant and brother of William Bakewell of Fatland Ford, came to Audubon's aid and supplied him with the necessary funds. He crossed the Atlantic and reached Couëron in the spring of 1805.

Once again in France, Audubon was in no hurry to make the return journey to be reunited with Lucy. He stayed at Couëron

for over a year (not two years, as he stated) 'in the very lap of comfort'. 'I went out shooting and hunting, drew every bird I procured, as well as many other objects of natural history and zoology, though these were not the subjects I had studied under the instruction of the celebrated David.' He did not succeed in persuading his father to get rid of Dacosta, but he did manage to obtain his consent to his marriage with Lucy. During Audubon's absence in the United States Napoleon had made himself emperor. Audubon said:

France was at that time in a state of convulsion; the republic had, as it were, dwindled into a half monarchical, half democratic era. Bonaparte was at the height of success, overflowing the country as the mountain torrent overflows the plains in its course. Levies, or conscriptions, were the order of the day, and my name being French my father felt uneasy lest I should be forced to take part in the political strife of those days.

Jean Audubon thought it best for his son to return to the United States and avoid being conscripted into the French army. He wanted him this time to go there with some special business activities in view and, to this end, he drew up a nine-year contract between his son and Ferdinand Rozier, the son of a commercial judge in Nantes, who had at Jean Audubon's request put some money into the Mill Grove lead mines. Ferdinand was eight years older than Audubon and, after seeing naval service off the American coast, was fired by the idea of making his fortune in the United States. The two young men sailed from Nantes in the brig *Polly* on 12 April 1806 and arrived in New York six weeks later after a perilous journey: the *Polly* was chased by a British privateer, the *Rattlesnake*, and was forced to stop to let the English captain come on board. He contented himself with impressing a couple of seamen and robbing the ship 'of almost everything that was nice in the way of provisions, took our pigs and sheep, coffee and wines' – but not the gold belonging to Audubon and Rozier which they had carefully hidden, wrapped up in clothing, under a cable in the bow of the ship.

Back in New York, Audubon hurried off to Philadelphia and then to Fatland Ford to see Lucy. Dacosta, however, was to prove more than a match for the two young entrepreneurs. He thwarted them at every turn in their efforts to form a company and mine the lead and, after a few months, they decided to sell him their half-share of Mill Grove and to look for new business openings in trade. Mill Grove thus went out of the hands of the Audubon family for ever. Audubon had now neither home nor

The landscape of eastern North America. *In the Catskills*, by F. E. Church.

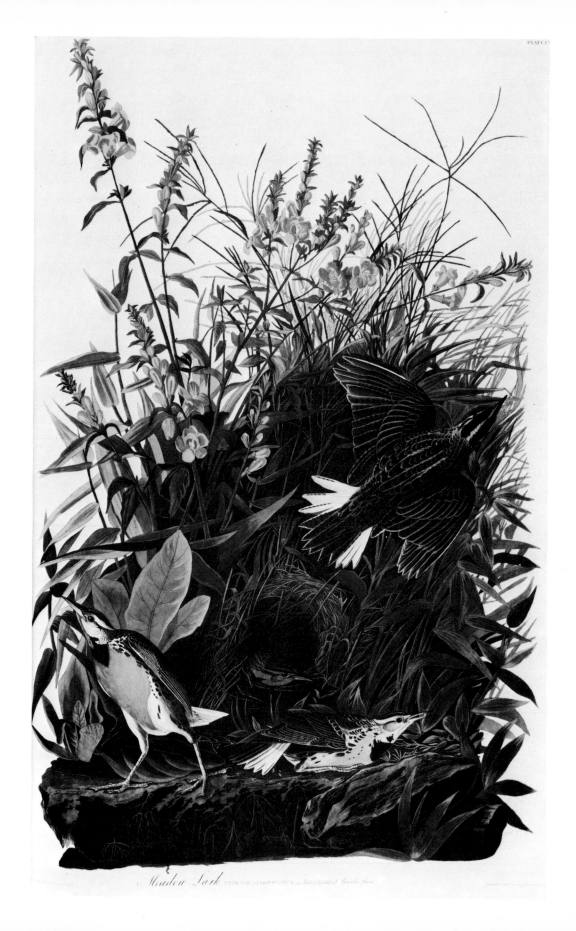

PLATE C.

Meadow Lark. STURNUS LUDOVICIANUS. Male & Female 1. Openuha Flour.

job; it was settled early in 1807 that he should go to New York to work in the counting house of Benjamin Bakewell's successful import business. Rozier, who knew no English, joined a French import house in Philadelphia. Audubon's 'commercial' letters from the Bakewell establishment are a comic phonetic blend of French and Quaker English, heavily interspersed with 'thees' and 'thous'. As was to be expected, 'the mercantile business did not suit me. The very first venture which I undertook was in indigo; it cost me several hundred pounds, the whole of which was lost.' He preferred to be out in the open, shooting and drawing birds, or to visit the museum of Dr Samuel L. Mitchell, a brilliant and versatile New York physician, politician and naturalist, who began one of the earliest American collections of natural history. Audubon supplied him with many birds and mammals, keeping them sometimes too long for the comfort of his neighbours who complained to the authorities about the odours emanating from his rooms.

Audubon had had his own museum of sorts at Mill Grove, of which William Bakewell, one of Lucy's brothers, wrote an interesting description:

On entering his room, I was astonished and delighted to find that it was turned into a museum. The walls were festooned with all kinds of bird's eggs, carefully blown out and strung on a thread. The chimney-piece was covered with stuffed squirrels, racoons and opossums; and the shelves around were likewise crowded with specimens, among which were fishes, frogs, snakes, lizards and other reptiles. Besides these stuffed varieties, many paintings were arrayed on the walls, chiefly of birds. He had great skill in stuffing and preserving animals of all kinds. He had also a trick in training dogs with great perfection, of which his famous dog, Zephyr, was a wonderful example.

He went on to talk about him more generally:

He was an admirable marksman, an expert swimmer, a clever rider, possessed of great activity, prodigious strength, and was notable for the elegance of his figure and the beauty of his features, and he aided nature by a careful attendance to his dress. Besides other accomplishments he was musical, a good fencer, danced well,

OPPOSITE Meadow lark (eastern meadowlark), Plate CXXXVI from *The Birds of America*. The background of wild flowers was painted by George Lehman.

47

and had some acquaintance with legerdemain tricks, worked in hair, and could plait willow baskets.

This was the attractive young man that Lucy had chosen to marry. The only practical skill that he had hitherto shown was in mounting specimens and preparing skins for Dr Mitchell in New York. He had not yet thought of becoming a professional naturalist or bird man; if he had, Dr Mitchell would have been the ideal person to help him. Audubon believed that he should persevere in commerce and that shooting, mounting and drawing birds should remain an absorbing hobby. His recent experiments at Mill Grove in using wires to hold the body of a bird in many different postures were beginning to affect his art significantly. He was dissatisfied with the traditional method of drawing birds from stuffed specimens which resulted in stodgy, wooden representations; the drama and energy which inform his later paintings were largely due to his skill in wiring up freshly killed birds.

In the summer of 1807 Audubon and Rozier said goodbye to Mill Grove and set off to make their fortunes in the West. They travelled a good thousand miles, first by stage coach over the Allegheny Mountains to Pittsburgh and then in a flatboat along the Ohio as far as Maysville, Kentucky, where they resumed their journey overland to Louisville. Here they decided to set up shop, having already acquired their opening stock from Benjamin Bakewell with a promissory note for $3,600 to fall due in eight months. Rozier had at once appreciated the commercial opportunities of Louisville, at that time a small trading and agricultural centre of a thousand people, overlooking the Ohio; two miles below the little town were the Falls of the Ohio which form a natural break in the navigation of the river.

'For a period of over twenty years, my life was a succession of vicissitudes ... my whole mind was ever filled with my passion for rambling and admiring those objects of nature from which alone I received the purest gratification.' This attitude to life did not make Audubon an ideal business partner at a time when every trader had to hustle and fight to hold his own with

OPPOSITE Summer red bird (summer tanager), watercolour painted, according to its inscription, in 1821 at Bayou Sara by Audubon and Joseph Mason.

FOLLOWING PAGES LEFT *Mill Grove, Pennsylvania*, painted by Thomas Birch. RIGHT Portrait of Audubon painted by his son, John Woodhouse Audubon, *c.* 1842.

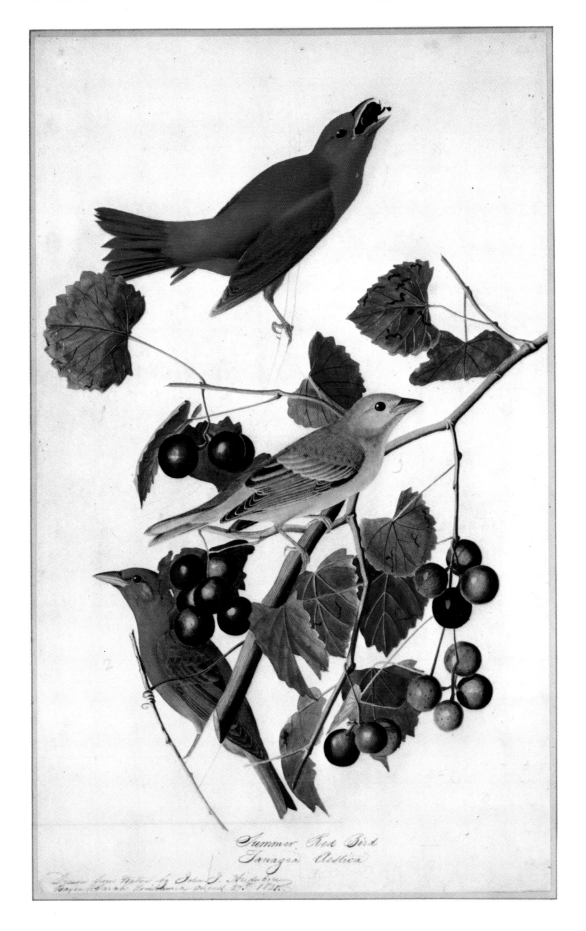

Summer Red Bird
Tanagra Aestiva

Drawn from Nature by John J. Audubon
Bayou Sarah Louisiana March 27th 1821

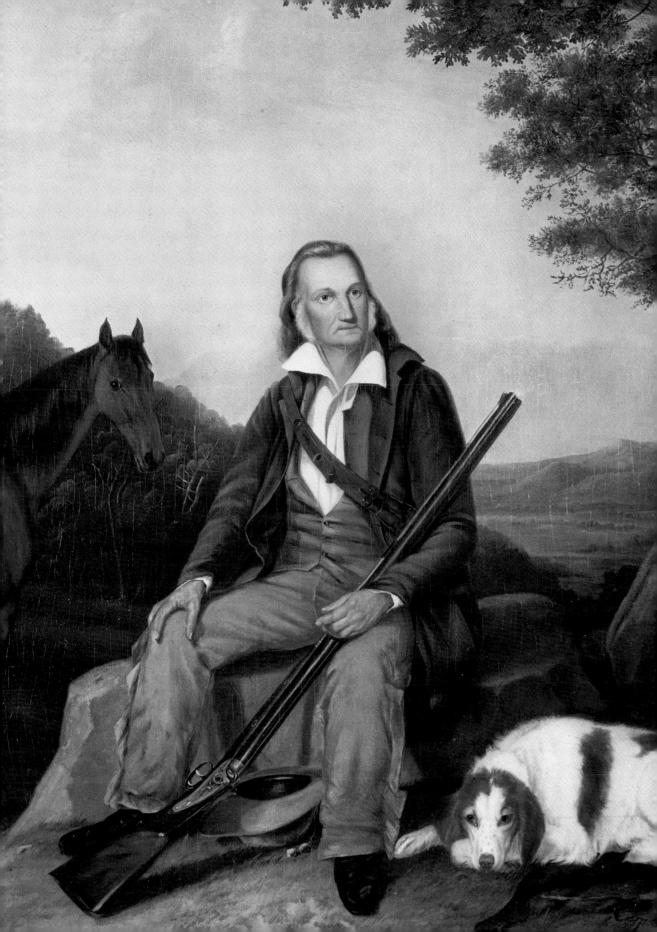

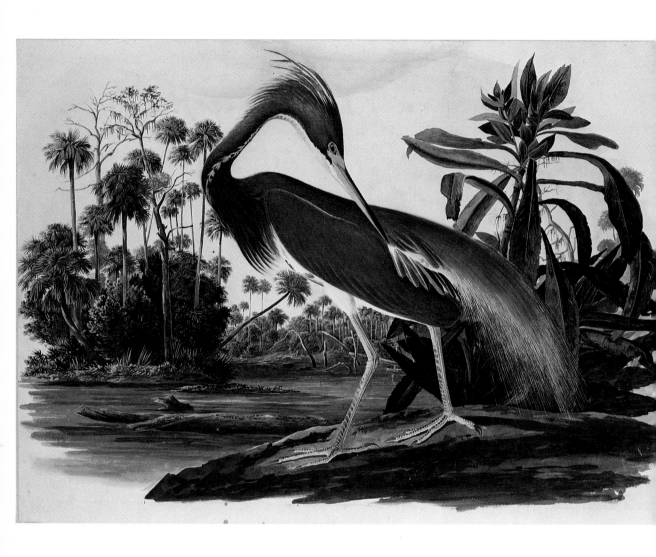

competitors. The uncertainties of the international situation made the lives of aspiring traders like Audubon and Rozier, who imported most of their goods from France, exceedingly hazardous. Soon after they had set up shop in Louisville President Jefferson signed the famous Embargo Act (22 December 1807) which, by prohibiting American merchant vessels from calling at foreign ports and foreign vessels from leaving American ports, ruined many merchants engaged in international trade. One of those ruined was Benjamin Bakewell whose business had become heavily dependent, through his connection with Rozier in Nantes, on French trade. He was rescued by friends who helped him start a glass business in Pittsburgh. The crisis did not worry Audubon; in March 1808 he left Rozier in Kentucky and returned to Pennsylvania to claim his bride.

The first definite date which Audubon gives in his rambling journals and autobiographical fragments is 8 April 1808. This was the day on which he was married to Lucy by the Rev. Dr Mortimer, an Episcopalian clergyman, in the drawing-room of Fatland Ford. The following day the young couple left for their new Kentucky home. They made the thousand-mile journey in twelve days, the only mishap being when their coach overturned when crossing the Alleghenies and Lucy suffered severe bruises. At Pittsburgh they floated down the Ohio – 'La belle rivière', as Audubon called it – towards Kentucky.

In Louisville the Audubons lived at The Indian Queen, one of the famous inns on the river. Here, on 26 June 1809, their son, Victor Gifford Audubon, was born. Although Lucy thought Louisville 'a very pleasantly situated place', she found the surrounding countryside 'rather flat'. Audubon saw it differently – 'The prospect from the town is such that it would please even the eye of a Swiss'. He saw things not as they were, but how he would like them to be. The store at Louisville,

... went on prosperously when I attended to it; but birds were birds then as now, and my thoughts were ever and anon turning toward them as the objects of my greatest delight. In short, I drew, I looked on nature only; my days were happy beyond human conception, and

OPPOSITE Louisiana heron, watercolour painted in 1832 for Plate CCXVII of *The Birds of America*. The background is a Florida key painted by Lehman. 'Delicate in form, beautiful in plumage. . . .' was Audubon's description of this beautiful bird.

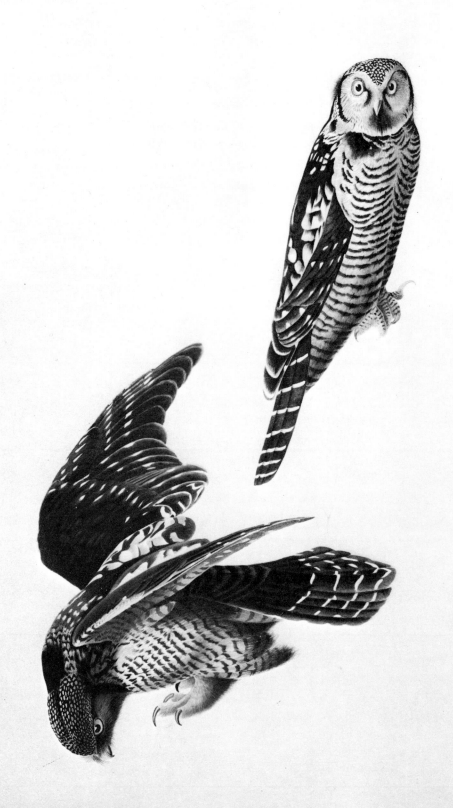

beyond this I really cared not. ... I seldom passed a day without drawing a bird, or noting something respecting its habits, Rozier meantime attending the counter. I could relate many curious anecdotes about him, but never mind them; he made out to grow rich, and what more could *he* wish for?

The serious-minded, commercially ambitious Rozier showed extraordinary forbearance towards his wayward, wilful colleague who unashamedly let him bear most of the burden of running the store. The only aspect of the work which Audubon really enjoyed was his frequent journeys to Philadelphia or New York to purchase goods; he enjoyed them because he could study birds and their habits as he travelled through the forests of Kentucky, Ohio and Pennsylvania.

By the year 1810, Audubon's portfolios contained over two hundred pictures of American birds; already he was painting them life-size, generally in pastel and using watercolours for the eyes, bills and feet. As far as the long-suffering Rozier was concerned, all this artistic energy was misplaced; their store was short of money and they were unable to restock. William Bakewell gave them $8,000 by selling 170 acres of land at Fatland Ford, this being Lucy's share of the estate. Poor Lucy bore this disposal of her dowry uncomplainingly. She was more concerned with how to spend her time during her husband's long absences. 'I am sorry there is no library here or book store of any kind; for I have very few of my own, and as Mr Audubon is constantly at the store [!] I should enjoy a book very much whilst alone.'

OPPOSITE Hawk owl, watercolour painted possibly during the winter of 1836–7. Audubon, who never saw any of these birds in the wild, was sent these specimens from Canada.

4

Failure in Business

ne fair morning I was surprised by the sudden entrance in our counting-room of Mr Alexander Wilson, the celebrated author of "American Ornithology", of which existence I had never until that moment been apprised. This happened in March 1810. How well do I remember him, as he then walked up to me! His long, rather hooked nose, the keenness of his eyes, and his prominent cheekbones, stamped his countenance with a peculiar character. His dress, too, was of a kind not usually seen in that part of the country; a short coat, trousers, and a waistcoat of grey cloth. His stature was not above the middle size. He had two volumes under his arm, and as he approached the table at which I was working, I thought I discovered something like astonishment in his countenance. He, however, immediately proceeded to disclose the object of his visit, which was to procure subscriptions for his work. He opened his books, explained the nature of his occupation, and requested my patronage.'

Until this moment, when Wilson walked into Audubon's country store with his little tame parakeet on his shoulder and

OPPOSITE Barn swallow, Plate CLXXIII of *The Birds of America*. The original watercolour was painted in the early 1830s, in New Jersey.

56

PLATE. CLXXIII

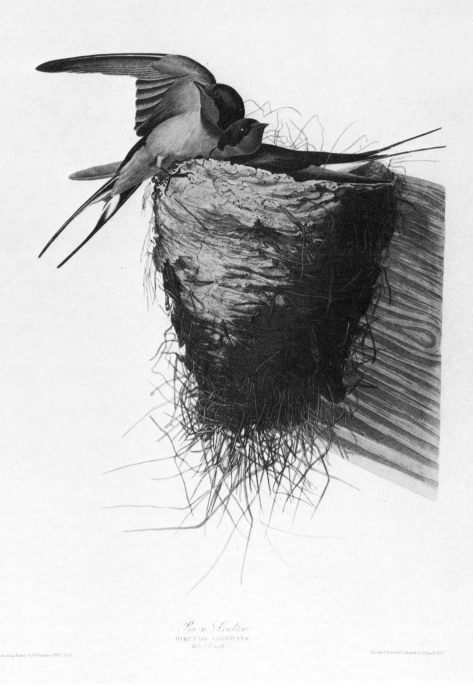

Barn Swallow
HIRUNDO AMERICANA
Male & Female

Drawn from Nature by J.J.Audubon FRS FLS

Engraved, Printed & Coloured by R.Havell 1833

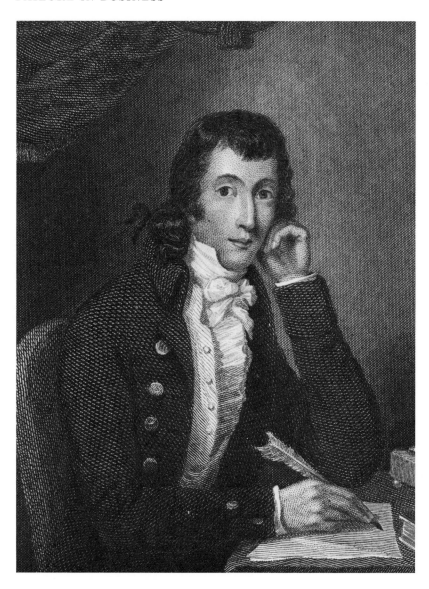

The Scottish-born
Alexander Wilson was
Audubon's rival as the
major pioneer of
American ornithology.

his portfolios under his arm, the two great pioneers of American ornithology had never heard of each other. Posterity, encouraged by the partisan accounts of contemporaries, has chosen to treat them as rivals. They take their place in history as antithetical personalities – like Gladstone and Disraeli, Jefferson and Hamilton – each unable to appreciate or to understand the other.

The two men were, it is true, as dissimilar as it is possible for

two human beings to be, and all they had in common was a love of birds. Wilson was a small, weasel-faced, embittered Scot of humble origins. Born in 1766, at the age of thirteen he began work as a weaver in Paisley, outside Glasgow. He hated the work and, at eighteen, became an itinerant pedlar, orator, poet and political agitator; the iron had entered his soul at all the injustices, real and imagined, that he had received from his hard-hearted employers. Starved of love and unattractive to women, he complained in his Scottish verses that poverty, that 'haggard harlot', was the only mistress in whose arms he had lain.

> ... So disfigur'd with thy scoffing,
> Need I wonder why so often
> Friends go past, nae answer gi'e me,
> Look their watch, and never see me.

His most famous poem, *Watty and Meg, or the taming of a Shrew*, published anonymously in 1792, was thought to be the work of Robert Burns. He used his versifying talents to attack the social evils of his day – the brutal factory owners and spinning barons; one obtained judgment against him for libel. Wilson, unable to pay the £12 fine, was thrown into prison for three months and, on being released, was ordered to burn the offending verses in public and to apologize to the libelled weaver. Bitter and utterly dejected, in 1794 he left Scotland for ever to start a new life in America. Up to this time the 'father of American ornithology' knew nothing whatsoever about birds; all he brought with him to his new country were a keen eye and the sensibility of a poet and artist. And yet he was to write the first great work on American birds. He became passionately proud of being an American and was quick to defend his new country against any slighting remarks by complacent Europeans. When he was later engaged in the study of American birds, he was scandalized by Buffon's theory that American birds were descended from European ancestors who, in crossing to the Western hemisphere by a northern route, had degenerated in the process. The European song thrush for example had, according to Buffon, after becoming an American

59

thrush, developed a harsh and unpleasant cry, 'as are the cries of all birds that live in wild countries inhabited by savages'. Wilson, of the *genus irritabile* at the best of times, exploded at this affront to his patriotism. 'The eternal reference of every animal of the New World to that of the Old ... would leave us in doubt whether even the Ka-te-dids of America were not originally nightingales of the Old World, degenerated by the inferiority of the food and climate of this upstart continent.'

For the first ten years of his life in his new country Wilson tried one thing after the other – printing, weaving, peddling, surveying and finally school-teaching in Virginia, New Jersey and Pennsylvania, where he taught at a school at Gray's Ferry on the Schuylkill River, less than forty miles from Mill Grove. Unlike Audubon, he found at this time some learned, sympathetic and intelligent friends, who encouraged his new interests of drawing and studying birds. The most important was the elderly William Bartram, the great botanist and America's best ornithologist before Wilson. Bartram invited him to come and live in his farmhouse on the Schuylkill which his father John Bartram – Quaker philosopher, traveller, botanist, agriculturalist and nurseryman – had built in 1792 with his own hands. Then there was the zoologist George Ord, later to become Audubon's enemy and Wilson's excessively partisan admirer, and Alexander Lawson, the engraver. They all urged him to escape from the drudgery of school-teaching and to follow his ambition of making known to the world the birds of his adopted country.

Alexander Lawson helped Wilson to learn to draw; in March 1804 Wilson informed him, 'I am most earnestly bent on pursuing my plan of making a collection of all the Birds of this part of N. America. ... I have been so long accustomed to the building of Airy Castles and brain Windmills that it has become one of my comforts of life, a sort of rough Bone that amuses me when sated with the dull drudgery of life.' He needed also to satisfy 'that Itch for Drawing which I caught from your honourable self'. His ornithological knowledge was still so meagre that he sent Bartram the same month some

drawings of birds, asking him to name them. 'I have now got my collection of native birds considerably enlarged and shall endeavour if possible to obtain all the smaller ones this summer. Be pleased to mark on the drawings the names of each bird with a pencil, as, except three or four, I do not know them.'

Neither Bartram nor any of his predecessors were able to be of much ornithological help to Wilson, since very few species of birds had been scientifically described by American writers; Bartram had given his own, often ambiguous, Latin names to the species which he listed. Wilson turned, no doubt reluctantly, to the European scientists to find the model for his classification of birds. Of particular help to him was William Turton's *A General System of Nature ... by Sir Charles Linné* of 1806, the English translation of the last edition of Linnaeus's *Systema Naturae*, the basis of modern classification. Wilson became the first American ornithologist to combine the Linnaean system of binomial nomenclature, giving the genus and species of each bird, with descriptions of the bird's habits, appearance and distribution, and a coloured illustration of each species. These principles were embodied in Wilson's nine-volume *American Ornithology*, the first two volumes of which he spread open on the counter of the Louisville store before the astonished eyes of Audubon on that historic day.

American Ornithology was something new in American publishing; the only way to finance the work, with all the vast expense of engraving, printing and colouring, was to obtain subscriptions at $120 a set. Wilson reached Louisville after crossing Pennsylvania on foot and sailing down the Ohio in a small skiff.

Audubon picked up a pen and was about to enter his name as a subscriber for the $120 set when Rozier muttered something to him in French. 'My dear Audubon,' he said, 'what induces you to subscribe to this work? Your drawings are certainly far better, and again you must know as much of the habits of American birds as this gentleman.' Audubon later said, 'Vanity and the encomiums of my friend prevented me from subscribing'. Wilson, looking surprised and displeased, asked

Lucy Bakewell Audubon
as a young woman.
Audubon's treatment of
his wife and children
was cavalier and
irresponsible, although
he undoubtedly loved
Lucy. 'With her',
he wrote, 'was I not
always rich?'

whether Audubon had done any drawings of birds. 'I rose, took down a large portfolio, laid it on the table, and shewed him, as I would shew you, kind reader, or any other person fond of such subjects, the whole of the contents, with the same patience with which he had shewn me his own engravings.' Wilson asked Audubon whether he proposed to publish his drawings and was surprised when he answered in the negative. He then asked permission to copy some of them; Audubon assented. 'It happened that he lodged in the same house with us, but his retired habits, I thought, exhibited either a strong feeling of discontent, or a decided melancholy. The Scotch airs which he played sweetly on his flute made me melancholy too, and I felt for him.' Audubon took him out shooting and he managed to obtain some new birds. 'But, reader, I did not subscribe to his work, for, even at that time, my collection was greater than his.'

Although Wilson's birds lacked both the classical splendour and florid romanticism of Audubon's *The Birds of America* and his text was factual and acerbic when compared with the exuberant intimacy of the *Ornithological Biography*, his influence on Audubon was immense. When Audubon turned over the pages of Wilson's first two volumes, he must have realized that here was a man who had made a profession out of a hobby. Audubon was still more of a sportsman than a naturalist and his drawings were haphazard and unsystematic. The sight of Wilson's first two volumes pointed out to him the direction which his own work could take. They contained the first attempt to represent birds in their natural surroundings; the text was informal and clearly written by someone who had studied bird life in the open. Wilson was not a gifted artist; his birds often appear to be stiff and their postures unnatural. They seldom have the grace and power of movement of Audubon's later birds. Nevertheless, Audubon adopted Wilson's artistic, scientific and descriptive approach and had reason to be grateful to the man who initiated the intelligent and thorough investigation of the American avifauna. Wilson continued his travels on horseback, wearing himself out in his search for subscribers. When he had obtained the required 250

subscriptions, his publisher decided to increase the number to 500. In 1813 he died in Philadelphia – 'under the lash of a bookseller', said Audubon. This was corrected by the daughter of his engraver Alexander Lawson, who said he had been killed by the dishonesty of a publisher.

Although Louisville was growing in size, Audubon and Rozier did not benefit from the increased trading opportunities: they found themselves under pressure from other traders who were pushing west. Audubon, although intent upon being a merchant, was too lazy and undisciplined to take his business seriously. 'Louisville did not give us up, we gave up Louisville. ... Merchants crowded to Louisville from our eastern cities. None of them were, as I was, intent on the study of birds, but all were deeply impressed by the value of dollars. I could not bear to give the attention required by my business, and which, indeed, every business calls for, and, therefore my business abandoned me.' In spite of having swallowed up Lucy Audubon's patrimony, the firm seemed doomed. Leaving aside Audubon's neglect of his business, there must have been other reasons why they were so badly hit by the new competition. Rozier's lack of English was a serious disadvantage in a rough frontier community; the long route along which merchandise travelled from the east was another. Audubon shamelessly tells us how, when driving horses before him laden with goods and dollars, he quite lost sight of the pack saddles and the cash they contained as he was busy studying the motions of a warbler.

For some reason or other, both Audubon and Rozier thought that their problems would be solved by moving 125 miles down the river to Henderson, or Redbanks as it was then known, consisting of 159 people living in a cluster of log cabins, their main requirements of life being whisky, gunpowder and coarse woollen clothes. The move, and the drama and activity connected with it, were just what Audubon liked – an invigorating alternative to the tedium of standing at a counter waiting for customers.

When I first landed in Henderson, Kentucky, my family, like the

FOLLOWING PAGES
White-headed eagle (bald eagle), Plate XXXI from *The Birds of America*. It is holding a catfish in its claw.

63

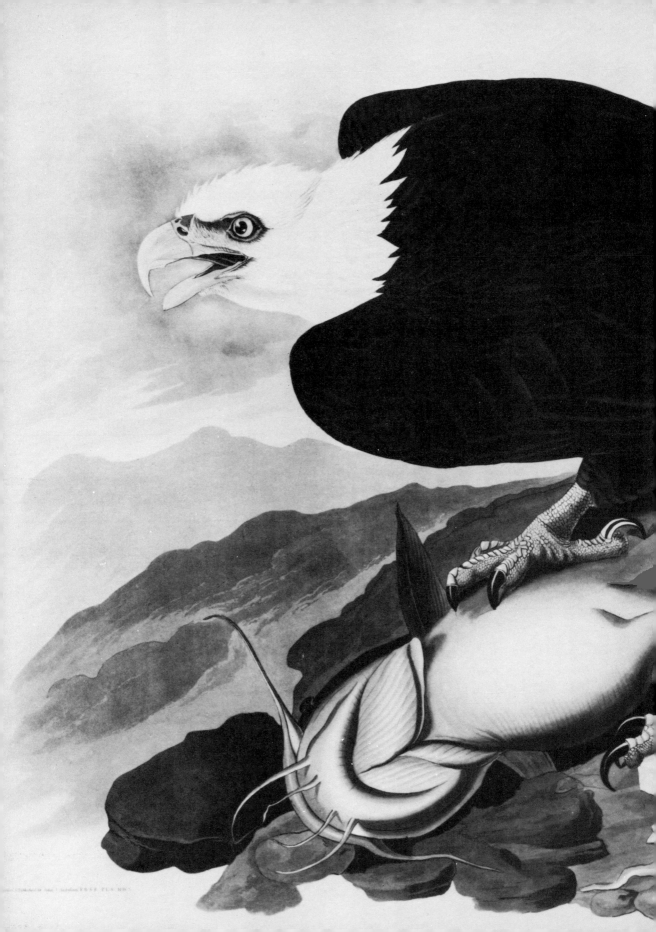

village was quite small. The latter consisted of six or eight houses, the former of my wife, myself and a young child. Few as the houses were, we fortunately found one empty. It was a log cabin, but as better could not have been found, we were well pleased. The country around was thinly settled and all purchasable provisions rather scarce; but our neighbours were friendly, and we had bought our bacon-hams; our pleasures were those of young people not long married; a single smile from our infant was, I assure you, more valued by us than all the treasures of a modern Croesus would have been. The woods were amply stocked with game, the river with fish; and now and then the hoarded sweets of the industrious bees were brought from some hollow tree to our little table.

Once again, Rozier was at his place behind the counter selling the odd 'bacon-ham', while Audubon, often taking with him their clerk Nat Pope, was roaming the countryside looking for rare birds, and bringing back game and fish for the pot.

Audubon had, in a rare attack of thoughtfulness, sent Lucy and their son Victor Gifford back to Fatland Ford for a few weeks before the move to Henderson. His treatment of Lucy at this time was unpardonable; whether she was submissive or stupid, whether she was actually pleased to exchange the comforts of Fatland Ford for a rough frontier life in a log cabin and a diet of bears and racoons – we do not know. She was very much the silent partner of the marriage. Her relations, particularly her new stepmother, disliked Audubon and were furious at his facile optimism and his failure to make a success of the store into which Lucy's patrimony had been sunk. It is possible that Lucy really had some glimmerings of his genius and that she, with astonishing perceptiveness, saw that during this period of fecklessness and complacency, artistic powers and knowledge were slowly maturing within him. As his granddaughter Maria wrote about him, 'Waiting times are long, longest to those who do not understand the silent inner growth which goes on and on, yet makes no outward sign for months and even years, as in the case of Audubon.'

Lucy undertook once again the dreadful journey by coach and by flatboat on the Ohio to take possession of her

Henderson log cabin. While she kept the home and Rozier kept the store, Audubon fished, hunted and rambled in the woods, 'to his heart's content, but his purse's depletion'. He developed an enthusiasm for catching catfish and constructed an enormous trotline for this purpose. With his clerk, Nat Pope, he took a stout line, two hundred yards long, and attached to it a hundred small lines, each five feet in length, on to which they tied hooks baited with live toads – a curious pastime for Audubon, the animal lover and naturalist. 'The Cat-fish is a voracious creature, not at all fine in feeding, but one who, like the vulture, contents himself with carrion when nothing better can be had. A few experiments proved to us that, of the dainties with which we tried to allure them to our hooks, they gave a decided preference, at that season, to *live toads*.' He returned to his cabin with baskets full of live, plump toads. 'Many "fine ladies", no doubt, would have swooned, or at least screamed and gone into hysterics ... fortunately we had no tragedy queen or sentimental spinster at Henderson.' Poor Lucy was obliged to prepare many catfish dishes, so successful had the live toads been in attracting these ugly whiskered creatures to her husband's trotline (Plate XXXI of *The Birds of America* shows a white-headed eagle about to eat a catfish).

After six months in Henderson, both partners decided to move their stores out of Kentucky; the Mississippi, the 'Father of the Waters', beckoned them. Their plan was to load their goods on to a keelboat, to float down the Ohio to the point where it met the Mississippi and then, at the junction of the two rivers, to have their boat 'cordelled' – that is, pulled upstream by a crew trudging along the bank – up the yellow, largely frozen river to the expanding city of St Louis. 'I placed Lucy and the children [Audubon in fact only had one child at this time] under the care of Dr Rankin and his wife.' He actually got her a job as governess at the home of Dr Adam Rankin, who had a farm outside Henderson. For nine weeks Audubon and Rozier drifted in their keelboat, laden with three hundred barrels of Monongahela whisky, gunpowder and other dry goods; after three days of stormy weather, they reached Cash

Trumpeter swan, Plate CCCLXXVI from *The Birds of America*. The original watercolour was painted in 1821 or 1822.

Creek at the mouth of the Ohio. Rozier was seething with boredom and impatience at the tedium of the journey, but Audubon, needless to say, loved every minute of it. 'Thousands of wild waterfowl were flying to the river and settling themselves on the borders. We permitted our boat to drift past, and amused ourselves firing into flocks of birds.' At Cash Creek they were held up for several weeks by floating ice. Rozier was at his wits' end, but Audubon was again delighted. He spent Christmas Day of 1810 with an Indian hunting party looking for wild swans. 'When one day's sport was over, we counted more than fifty of these beautiful birds, whose skins were intended for the ladies of Europe.' He had joined the Indians in their canoe at dawn; the squaws did the paddling while the hunters slept. On reaching the bank, the squaws went in search of nuts and the men made for the lake.

When the lake burst on our view there were the swans by the hundreds, and white as rich cream, either dipping their black bills in

68

the water, or stretching out one leg on its surface, or gently floating along . . . the moment our vedette was seen, it seemed as if thousands of large, fat, and heavy swans were startled . . . as the first party fired, the game rose and flew within easy distance of the party on the opposite side, when they fired again, and I saw the water covered with birds, floating with their backs downwards, and their heads sunk in the water, and their legs kicking in the air.

Meanwhile Rozier 'brooded in silence over a mishap which had given me great cause for rejoicing'. This 'mishap' of the floating ice brought into sharp relief the very different personalities of these two Frenchmen. Their friendship was not to survive the long, difficult and dangerous journey up the Mississippi; they were constantly trying to avoid the ice packs and having to warp the heavy boat and cargo against the current, and averaged only about one mile an hour. The weather got so

Coon Hunt, painted by an unknown artist *c.* 1830.

bad that they were forced to moor the boat in a bend of the river at Tawapatee Bottom and unload the cargo. They waited six weeks for the ice to break up. 'The sorrows of Rozier were too great to be described; wrapped in a blanket, like a squirrel in winter quarters with his tail about his nose, he slept and dreamed his time away, being seldom seen except at meals.' Audubon, of course, drew, joined the Indians in hunting bears, wolves, deer, cougars, racoons, opossums and wild turkeys, and tramped through the forests. The weather got worse; the river was frozen over and the wolves stalked the swans who gathered on the ice.

It was curious to see the snow-white birds lying all flat on the ice, but keenly intent on watching the motions of their insidious enemies, until the latter advanced within the distance of a few hundred yards, when the swans, sounding their trumpet-notes of alarm, would all rise, spread out their broad wings, and after running some yards and battering the ice until the noise echoed like thunder through the woods, rose exultingly into the air, leaving their pursuers to devise other schemes for gratifying their craving appetites.

So one day followed another in their winter quarters; Rozier was miserable and Audubon infuriatingly happy. 'The Indians made baskets of canes, Mr Pope played on the violin, I accompanied on the flute, the men danced to the tunes, and the squaws looked on and laughed, and the hunters smoked their pipes with such serenity as only Indians can, and I never regretted one day spent there.' But even Audubon agreed that their food presented a problem; after a couple of weeks they ran out of bread and used as a substitute the breasts of turkeys, buttered with bear's grease. This and their diet of bear's meat and opossum filled them with nausea.

Suddenly, one day, they heard some splitting noises like the reports of heavy artillery; the ice had begun to break up. 'The two streams seemed to rush against each other with violence, in consequence of which the congealed mass was broken into large fragments, some of which rose nearly erect here and there, and again fell with a thundering crash, as the wounded whale, when in the agonies of death, springs up with furious

force, and again plunges into the foaming waters.' Within a few hours the ice had broken up; they loaded the boat and pushed their way with poles up the Mississippi as far as Ste Geneviève, a small French settlement in Upper Louisiana. They sold their whisky, which had cost them twenty-five cents, for two dollars a gallon. Trading prospects looked brighter here than in Henderson. Audubon, however, took an immediate dislike to the place. 'I found at once that it was not the place for me; its population was then composed of low French Canadians, uneducated and uncouth. ... Rozier, on the contrary, liked it; he found plenty of French with whom to converse.' The constant quarrels and tensions between Audubon and Rozier made the continuance of their partnership impossible; the businessman could no longer endure the happy-go-lucky attitude of the dilettante. Audubon proposed selling his share of the business to Rozier, who promptly agreed, paying part in cash and part in notes. On 6 April 1811 the partnership was formally dissolved, the partners summing up the situation as follows – 'Rozier cared only for money and liked Ste Geneviève', and 'Audubon had no taste for commerce, and was continually in the forest.'

Audubon then returned to Henderson – whether on horse or foot, we shall never know. He characteristically left two divergent accounts of the return journey. In one he rode back on 'a beauty of a horse, for which I paid dearly enough'. In another, 'I parted with Mr Rozier and walked to Henderson in four days 165 miles.' Rozier's business prospered; he married, had ten children and died in 1864 aged eighty-seven, well-known as one of the leading merchants of the Missouri and upper Mississippi valley.

The years 1811–20 were a disastrous period as far as Audubon's finances were concerned. In the summer of 1811 he entered into a new partnership with his brother-in-law Thomas Woodhouse Bakewell, who was about to open a commission house in New Orleans which would import goods from England. Bakewell had close links with a Liverpool export house specializing in cotton. The 1812 war between England

Henderson 19th Octr. 1818—

Mr. Fd. Rozier.

Dear Rozier—

We Received yours by your Keel Boat, but were quite unable to satisfy the wants of your Men having none of the articles they wished, a few days since I reiterated to Mr. Fowler the wish you had to get Saml. & Hopkins's Note paid; he (F. Fowler) has paid it to us with the interest up to the 6th. Instant, the whole amounting to 119.13 $ on which he Charges a Commission for Collection of 5 pCt. Living in our hands a residue of One hundred and seven dollars $\frac{48}{100}$ for which sum we have Credited you and will pay to your Order when ever called for—

We Remain Sincerely
Yours &c
Audubon & Bakewell

We have receipted the note in your name — A.&B.

72

and the United States was about to break out and it needed little commercial common sense to realize that a new business, drawing all its supplies from an enemy country, was not starting life under the best auspices. But this thought eluded the two partners and, in the spring of 1812, a couple of months before the outbreak of war, 'Audubon & Bakewell' opened their business in New Orleans. Thomas had already moved there and it was settled that the Audubons would join him within a few months.

Meanwhile Audubon returned to Henderson from Fatland Ford where he had been staying with Lucy and Victor. On the way he met Vincent Nolte, a German merchant from New Orleans, who gave an amusing sketch of Audubon at this time in his *Fifty Years in Both Hemispheres*. Nolte came across Audubon in a small inn near the falls of the Juniata River. The landlady hoped he would not mind sharing a table with a 'strange gentleman'. Nolte thought him 'an odd fish'; Audubon had a Madras handkerchief wrapped round his head like a French sailor or docker. Nolte approached him and expressed the hope that he had no objection to his joining him for breakfast:

'Oh, no sir,' he replied with a strong French accent, which made the words sound like, 'No, sare.' 'Ah!' I said, 'you are a Frenchman, sir?' 'No, sare, hi emm en Heenglishmen.' 'Why,' I asked in return, 'you look like a Frenchman and you speak like one.' 'Hi emm en Heenglishmen becas hi got a Heenglish wife,' he answered. . . . This man, who afterwards won for himself so great a name in natural history, particularly ornithology, was Audubon. He was not thinking at that time of studying natural history. He wanted to be a merchant.

In January 1812 Audubon and Nolte travelled together from Pittsburgh in one of two flatboats that Nolte had bought. Audubon had some money to collect from Rozier. In Maysville Audubon and Nolte were dining in an inn; suddenly Audubon leapt up, took some cards, nails and a hammer out of his pockets and nailed a card to the door of the inn. It read:

OPPOSITE Letter to Ferdinand Rozier, dated 19 October 1813 and signed 'Audubon & Bakewell'. Their joint business venture was opened in New Orleans in the spring of 1812, but after the war in that year they moved to Henderson, Kentucky.

Audubon & Bakewell
Commission Merchants
Pork, Lard and Flour
New Orleans

As he did so, he said in French, 'Now I am going to lay the foundations of my new business.' Nolte was gratified to think that his own trading business in New Orleans would not be endangered by this competition.

The war destroyed the prospects for 'Audubon & Bakewell' in New Orleans. Bakewell came north in low spirits. Audubon had in the meantime started a new general store in Henderson; it was a single-storey building of hewn logs and adjoining it was his own log dwelling. He enjoyed life in Henderson, where he had bought four one-acre lots from the Transylvania Company.

The pleasure which I have felt at Henderson, and under the roof of that log cabin, can never be effaced from my heart until after death ... in less than twelve months I had again risen in the world. I purchased adjoining land and was doing extremely well when Thomas Bakewell came once more on the tapis, and joined me in commerce. We prospered for a round rate for a while, but unfortunately for me, he took it into his brain to persuade me to erect a steam-mill at Henderson, and to join to our partnership an Englishman of the name of Pears, now dead.

With these words Audubon introduces us to the most tragic and disastrous of all his enterprises – the steam sawmill and gristmill on the Henderson riverfront. He lost not only what remained of his own money, but also that of several other investors, one of whom was George Keats, brother of the poet.

Well, up went the steam-mill at enormous expense, in a country then as unfit for such a thing as it would now be for me to settle on the moon.... How I laboured in that infernal mill from dawn to dark, nay at times, all night. My pecuniary troubles increased, I had heavy bills to pay which I could not pay or take up.... I parted with every particle of property I held to my credit, only keeping the clothes I wore that day, my original drawings, and my gun.

The 'infernal mill' was one of the sights of Henderson. Built

74

on stone foundations, the weather-boarding was of whipsawed yellow poplar and the joists of unhewn logs. At first things went well; steam hissed and smoke rolled out of the tall chimney, as logs were turned into lumber and corn was ground into meal. The mill was, however, too big for such a small place and the volume of business was simply not forthcoming. There was not much demand for lumber and very little wheat was grown in the district.

ABOVE LEFT Audubon's mill at Henderson.

ABOVE RIGHT Rozier and Audubon's store at Ste Geneviève, Missouri.

A blot on Audubon's memory is his treatment of George Keats – a blot because the money, or some of it, which he had given Audubon to invest in a new steamboat enterprise belonged to his brother John, who hoped, by investing this money successfully, to pay his debts and marry Fanny Brawne. George Keats and his wife Georgiana had emigrated to the United States; their plan was to farm in the west and to make enough money to improve the family finances. On their way to the west, they had the misfortune to meet Audubon in Henderson. Impressed by Audubon's personality, his store, his mill, and his confident talk about a new steamboat venture, Keats agreed to put into it most of his own and his brother's money. The money was lost and the Keats family ruined. Lovers of literature know about Audubon through John Keats's heartbreaking letter. 'I cannot help thinking Mr Audubon a dishonest man. Why did he make you believe him a Man of Property? How is it his circumstances have altered so suddenly? I cannot help thinking Mr Audubon has deceived

RIGHT The printing plate from which Plate CXXI, the snowy owl (shown OPPOSITE in the original watercolour of 1829), was produced.

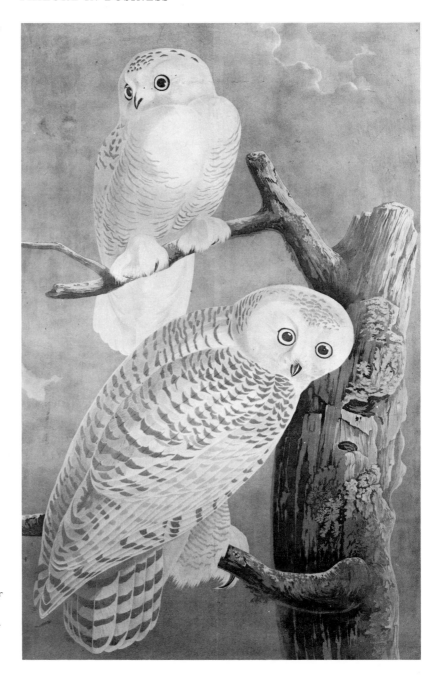

FOLLOWING PAGES *View of Hudson River, Toppan Bay, near Sing Sing*, painted by Audubon's engraver, Robert Havell.

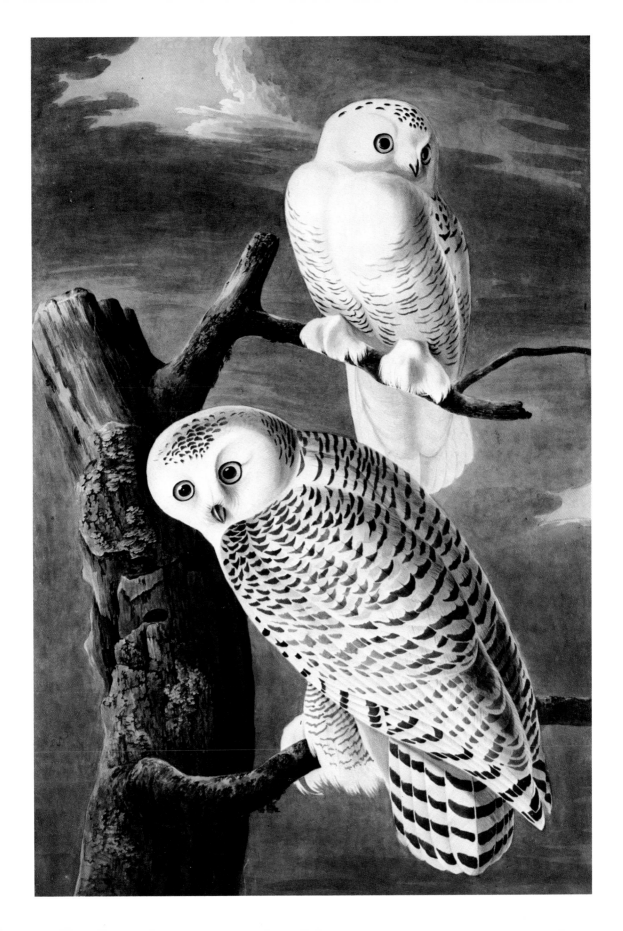

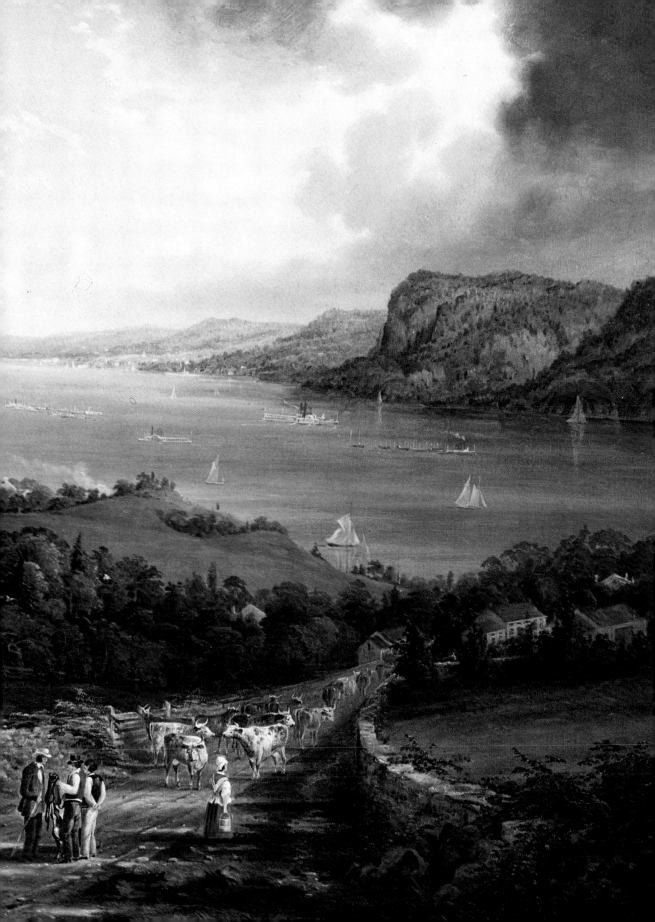

you. I shall not like the sight of him,' Keats was to write.

The inhabitants of Henderson shared John Keats's view of Audubon. His business failures and subsequent bankruptcy lost him most of his friends; this sudden decline in his local popularity was not helped by his method of defending himself when belaboured by a man called Bowen, one of a group who had bought the steamboat and paid for it in worthless notes. Audubon had chased the boat to New Orleans in a skiff rowed by two Negroes and tried to have it attached. On his return to Henderson he found a furious Bowen lying in wait for him outside his house (he was apparently furious because Audubon had taken legal action against him).

I observed him marching towards me with a heavy club in his hand. I stood still and he soon reached me. He complained of my conduct to him at New Orleans, and suddenly raising his bludgeon laid it about me. Though white with wrath, I neither spoke nor moved till he had given me twelve severe blows, then, drawing my dagger with my left hand (unfortunately my right was disabled and in a sling, having been caught and much injured in the wheels of the steam engine), I stabbed him and he instantly fell.

Such methods of dealing with an adversary were thought treacherous, underhand and foreign in Henderson, where fists and pistols were the recognized weapons.

We now have Audubon at the nadir of his fortunes, disliked, despised and distrusted by his friends, relations and acquaintances. Lucy, however, never wavered in her loyalty; his only comfort during the bleak months of 1819 were his wife and his two sons (the second, John Woodhouse Audubon, had been born in 1812).

Without a dollar in the world, bereft of all revenues beyond my personal talents and aquirements, I left my dear log house, my delightful garden and orchards, and with that heaviest of heavy burdens, a heavy heart, I turned my face towards Louisville. This was the saddest of all my journeys – the only one in my life when the wild turkeys that so often crossed my path and the thousands of lesser birds that enlivened the woods and prairies, all looked like enemies and I turned my eyes from them.

OPPOSITE Trumpeter swan, Plate CCCCVI from *The Birds of America*. The original watercolour was executed in 1836 or 1837.

81

5

Birth of
the Great Idea

‘udubon was one of the handsomest men I ever saw. In person he was tall and slender, his blue eyes were an eagle’s in brightness, his teeth were white and even, his hair a beautiful chestnut colour, very glossy and curly. His bearing was courteous and refined, simple and unassuming.’

In these words Mrs Nathaniel Wells Pope, the wife of his Henderson clerk and fellow hunter, described Audubon in her *Reminiscences*. His charm and good looks were of little use to the disgraced, bankrupt storekeeper who had fled from Henderson to Louisville, where his creditors caught up with him. There in 1819 he was gaoled for debt, but later was released on a plea of bankruptcy. He wandered disconsolately to nearby Shippingport, to the house of Lucy’s brother-in-law, Nicholas Berthoud. The Berthouds, angered by his Henderson failure and its repercussions upon Lucy, were not disposed to help him. Lucy, however, arrived with her sons at Shippingport and moved into her sister’s house; there she had a daughter, Rosa, who died when a few months old. (In 1815 she had also had a daughter, who had lived only a short time.) Audubon admitted

Pileaded Woodpecker

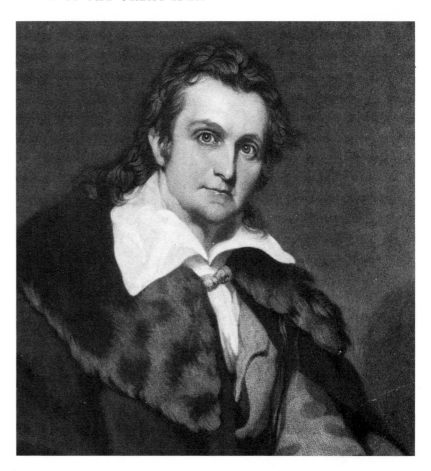

Engraving of a
portrait of Audubon
by F. Cruikshank,
published by Havell.

that his wife 'felt the pangs of our misfortunes perhaps more
heavily than I, but never for an hour lost her courage; her brave
and cheerful spirit accepted all, and no reproaches from her
beloved lips ever wounded my heart. With her was I not always
rich?'

What was Audubon now to do? 'Was I to repine because I
had acted like an honest man? Was I inclined to cut my throat
in foolish despair? No!! I *had* talents, and to them I instantly
resorted.' The talents in question were those of drawing
likenesses of people. He started at once doing portraits in
crayon of the human 'head divine', and after a few weeks he
had received so many commissions that he was able to rent a
house in Louisville and have his family with him once again.
He charged five dollars a head. He was much in demand for

portraying persons on their deathbeds and one clergyman went as far as having his dead child exhumed in order to have a likeness, at Audubon's hand, of its face, 'which, by the way, I gave to the parents as if still alive, to their intense satisfaction'.

Audubon did not let his new activities as a crayon portraitist interrupt his drawings of birds. 'In this particular there seemed to hover round me almost a mania, and I would even give up doing a head, the profits of which would have supplied our wants for a week or more, to represent a little citizen of the feathered tribe.' He said that one of the remarkable things about his adverse circumstances:

was that I never for a day gave up listening to the song of our birds, or watching their peculiar habits, or delineating them in the best way that I could; nay, during my deepest troubles I frequently would wrench myself from the persons around me, and retire to some secluded part of our noble forests; and many a time, at the sound of the wood-thrushes melodies have I fallen on my knees, and there prayed earnestly to our God.

In the winter of 1819 Audubon was offered the job of a taxidermist in Cincinnati, in the Western Museum of Dr Daniel Drake which was attached to Cincinnati College. His salary was $120 a month and he was expected to demonstrate his skill in stuffing fishes. The salary, for various reasons, was not always paid in full ('the members of the College museum were splendid promisers and very bad paymasters'); Audubon therefore returned to his crayon portraits and also started a drawing school. Lucy did her best to restrain him from embarking on any extravagant and ill-thought-out ventures, and they managed to live quite cheaply. Audubon wrote:

Our living here is extremely moderate; the markets are well supplied and cheap, beef only two and a half cents a pound, and I am able to provide a good deal myself; Partridges are frequently in the streets, and I can shoot Wild Turkeys within a mile or so; Squirrels and Woodcock are very abundant in the season and fish always easily caught.

Lucy, before setting off for Cincinnati, had been caught up in

Audubon had a useful talent for capturing quick likenesses of people. This portrait of a Miss Jennett Benedict was drawn in 1824.

the gay Christmas season in Louisville. John Keats wrote to his brother,

I was surprised to hear of the state of society at Louisville; it seems you are just as ridiculous there as we are here – threepenny parties, halfpenny dances. The best thing I have heard of is your shooting; for it seems you follow the gun. Give my compliments to Mrs Audubon and tell her I cannot think her either good-looking or honest. Tell Mr Audubon he's a fool. . . .

Audubon did sporadic portraits until 1826, the year of his journey to England; of about one hundred portraits, a third are still in existence. In 1823 he was to do a certain number of oil portraits. He turned out to have a remarkable gift for capturing likenesses, a gift which was to stand him in good stead now and in the future. The dashed-off likeness of a friend or stranger brought him in some urgently needed money. His sons, particularly John Woodhouse, were to have an even greater facility in this form of art than their father.

In 1820 came Audubon's moment of illumination; he was seized by what he called the '*Great Idea*', ten years after his meeting with Alexander Wilson, of publishing his drawings – not simply the haphazard collection in his portfolio, but a comprehensive and complete collection of all the American birds, life-size and in their natural surroundings. In further-ance of this scheme he planned a journey through the Southern states, down the Ohio and Mississippi Rivers to New Orleans, east to Florida Keys and back to Cincinnati via Arkansas and Hot Springs. He would find new bird specimens, dissect and draw them, study the countryside and vegetation and make notes for the text that would accompany his drawings.

On 12 October 1820 Audubon, aged thirty-five, embarked on the most important journey in his career. The bankrupt, itinerant artist and tutor, with his gun, portfolios of bird draw-ings, black chalk and watercolours, set out to enlarge his knowledge and enrich his portfolio. He took with him on the flatboat to New Orleans a thirteen-year-old boy called Joseph Mason, who had been one of his pupils at his Cincinnati art

academy. Mason (1807–83) was later one of Audubon's most important artistic collaborators in *The Birds of America*; he painted the floral backgrounds to no fewer than fifty of the 435 plates. At an early age he had evinced a love of flowers which he drew with the same delight as Audubon his birds.

In Cincinnati Audubon said goodbye to his wife and sons, whom he was not to see again for over a year. On the very day that he boarded the flatboat, he started to keep a journal; it is a disorderly, semi-literate account of daily events, his impressions of the countryside and the people he met, and of bird notes. It opens thus:

Audubon's hunting equipment. Top row – his hat, and an Indian buffalo-hide arrow case. Middle row – his shotgun. Bottom row, left to right – his pistol, a Dakota Indian war club, pipe-tomahawk, and a gun-shaped war club of the Mandan Indians.

I left Cincinnati this afternoon at half past 4'o'clock, on Board of Mr Jacob Aumack's flat Boat – bound to New Orleans – the feeling of a Husband and a Father, were My Lot when I kissed My Beloved Wife and Children with an expectation of being absent for Seven Months. ... Without any Money My Talents are to be My Support and My enthusiasm my Guide in My difficulties, the whole of which I am ready to exert to keep and to surmount.

On 3 November the flatboat 'passed Henderson about sun raise. I looked on the mill perhaps for the Last Time, and with thoughts that made my Blood almost Cold bid it an eternal farewell'. As a matter of fact, the flatboat did stop at or near Henderson, but Audubon did not want to admit that he lacked the courage to disembark; he wanted to recover Dash, a female hunting dog that he had left there. His friends on board, understanding his dilemma, went in search of Dash, found her and restored her to her owner.

The journal's pages are filled with accounts of birds killed and dissected by Audubon. He was now killing rather less for sport and more in the interests of his new ornithological undertaking. Nevertheless, his daily bag was large and varied. The first day

We shot thirty Partridges – Wood Cock – 27 Grey Squirrels – a Barn Owl – a Young Turkey Buzzard and an Autumnal Warbler as Mr A. Willson [sic] as being pleased to denominate the young of the Rump Yellow Warbler – this was a Young Male in beautiful plumage for the season and I Drew it – as I feel perfectly Convinced that Mr Willson has made an Error in presenting this Bird as a New Specie I shall only reccomend You to Examine attentively My Drawing of Each and his Description – its Stomach was filled with the remaines of Small Winged Insects and 3 Seeds of Some Berries, the names of which I could not determine.

This awareness of the bird as a species and his anatomical and biological approach show the influence of Dr Daniel Drake of Cincinnati and his 'closet' ornithology – mainly taxidermy and taxonomy. This distinguished man was a prolific writer on medical subjects and very interested in all branches of natural history. Cincinnati has to thank him for the founding of a large

number of its institutions. He undoubtedly made Audubon more scientifically minded. Two days later, on 14 October, 'We returned to our Boat with a Wild Turkey 7 Partridges a Tall Tale Godwit and a Hermit Thrush which was too much torn to make a drawing of it this was the first time I had met with this Bird and felt particularly Mortified at the Situation.' As the hermit thrush is a relatively common bird, it is extraordinary that he should have first knowingly encountered it on this expedition. This is, perhaps, a sign of his growing scientific awareness.

Audubon's rough, unsentimental way of looking at things is shown in his description of the opossum episode, in which his dog Dash showed an unaccustomed amount of spirit. 'Cap' C. [Captain Cummings] Brought an Opossum, Dash after having broke I thought all its bones left it – it was thrown over Board as if dead, yet the moment he toucht the Watter he swam for the Boats – so tenacious of Life are these animals that it tooked a heavy blow of the Axe to finish him.' Audubon was more the 'American woodsman' at this period than at any other time of his life; his description to Lucy of his clothes and sanitary habits bears little resemblance to those later paintings of the dandified out-of-doors naturalist in his elegant, open-necked white shirt contemplatively fondling his gun. 'When we left Cincinnati, we agreed to shave and Clean every Sunday – and often have been anxious to see the day come for certainly a shirt worn one week, hunting every day and sleeping in Buffalo robes at night soon become Soiled and Desagreable.'

Audubon's journals are his only writings which have been published exactly as they were written – *verbatim et literatim* – showing his imperfect spelling and grammar and his whimsical use of capital letters. The passages from his writings quoted in earlier chapters are from an autobiographical fragment, *Myself*, whose idiosyncratic spelling was 'corrected' by the publishers, and from the 'Episodes' of his *Ornithological Biography*, written with English readers in mind, which was thoroughly 'copy-edited' by William MacGillivray, the Scottish co-author of a great part of the scientific descriptions. In

the 'introductory address' to this book Audubon tells a story which, although perhaps – knowing the author – untrue, has become, like Robert Bruce and the spider, one of those moral tales for children to encourage perseverance and stoicism in adversity. He describes how he left Henderson one day to go to Philadelphia.

I locked up all my drawings before my departure, placed them carefully in a wooden box, and gave them in charge to a relative, with injunctions to see that no injury should happen to them. My absence was of several months; and when I returned, after having enjoyed the pleasures of home for a few days, I inquired after my box, and what I was pleased to call my treasure. The box was produced, and opened; – but, reader, feel for me – a pair of Norway rats had taken possession of the whole, and had reared a young family amongst the gnawed bits of paper, which, but a few months before, represented nearly a thousand inhabitants of the air! The burning heat which instantly rushed through my brain was too great to be endured, without affecting the whole of my nervous system. I slept not for several nights, and the days passed like days of oblivion, – until the animal powers being recalled into action, through the strength of my constitution, I took up my gun, my note-book, and my pencils, and went forth to the woods as gaily as if nothing had happened. I felt pleased that I might now make much better drawings than before, and, ere a period not exceeding three years had elapsed, I had a portfolio filled again!

Every child's life of Audubon during the last hundred years has contained this moralistic tale. He must have known how strongly it would appeal to the nineteenth-century ethos; Samuel Smiles, indeed, quoted this passage in his Victorian bestseller, *Self-Help*.

Audubon's 'Delineations of American Scenery and Manners' in his *Ornithological Biography* have given, no doubt deliberately, a false impression of him as an intrepid frontiersman, a great hunter and explorer. He talks, for example, about his friendship with Daniel Boone, about the violent and sombre aspects of frontier life, about the rigours of life in the forests and swamps of the Ohio and Mississippi valleys. Unlike Boone,

90

Audubon was not a real frontiersman; 'Audubon & Rozier' had not been a wilderness trading post, nor had they bartered their goods with Indians. Boone, that famous scout, hunter and adversary of the Indians, had discovered Kentucky's Blue Grass region nearly forty years earlier; in 1776 he laid out the Wilderness Trail which brought many thousands of settlers into that area. By the time Audubon arrived in Kentucky, the Indians were out and slavery was in; its inhabitants no longer represented the front line against barbarism. Audubon claimed to have spent a night with Boone in a log cabin after a hunting expedition. (Boone was by now a very old man living in Missouri and was on a visit to Kentucky to see his brother Squire.) This may have been true or it may not. With Audubon one never knows. He remembered, or claimed to remember, being taught by Boone how to 'bark' squirrels. They found a clump of black walnuts, oaks and hickories, densely populated by squirrels. Boone selected a squirrel and fired just beneath it; the impact of the bullet on the bark killed the squirrel and sent it whirling through the air.

Self-portrait of Audubon as the 'American woodsman', executed in Liverpool in 1826.

Audubon gave his own description of Boone's physique. 'The stature and general appearance of this wanderer of the western forests approached the gigantic. His chest was broad and prominent; his muscular powers displayed themselves in every limb; his countenance gave indication of his great courage, enterprise, and perseverances.' By other contemporary accounts, Boone was smallish and rather slight looking. Audubon made the same 'mistake' about his father's height, giving him several inches more than was his due.

In the Episode, 'The Regulators' (they were a kind of self-appointed frontier police), Audubon writes that Samuel Mason (or 'Meason'), the Kentucky outlaw who preyed on flatboats, was finally caught and his head stuck on a pole outside Henderson. This story also is not quite true. Audubon did not, for some reason or other, mention the other bandit, Macijah Sharpe, who used to push lovers off a cliff for the fun of watching them fall and hearing them scream.

When Audubon returned to Henderson from Ste Geneviève,

91

after parting company with Rozier, he sought shelter in a lonely Indian log cabin, he tells us in the Episode, 'The Prairie'. He had been walking far, his only company being his knapsack, dog and gun (in another version he was riding a horse).

I saw the sun sinking below the horizon long before I could perceive any appearance of woodland, and nothing in the shape of man had I met with that day. The track which I followed was only an old Indian trace, and as darkness overshadowed the prairie I felt some desire to reach at least a copse, in which I might lie down to rest. The Night Hawks were skimming over and around me, attracted by the buzzing wings of the beetles which form their food, and the distant howling of the wolves gave me some hope that I should soon arrive at the skirts of some woodlands.

The story then becomes more ghoulish. In the hut was a woman who coveted Audubon's watch; she put the chain around her brawny neck as he and his dog helped themselves to venison. A young Indian sat motionless by the fire, his face covered in blood; when aiming at a racoon in a tree, the arrow had bounced back and pierced his right eye. He tried to warn Audubon with various gestures that the woman was planning to cut his throat, this being the simplest way to become the owner of his fine watch. Audubon got the message and, after surreptitiously loading both barrels of his gun, he lay down on some bearskins, feigning sleep. 'Judge of my astonishment, reader, when I saw this incarnate fiend take a large carving-knife, and go to the grindstone to whet its edge; I saw her pour the water on the turning machine, and watched her working away with the dangerous instrument, until the cold sweat covered every part of my body, in despite of my determination to defend myself to the last.' The woman gave the knife to her two sons, who, fortunately for Audubon, had been drinking themselves into a stupor, and instructed them to dispatch him quickly. This was Audubon's moment; he jumped up, cocked his gun and, with the timely assistance of two strangers, marched mother and sons off to the wood and set fire to their cabin.

In 1819 Audubon was
offered a post as a
taxidermist in
Cincinnati. *View of
Cincinnati*, painted by
Worthington Whittredge.

The town of Natchez on the Mississippi, a rough place notorious for its gambling dens and whore-houses.

'Will you believe, good-natured reader, that not many miles from the place where this adventure happened ... large roads are now laid out, cultivation has converted the woods into fertile fields, taverns have been erected, and much of what the Americans call comfort is to be met with?' With his stories of the roughness and hazards of a frontier life which had actually vanished before his arrival in those parts, Audubon came to symbolize a vanished America. His later social success in England owed much to this projection of himself as the American woodsman, a romantic figure in the age of romanticism, a Rousseau of the west.

94

Although he embroidered and exaggerated, Audubon may claim to have experienced the great stretches of frontier wilderness and to have recorded their decline. If the inhabitants were no longer pioneers in buckskin, they were still far from being, in the words of an American writer, 'gentry in buckles and lace'. He described the local population as being 'derived from the refuse of every other country'.

So the journey continued down the Mississippi, Audubon hunting, drawing and dissecting. On Christmas Day the flatboat sighted Natchez, one of the roughest places on the Mississippi, a hotbed of gambling, prostitution and crime. As he later strolled along its streets he met Lucy's brother-in-law from Shippingport, Nicholas Berthoud, who invited him to join him in his keelboat for the rest of the journey to New Orleans. On New Year's Day 1821 the keelboat reached Bayou Sara, a small village at the mouth of an inlet and later to be the temporary home of Audubon and his family. Up to this point they had been towed by a steamer, the *Columbus*, which now set the keelboat adrift, but not before Audubon, now quite destitute, had been paid some gold coins for drawing a likeness of

Aquatint of New Orleans, 1841. Audubon tried to raise some money in New Orleans by drawing portraits of the citizens and their families.

95

the captain. His spirits were low because he had lost somewhere in Natchez – perhaps in a brothel or gambling den – a portfolio containing some of the drawings which he had done since leaving Cincinnati. (It was recovered two months later.)

On 7 January Audubon landed at New Orleans without any money to pay for a night's lodging. He was now in the old capital of Louisiana where, so he told his sons, his father had married a lady of 'Spanish extraction'. (New Orleans later entered into the spirit of Audubon's assertions by claiming him as a native son and raising a bronze monument to his memory.) 'I rose early, tormented by many disagreeable thoughts, nearly again without a cent, in a Busling City where no one cares a fig for a Man in my situation.' He wandered round the markets looking for birds to draw. 'We found Vast Many Malards, some Teals, some American Widgeons, Canada Geese, Snow Geese, Mergansers, Robins; Blue Birds; Red Wing Starlings – Tell Tale Godwits – every thing selling extremely high $1.25 for one pare of Ducks, 1.50 for a Goose etc.' He saw some white herons and a new species of snipe, but the snipe was too plucked to become a subject for a drawing.

It was during the years 1821 to 1824 that Audubon came into his full powers as a painter of birds and as a master of design. His style was now set and he never really changed his working methods afterwards. He had resolved in Cincinnati to do a hundred drawings of birds before making serious efforts to find a publisher. In Natchez and now in New Orleans he tried everywhere to get hold of a copy of Wilson's *American Ornithology*, doubtless regretting that he had permitted jealousy and vanity to stay his hand when poised to enter his name as a subscriber all those years ago. That he finally succeeded is shown by the fact that he sent Lucy twenty drawings of birds 'not described by Willson'; these included the originals of some of his most famous plates, such as the great-footed hawk, the white-headed eagle and the hen turkey. They were evidence of how much he had improved as a bird artist.

Audubon combed New Orleans for commissions to sketch portraits. He was only moderately successful; he did black

96

chalk likenesses of the British consul and of various New Orleans citizens and their children. Nevertheless, he was able to send Lucy $270 and a thirty-six-piece dinner service of Queensware crockery which cost him $36.33. He was charging $25 a drawing. His most interesting assignment was with a 'Fair Incognito', the details of which were struck out of his journal by his horrified female descendants. A heavily veiled, wealthy-looking woman accosted him one evening as he was walking along a narrow street in New Orleans, carrying his portfolio; she beckoned him to follow her to her house in the Rue Amour. Throwing back her veil, she revealed a beautiful face. She asked him whether he had ever drawn a full figure, naked. 'Had I been shot with a 48-pounder through my heart, my articulating powers would not have been more suddenly stopped.' Certainly Audubon had drawn the human figure before, but that had been in a formal life class, along with other artists. This situation was rather different. Finally he managed to stutter out a mumbled, '*Oui*'. 'For ten days, at the exception of One Sunday that she went out of the city, I had the pleasure of this beautiful woman's company about one hour naked, and two talking on different subjects.' The drawing finished, she went out of his life. As payment she gave him a gun. He gave the details of this little *affaire* in a letter to Lucy, which he copied from his journal.

After spending five months in New Orleans, Audubon decided to return to Lucy. He had not much to show for his stay there; he had neither made money as a portrait artist, nor had he drawn, during the winter, the birds that migrate to Louisiana for the colder months. Lucy had written tartly that, if he did not keep her better provided for, he need not return to her. He and Mason loaded their portfolios, pencils, chalks, guns and flutes on board the *Columbus*, the same boat that had towed them downstream six months earlier. They were glad to see the last of their landlady; 'the filthiness of her manners did not agree with our Feelings and by this time We had discovered that a Clean Sweet Housekeeper is quite Necessary to a Naturalist.'

6

Mississippi
Wanderings

It was either on board the *Columbus* or rather earlier – nobody seems certain about this – that Audubon met Mrs James Pirrie and her daughter Eliza. Mrs Pirrie was the wife of a prosperous cotton planter of West Feliciana parish near Bayou Sara, where Nicholas Berthoud's keelboat had stopped on New Year's Day six months earlier. Audubon had smartened himself up since his journey down the Mississippi, when he had had an occasional shave and changed his shirt once a week. In New Orleans he had a suit of nankeen specially made for him; he combed his hair, shaved daily and turned himself into a 'ladies' man'. Mrs Pirrie, either on board or off, fell for his winning manners and flowing ringlets and invited him to come to Bayou Sara until the end of the year, as tutor to her daughter Eliza.

I had attended a Miss Pirrie to Enhance her natural Tallen for Drawing for some days when her Mother, Whom I intend Noticing in due time, asked Me to Think about My Spending the summer and fall at the farm near Bayou Sarah: I was glad of such an overture, but would have greatly prefered her Living in the Floridas – We con-

OPPOSITE Barn owl, Plate CLXXI from *The Birds of America*. The original watercolour was painted in 1832 in New Jersey, from specimens sent him by a friend. Audubon added the ground squirrel, 'as being an animal on which the species is likely to feed'.

98

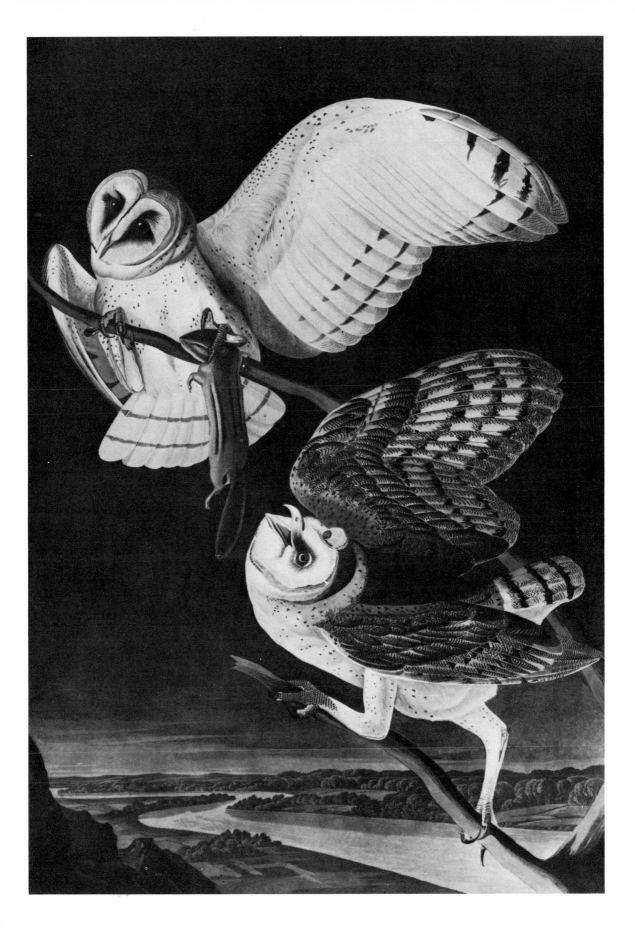

ABOVE Oakley, the Pirries' plantation house on Bayou Sara in Louisiana.

BELOW Audubon's portrait of Eliza Pirrie, 'my lovely Miss Pirrie, of Oakley', executed in 1821.

cluded the Bargain promising me 60 Dollars per Month for One half of My time to teach Miss Eliza all I could in Drawing Music Dancing etc etc for Joseph and Myself – so that after the One hundred Diferent Plans I had form[d] as Opposite as Could be to this, I found Myself bound for several Months on a Farm in Louisiana.

This arrangement was advantageous to Audubon; one of the terms of his appointment was that half his time would be free for hunting and drawing. On 18 June he and Joseph Mason arrived at Oakley, the Pirries' plantation on Bayou Sara. It was a hot and sultry day; Audubon had never experienced this type of countryside.

The Rich Magnolia covered with its Odoriferous Blossoms, the Holy, the Beech, the Tall Yellow Poplar, the Hilly ground, even the Red Clay I Looked at with amazement and such entire change in so Short a time appears often supernatural, and surrounded once more by thousands of Warblers and Thrushes, I enjoy[d] Nature.

Many of the pictures which were later to establish his fame were drawn in this part of Louisiana. As the slaves led the way along the dusty road to Oakley, 'My Eyes soon Met hovering over us the Long Wished for Mississippi Kite and Swallow Tailed Hawk, but our guns were pack[d] and we could only then anticipate the pleasure of procuring them shortly.'

James Pirrie ('Anxious to Know him, I Inspected his features by Lavater's directions') came from Fife in Scotland. He settled in this part of Louisiana when it was known as West Florida, at first under British and then under Spanish rule. In 1810 President Madison annexed it to the United States. This part of the country was particularly rich in fauna and flora; the deep magnolia woods sheltered thousands of birds of different species. During his five months at Oakley, Audubon worked harder than ever before; when he was not instructing 'my lovely Miss Pirrie, of Oakley' in those essential attainments for a young lady – drawing, dancing and music – he was out of doors with his gun, paper, pencil and colours. The birds which he drew in the Feliciana parish represent the consummation of his art; Audubon became infatuated with this bird paradise. In

the meantime, Joseph Mason also perfected his technique for drawing the vegetation to provide a setting for his master's birds.

Audubon's artistic flair for the portrayal of birds began in Bayou Sara to exhibit certain characteristics which are unmistakably his own – a concern for the living animal and a vigorous, unequalled sense of drama, colour and design. Of his predecessors, Thomas Bewick is the only bird artist whose drawings show a comparable, although quite different, charm. His *History of British Birds* (1797–1804), frequently cited by Wilson, with its simple, unaffected descriptions of birds and their habits and the exquisitely accurate woodcuts of the birds discussed, was, in its approach, a forerunner of both Wilson and Audubon. Bewick showed how well the woodcut could be used in the interests of ornithology, given a combination of scientific knowledge and artistic skill. On the other hand, the

The Englishman Thomas Bewick, who specialized in fine woodcuts, was one of the few fellow bird artists with whom Audubon achieved *rapport*.

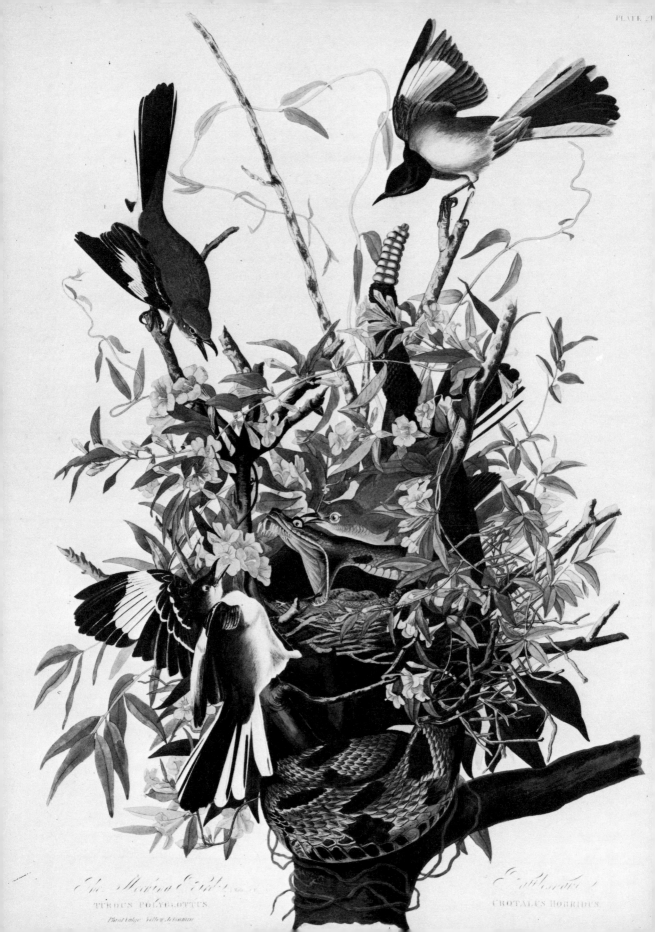

PLATE 21

The Mocking Bird
TURDUS POLYGLOTTUS

CROTALUS HORRIDUS

woodcut as a medium was more laborious than metal engraving and the pictures were generally much smaller.

When Audubon later came to England he visited Bewick and was delighted by his friendliness and humour. Audubon, promoting both himself and *America, my Country* – soon to become his motto – became, every now and then, the aggressive patriot. About his meeting with Bewick he wrote, 'Now and then he would start and exclaim, "Oh, that I were young again! I would go to America too. Hey! what a country it will be, Mr Audubon." I retorted by exclaiming, "Hey! what a country it is already, Mr Bewick!"'

In October 1821 Audubon was dismissed by Mrs Pirrie, two months before his term of engagement was due to end. The attractive but sickly Eliza had taken a strong fancy to her handsome, thirty-six-year-old drawing master; fever time was approaching and her doctor, jealous and, according to Audubon, infatuated with Eliza, urged Mrs Pirrie to end her daughter's lessons, which she unceremoniously did. Five of her children had died in seasonal epidemics and Eliza was the only survivor; all the more importance was therefore attached by the anxious mother to her doctor's recommendations.

In his journal, two months earlier, Audubon describes how he drew a rattlesnake, almost six feet long, which he had killed and brought back to Oakley. This drawing marks the beginning of a long and bitter controversy later waged by the eccentric English naturalist, Charles Waterton, and various of Audubon's Philadelphia enemies, centring on his picture of mocking-birds defending their jasmine-embowered nest against the designs of a rattlesnake (*The Birds of America*, Plate XXI). His critics stated that a rattlesnake was unable to climb trees and that this was one of many examples of his indifference to truth in his bird pictures and text romances. It is nice to know that Audubon was, in this instance, found to be scientifically correct. He drew the rattlesnake from the position it takes before striking madly with its fangs. 'The heat of the weather would not permit me to spend more than 16 hours on it – my amiable pupil Miss Eliza Pirrie also drew the same Snake;

OPPOSITE Mocking-bird, Plate XXI from *The Birds of America*. When this plate appeared in 1827 it was severely criticized by those ornithologists who were convinced that rattlesnakes never climbed trees, and that their fangs did not curl outwards. Audubon was later vindicated on both scores.

it is with much pleasure that I now mention her name expecting to remember often her sweet disposition and the happy days spent near her.' We may infer from these lines that Audubon may well have behaved foolishly or unwisely in regard to the susceptible Miss Pirrie.

Audubon and Joseph Mason left Oakley on 20 October 1821 and returned to New Orleans. Thus ended Audubon's idyllically happy months with the Pirries at Oakley.

> Three months out of the 4 we lived there were spent in peaceable tranquillity; giving regular Daily Lesson to Miss P. of Drawing, Music, Dancing, Arithmetick, and some trifling acquirements such as Working Hair and Hunting and Drawing My Cherished Birds of America; Seldom troublesome of Disposition, and not Caring for or Scarcely even partaking or mixing with the constant Transient Visitors at the House, *We* were called *good Men* and now and then received a Chearing Look from the Mistress of the House and *Sometimes* also one Glance of Approbation of the More Circumspect Miss Pirrie.

Later, in December of the same year, she cut him dead in a New Orleans street.

At about the time that Audubon left Oakley, his stepmother Anne Moynet Audubon died at Les Tourterelles, the home of her daughter near La Gerbetière. Incredible as it may seem, he did not learn of her death for many years; in 1828 he was still writing about her as if she was alive. But this may be another example of his somewhat pointless whimsicality.

In New Orleans Audubon looked around for more pupils. When he was not giving drawing lessons, he was putting order into the drawings which had resulted from that fecund period of productivity in Bayou Sara. He worked hard on the drier side of ornithology,

> writing every day, from morning until night, omitting no observations, correcting, re-arranging from my notes and measurements, and posting up; particularly all my land birds. The great many errors I found in the work of Wilson astonished me. I try to speak of them with care, and as seldom as possible, knowing the good will of that man, and the many vast hearsay accounts he depended on.

Since he had left Cincinnati, he reflected, he had completed sixty-two drawings of birds and plants, three of quadrupeds and two of snakes (including the famous rattlesnake); in addition to this he had done about fifty portraits, as well as a full-length picture of Father Antonio, a popular New Orleans priest. He had been able to send some money to his wife and his 'Kentucky lads'. This résumé of his achievements since Cincinnati appeared to satisfy him. He was not, however, content; his difficulty in getting work in New Orleans showed that something was really wrong. He made a deplorable impression on most people whom he approached for work, and the common view was that he was an adventurer and a bounder. This feeling of rejection reflected itself in the asperities of his journal. The failure of Lucy and the children to arrive filled his mind with hideous, despairing forebodings.

In December 1821, at Audubon's entreaty, Lucy reluctantly came south to New Orleans with her sons. Another bleak financial period now started; Audubon discontinued his journal, as he could not afford to buy another blank book. Lucy got a job as a nurse to a family called Brand, some of whose members took drawing lessons from Audubon, and there she stayed until the death of her infant charge in September 1822.

Although Audubon's spirits were better, his own financial situation did not improve after the arrival of Lucy and the children. His joy at being reunited with his family after a separation of fourteen months did not stop him deciding to leave New Orleans in March 1822 to try his luck in Natchez, that wicked Mississippi town. Lucy, having just arrived, was not going to let herself be uprooted so soon. So Audubon and Mason, about whose activities we hear so little, left New Orleans on 16 March on the steamboat *Eclat*. In Natchez he found some private pupils for French, music and drawing, and at Washington, nine miles away from Natchez, he got a job at a school. All these activities prevented him from making any progress with his drawing. 'While work flowed upon me, the hope of completing my book upon the birds of America became less clear; and full of despair, I feared my hopes of becoming

known to Europe as a naturalist were destined to be blasted.'

From October 1821 when he left Bayou Sara, to the end of 1824 when he returned there in different circumstances, Audubon's life is a wretched, confused, unhappy chapter of futility, bankruptcy and haphazard wanderings, which historians are pleased to call his 'Odyssey'. In his dealings with others he cuts a sorry figure, gratuitously making enemies and showing all the nastiest sides of his character – vanity, ingratitude and ill-temper. At times we wonder whether he is mad, or whether we should write him off as a talented and exasperating bore, crook and *poseur*.

In August 1822 Joseph Mason announced his intention of leaving.

> We experienced great pain in parting. I gave him paper and chalks to work his way with, and the double-barrelled gun ... which I had purchased in Philadelphia in 1805. ... He accompanied me on a hunting excursion, beginning at Cincinnati, and ending in the State of Louisiana, which lasted 18 months. He drew with me; he was my *daily companion*, and we both rolled ourselves together on bufaloe robes at night.

Mason was no longer benefiting artistically from his association with Audubon; he had been to him a docile and sympathetic companion. Apart from painting the flowers and plants which are an indispensable element of the bird pictures, he had shared with him the sorrows of poverty and the inconveniences occasioned by Audubon's carelessness, such as the disappearance of his pocket-book and portfolio. Mason, on leaving, gave him his drawings with their pencilled signatures, 'Plant by Jos. Mason'. He went on to Philadelphia, where he found work at Bartram's botanical garden. Audubon later refused to acknowledge the assistance which he had received from Mason, even removing his signature from his drawings before sending them to the engraver.

Lucy came to Natchez in September 1822 and obtained a post as governess to a minister's children. Audubon thought of starting a business in Mexico and he had lessons in oil painting from John Stein (or Steen), an itinerant portrait painter; his

Cotton Plantation, painted
by C. Giroux.

first effort in oils was to copy an otter from one of his own
drawings. He became quite a competent oil painter and later,
in England, his brush helped finance the production of his
early plates.

In January 1823 Lucy was invited to establish and run a
private school on a plantation called Beech Woods near Bayou
Sara. As the minister often failed to pay her salary, she
accepted. The school was intended for the children of Captain
and Mrs Robert Percy, the owner of the plantation on Big Sara
Creek.

The Percys lived not far from the Pirries in the Feliciana
country, Audubon's 'Happyland'. Before coming to America in
1796, Captain Robert Percy had been an officer in the British
navy. His plantation was near St Francisville, then at the
height of its prosperity as a cotton centre. The parish of West
Feliciana was one of the richest cotton-producing areas of
Louisiana. Lucy's seven-year rule at Beech Woods, where she
went with her sons at the beginning of 1823, was a very happy
time for her and her pupils. They needed instruction in read-
ing, writing, arithmetic, 'social culture' and music, and it was
universally agreed in the neighbourhood that nobody was

better qualified to supply these requirements than the English wife of an eccentric French artist.

Audubon remained in Natchez, working on his oils. He became a perambulating portrait painter, setting off in March with his teacher John Stein for the south in 'un chariot à la dearborn', looking for sitters wishing to bequeath their features to posterity. Before going he released his birds. 'The many birds I had collected to take to France [his first mention of such an intention] I made free; some of the doves had become so fond of me that I was obliged to chase them to the woods, fearing the wickedness of the boys, who would no doubt, have with pleasure destroyed them.' The dearborn found its way, on creaking wheels, to the Feliciana country, and at Beech Woods Victor Audubon joined the expedition making for Baton Rouge, today's capital of Louisiana. They were looking for sitters amongst the prosperous owners of the cotton plantations.

Audubon had elevated thoughts about his vocation and became bored with portrait painting. He soon quarrelled with Stein. 'I had finally determined to break through all bonds and pursue my ornithological pursuit. My best friends solemnly regard me as a madman, and my wife and family alone gave me encouragement. My wife determined that my genius should prevail and that my final success shall be triumphant.' The two artists parted in Jackson, the capital of Feliciana parish. Audubon found Jackson 'a mean place, a rendezvous for gamblers and vagabonds[!]' and he left it, 'disgusted with the place and its people'. He hurried back to Lucy and was given a part-time job by Mrs Percy, teaching music and drawing during the summer months. He continued with his oil portraiture (seated in front of a mirror he painted a self-portrait); he called on Eliza Pirrie, who had not married the jealous doctor, but eloped with a neighbour who caught pneumonia carrying her through the rushing waters of the Homochitto River and died a few weeks later; he wandered, of course, through the woodlands and swamps of the Mississippi.

Audubon was sensitive about being a part-time teacher in a

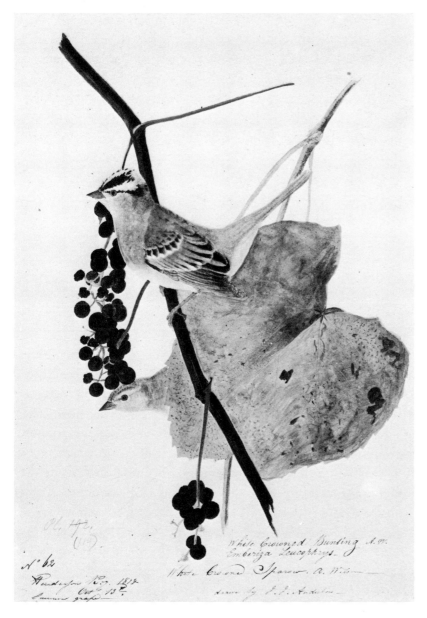

White-crowned sparrow,
watercolour inscribed
by Audubon to the effect
that it was painted in
Henderson, Kentucky,
on 13 October 1814.

school run by his wife. This touchiness caused him to take
offence at imagined slights and led to his being dismissed once
again by the angry mistress of a plantation in 'Happyland'.
Mrs Percy disliked the jaundiced complexion he had given her
daughters in their portraits and asked him to lighten the
colour. He took this as an insult to his art and started abusing

her. This was not the way to treat imperious wives of rich plantation owners. He was on his travels again; he returned to Natchez, taking with him his son Victor. He had no idea what to do. 'I thought of going to Philadelphia, and again of going to Louisville, and once more entering upon mercantile pursuits – but had no money to move anywhere!'

In the autumn of 1823 Audubon made his way slowly to Philadelphia, the centre of science and scholarship in the United States, and the home of the country's leading naturalists. It was not to be for him the 'City of Brotherly Love'. His plan, encouraged by Lucy, was to exhibit his drawings there and to find someone who would have them engraved and published. On 3 October father and son boarded the steamboat *Magnet* from Louisville. Low water prevented the *Magnet* from entering the Ohio; Audubon and Victor walked the remaining several hundred miles, the rigours of which he describes in two of his Episodes. Before setting off, he revealed his true feelings in a letter to Rozier. 'I am yet, my dear Rozier, on the wing, and God knows how long I may yet remain so. I am now bound to Shippingport to see if I can, through my *former friends* there, bring about some change in my situation. I am now rather wearied of the world. I have, I believe, seen too much of it.'

Victor returned to the Berthouds' counting house; they were not, however, inclined to do anything to help his worthless father. Audubon, who had arrived at Louisville with thirteen dollars in his pocket, spent the winter in Shippingport painting street signs, portraits, the inside of a steamboat and landscapes. 'Busy at work, when the weather permitted, and resolved to paint one hundred views of the American scenery. I shall not be surprised to see myself seated at the foot of Niagara.'

At the beginning of April 1824 Audubon arrived in Philadelphia. 'I purchased a new suit of clothes and dressed myself with extreme neatness.' In spite of having lived at Mill Grove and been on many visits to Philadelphia to buy provisions for his stores, he did not know anyone there of consequence. He should have taken into account the fact that he was, in a way,

entering enemy territory; many Philadelphia naturalists had a vested interest in the success of Wilson's *American Ornithology*, whose nine volumes had appeared during the years 1808–14. A sequel of four volumes was just about to be published by Charles Lucien Bonaparte under the title *American Ornithology not given by Wilson* (1825–33). Bonaparte, whom Audubon preferred to call 'The Prince of Musignano', was the son of Lucien Bonaparte, Napoleon's brother; he came to America with his uncle Joseph, formerly King of Spain, who settled in Philadelphia. Bonaparte, who was only twenty-one when he first met Audubon, was already a distinguished naturalist; in his sequel to Wilson's book he added a further hundred birds. More of a 'closet' naturalist than a field student, he immediately befriended Audubon, introduced him to the members of the august Academy of Natural Sciences, and arranged for his drawings to be exhibited at that institution.

So far, so good for Audubon. But within a few days his conceit and stupidity had undone all the good that Bonaparte's endeavours and the undoubted interest excited by his drawings had achieved. In quick succession he made three enemies. The first was Titian R. Peale, later famous for his studies of birds and animals in Polynesia, who was the chief illustrator of Bonaparte's book and proud of the fact that all his bird portraits were drawn from 'recent' birds and not from preserved specimens. Audubon, over-confident after the unexpected warmth of his reception in Philadelphia, made no effort to conceal his contempt for Peale's drawings. 'He represented them as if seated for a portrait.'

The second enemy was Alexander Lawson, who had engraved the plates for Wilson 'with the birds always before him'. He was now starting to engrave the plates for Bonaparte. Audubon was angry when Lawson said his drawings were too soft and too like paintings to be suitable for engraving, and angrier still when he added that they were 'ill drawn, not true to nature and anatomically incorrect'. Nevertheless, Lawson engraved one of Audubon's drawings, the boat-tailed grackle, which appeared in Bonaparte's book.

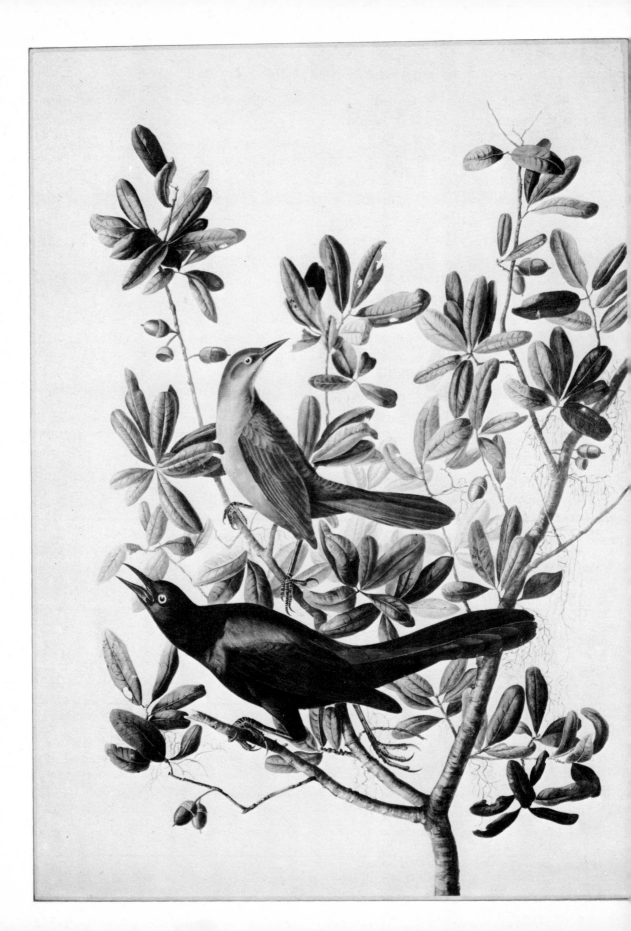

Audubon's third and most implacable enemy was George Ord, Wilson's friend and biographer and the editor of the last two volumes of his book. Ord, a peppery and complex creature, regarded the furtherance of Wilson's fame as being the most important thing in his life. He, more than Audubon, set the scene for the rivalry and acrimony which for many years bedevilled the straightforward appreciation of the work of these two men. That day, at the Academy of Natural Sciences, Ord looked at Audubon's drawings with jealousy and fury. He was himself preparing the two new editions of his hero's book, and naturally he did not relish the idea of a competitor. Audubon provocatively boasted of the superiority of his drawings to those of Wilson. Ord objected to Audubon's habit of wreathing his birds in plants and other forms of ornamentation.

The Philadelphia natural history 'establishment' made certain that Audubon would not find a publisher there for his book. He made, however, a valuable new friend – Edward Harris, a rich young man from Morristown, New Jersey, who spotted Audubon's good points and bought some of his drawings. He was later to accompany him to Florida in 1837 and on the Missouri River expedition in 1843. This and the encouragement of Bonaparte that he take his drawings to Europe for publication were the only positive results of his stay in Philadelphia. Other than that, he went round looking for drawing pupils at one dollar a lesson. 'I found the citizens unwilling to pay for art, although they affected to patronize it.'

Audubon had now nowhere in particular to go. Until the end of the year 1824, when he returned to Lucy at Bayou Sara, his life was a series of purposeless journeys to New York City, Buffalo, Niagara, Pittsburgh and Cincinnati, without any money, sketching the odd traveller. His mind, however, was made up; he would go to Europe, come what may. His quarrel with Mrs Percy was made up and the year 1825 was for Audubon a happy one spent at Bayou Sara, teaching French, music, dancing, drawing and fencing. By the spring of 1826 he had, with Lucy's help, accumulated $1,700 for his momentous trip.

OPPOSITE Boat-tailed grackle, watercolour of 1832 for Plate CLXXXVII in *The Birds of America*. The background of live oak covered with Spanish moss was executed by George Lehman.

7

An Odd-fish
in England

 n 17 May 1826 Audubon set sail for Liverpool on the cotton schooner *Delos*. He arrived on 21 July; it was a rainy morning and on entering the city, 'the smoke became so oppressive to my lungs that I could hardly breathe; it affected my eyes also'. He cleared his belongings through Customs, having to pay twopence duty on each of his drawings, because they were watercoloured, and fourpence a pound for each of his American-printed books. He had left Louisiana with £340; this modest amount of money did not stop him from buying, on his first day in Liverpool, two watches with the necessary fobs, chains and seals for £120, one for himself and one for his 'Beloved Friend' – Lucy.

OPPOSITE Carolina parakeet, Plate XXVI from *The Birds of America*. The original watercolour was painted in Louisiana in 1825. The last of this lovely species died in Cincinnati Zoo in 1914, at about the same time as the better-known passenger pigeon.

Audubon was quick to make use of his letters of introduction. 'I received a polite note from Mr Rathbone this morning, inviting me to dine next Wednesday with him and Mr Roscoe. I shall not forget the appointment.' Vincent Nolte, the New Orleans merchant whom he had first met on the way from Philadelphia to Pittsburgh, had written about him to Richard Rathbone, a member of a wealthy, educated, banking and

114

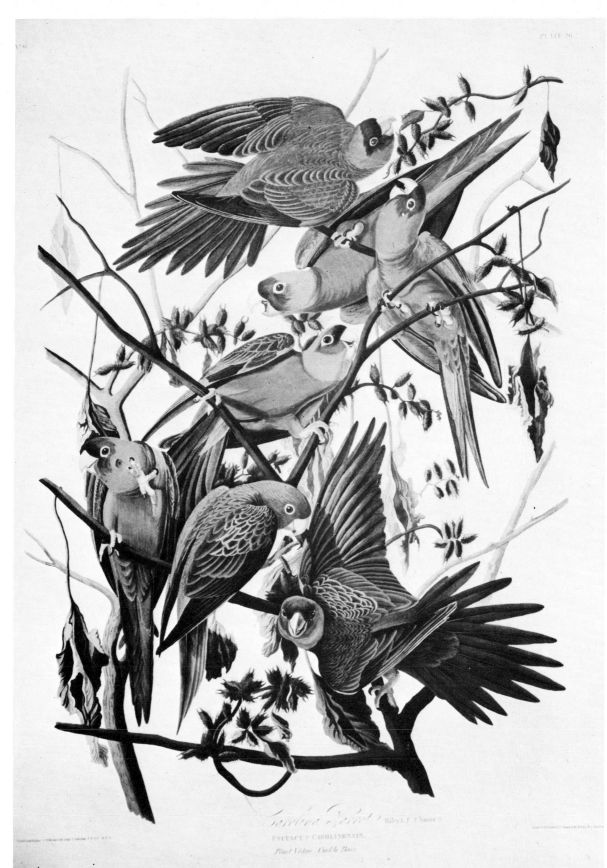

PLATE 26

Carolina Parrot. Males 1, 2 Young 3
PSITTACUS CAROLINENSIS
Plant Vulgo Cockle Burr

26 april 1826—

I Left My Beloved Wife Lucy Audubon
and My Son John Woodhouse on Tuesday
afternoon the 26th April, bound to England
remained at Doctor Pope of St Francisville
untill Wednesday 4 o'clock P. M. in the
Steam Boat Red River Cap "Kimble"
having for Companions Mrs A. Hall & John
Holiday — reached New Orleans Thursday 27th
at 12 — Visited many Vessels for My Passage
and concluded to go in the Ship Delos of
Kennebunk Cap Joseph Hatch bound to
Liverpool, Loaded with Cotton entirely —

The Red River Steam Boat Left on her
return on Sunday and I wrote by her to thee
My Dearest friend and forward thee 2 small Boxes
of Flowering Plants —
few, Spoke to & walked with Charles Briggs,
much altered young Man —
Lived at New Orleans at G. L. Saffords
in Company with Cotton —
During My Stay at New Orleans, I saw My old
and friendly acquaintances the family Pamar,
but the whole time spent in that City was heavy
& dull — a few Gentlemen call to see My Drawings —
I Generally walked from Morning untill Dusk My
hands behind me, paying but very partially attention
to all I saw — New Orleans to a Man who
does not trade in Dollars or any other such Stuff
is a Miserable Spot —
fatigued and discovering that the Ship could not
be ready for Sea for several days, I ascended
the Mississippi again in the Red River and once more
found Myself with my Wife and Child, I arrived at
Mrs Percy at 3 o'clock in the morning, having had
a Dark ride through the Magnolia Woods but the
Moments that afterwards full repaid me —
I remained 2 days and 3 Nights, was a Wedding
of Miss Virginia Chisholm with Mr D. Hall &c
I left in Company with Lucy, Mrs Percy's house at
[...] side and went to. Breakfast at My good

116

LEFT The first page of
Audubon's journal of his
voyage from New
Orleans to Liverpool
in 1826.

ABOVE Audubon's love of practical jokes is shown in these sketches of fantastic fish which he drew for a gullible naturalist acquaintance.

mercantile family. Liverpool was at this period the richest city in England after London, its prosperity being largely based on cotton imports from the Southern states. Its leading families made up for their lack of lineage in an enlightened and assiduous pursuit of the arts and sciences. The Rathbones and Roscoes were admirable examples of such high-minded mercantile families.

Audubon had long ago forgotten his hostility to England as the enemy of his native and of his adopted country. Indeed, he soon had good reason to like England. 'The *well bred* society of England is the perfection of manners; such tone of voice I have never heard in America.' Liverpool treated him as a visiting celebrity and the Rathbones were, from the very beginning, unsparing in their efforts to help him. Richard Rathbone was determined to do everything possible to get Audubon's drawings published. His son later recorded the sympathetic impression which Audubon had made on his family.

To us there was a halo of romance about Mr Audubon, artist, naturalist, *quondam* backwoodsman, and the author of that splendid work which I used to see on a table constructed to hold the copy belonging to my Uncle William, opening with hinges so as to raise the bird portraits as if on a desk. But still more I remember his amiable character, though tinged with a melancholy by past sufferings; and his beautiful, expressive face, kept alive in my memory by his autograph crayon sketch thereof, in profile, with the words written at foot 'Audubon at Green Bank. *Almost* happy, 9th September 1826'.

Audubon gave Richard Rathbone his oil painting of an otter trying to gnaw through its front foot, caught in a trap. Its head was thrown up, contorted with pain, and its wide-open jaws dripping with blood. This picture hung in the Rathbone parlour for many years until Mrs Rathbone 'could no longer bear the horror of it' and persuaded her husband to part with it. Audubon avoided in Liverpool the mistake he had made in Philadelphia of being aggressively over-confident. He was obviously touched by the disinterested friendliness of the Rathbones and the eager, earnest, well-bred Liverpudlians

Self-portrait in black chalk executed in Liverpool. It was inscribed, 'Audubon at Green Bank. *Almost* happy, 9th September 1826'.

saw him at his very best. He first showed the Rathbones his drawings at Green Bank, their country house outside Liverpool. 'What sensations I had whilst I helped to untie the fastenings of my portfolio! ... I was panting like the winged Pheasant, but ah! these kind people praised *my Birds*, and I felt the praise to be honest; once more I breathed freely.'

The next thing was to win the approval of William Roscoe for the drawings. This man, a well-known historical, botanical and miscellaneous writer, was the pre-eminent figure in Liverpool's intellectual and scientific world. After an anxious dinner with him, Audubon slipped the drawings, one after the other, out of his portfolio. 'After looking at a few only, the great man said heartily: "Mr Audubon, I am filled with surprise and admiration."' Thus started his conquest of Liverpool. Within ten days of his arrival his drawings were exhibited at the Royal Institution. He put up 'two hundred and twenty-five of my drawings; the *coup d'oeil* was not bad, and the room was crowded. ... I was wearied with bowing to the many to whom I was introduced. Some one was found copying one of the pictures, but the doorkeeper, an alert Scotchman, saw his attempt, turned him out, and tore his sketch.' Lucy Audubon's

sister Anne Gordon, whose husband was a Liverpool businessman, advised him to have his 'frontier' ringlets cut off and to buy a fashionable coat before the exhibition opened. Audubon sensed that his popularity in Liverpool was partly because he was an 'odd-fish' and an 'American woodsman'; reluctantly he got a new coat, but nothing would induce him to have his locks shorn. He wrote to his son Victor saying,

You would be surprised to see the marked attentions paid me where ever I go by the first people of Liverpool – My exhibition attracts the *beau monde* altogether and the Lords of England look at them with wonder more so I assure thee than at my flowing curly locks that again loosely are about my shoulders – The Ladies of England are Ladies indeed – Beauty, suavity of manners and the most improved education render them desirable objects of admiration.

Although 'my locks flow freely from under my hat in the breeze, and nearly every lady I met looked at them with curiosity', he was persuaded to part with them the following March.

The exhibition was a great success; over four hundred people came the second day. The Rathbones, thoughtful as ever, advised him to charge for admission; Audubon was unwilling to do this until the committee of the Royal Institution, at Rathbone's tactful suggestion, actually requested him to charge admission. 'This request must and will, I am sure, take off any discredit attached to the tormented feeling of showing my work for money.' He netted £100. Never in his life had Audubon been so lionized, so fêted, so successful. His cause became that of Liverpool's leading citizens. 'Seldom,' wrote Audubon's principal biographer, Francis H. Herrick, 'has the role of Maecenas been played more effectively and with less ostentation than by those intelligent men of affairs, to whom Audubon, with his fine enthusiasm and bold literary plans, seemed to embody all the romance of the New World.' Hardly a day went by without his being invited to some elegant Liverpool gathering. Everyone sat open-mouthed as he imitated the calls of American birds and told of his experiences with bears, wolves and Indians. It is no wonder, in view of his great success as a *raconteur*, that he later decided to intersperse his

The Rathbones introduced Audubon to Lord Stanley, later the Earl of Derby. This engraving shows antelopes from his menagerie at Knowsley.

bird-biographies with personalized Episodes about his life.

The Rathbones were anxious for Audubon to show his drawings to Lord Stanley (later the 14th Earl of Derby, prime minister and 'the most perfect orator of his day'), whose family home, Knowsley, tinged with its aristocratic splendour the urban sprawl of Liverpool. Audubon trembled in anticipation before meeting this famous nobleman and sportsman, patron of literature, the arts and the sciences. As Lord Stanley was announced, 'I have not the least doubt that if my head had been looked at, it would have been thought to be the body, globularly closed, of one of our largest porcupines; all my hair – and I have enough – stood straight on end, I am sure.' He was soon put at ease by the disarming affability of Lord Stanley, who even got down on his knees in order to examine the drawings more closely as he spread them out on the floor. 'Fine! Beautiful!' were his exclamations. After this first experience, Audubon took his meetings with the great rather more calmly. He was annoyed with himself because of his snobbery. 'I am a very poor fool, to be sure, to be troubled at the idea of meeting an English *gentleman*, when those I have met have been in kindness, manners, talents, all I could desire, far more than I expected.'

To repay the kindness he had been receiving and to earn

some money for himself, he started painting again – oil pictures of trapped otters, wild turkeys, English sporting life and sketches of the birds around Liverpool. The vigour and freshness of his style delighted the English.

No one, I think, paints in my method; I, who have never studied but by piecemeal, form my pictures according to my ways of study. For instance, I am now working on a Fox; I take one neatly killed, put him up with wires, and when satisfied with the truth of the position, I take my palette and work as rapidly as possible; the same with my birds. If practicable, I finish the bird at one sitting, – often, it is true, of fourteen hours, – so that I think they are correct, both in detail and composition.

The psychological effects of his Liverpool welcome were incalculable. 'I am well received everywhere, my works praised and admired, and my poor heart is at last relieved from the great anxiety that has for so many years agitated it, for I now

English Pheasants Surprised by a Spanish Dog, one of Audubon's sporting paintings.

know that I have not worked in vain.' He had recovered his pride in himself; and yet, for all the kindness of his new English friends, he missed America – its wild life and freedom to roam. He spent a weekend with the Roscoes; all he could find was the odd sooty sparrow and there was not even a frog to be found in the pond. 'No mocassin nor copper-headed snake is near its margins; no snowy Heron, no Rose-coloured Ibis ever is seen here, wild and charming; no sprightly trout, nor waiting gar-fish, while above hovers no Vulture watching for the spoils of the hunt, nor Eagle perched on dreary cypress in a gloomy silence.' When walking back to Liverpool from the Roscoes, he was shocked by the number of 'Trespassers will be prosecuted' signs. He found England 'all hospitality *within* and ferocity *without*. No one dare *trespass*, as it is called. Signs of *large dogs* are put up; steel traps and spring guns are set up, and even *eyes* are kept out by high walls. Everywhere we meet beggars, for England though rich, has poverty gaping every way you look, and the beggars ask for *bread*, – yes, absolutely for food.'

At the beginning of September 1826, Audubon moved on to Manchester. A welcome on the Liverpool scale could not be expected to repeat itself. He had no illusions that his Liverpool success was due more to the efforts of his powerful patrons than to the drawings themselves.

It must have been an unnerving experience for the 'American woodsman' to be precipitated into the world's largest industrial city. Semi-slave migrant labour from Ireland was pouring into the 'City of Spindles'; this led to the emergence of those Manchester slums, to be described so graphically by Engels a few years later. As might have been expected, Audubon hated Manchester. 'The vast number of youth of both sexes, with sallow complexions, ragged apparel, and downcast looks, made me feel they were not as happy as the slaves in Louisiana.' He thought it a 'miserably laid out place, and the smokiest I ever was in. I think I ought not to use the word "laid out" at all. It is composed of an astonishing number of small, dirty, narrow, crooked lanes, where one cart can scarce pass another. It is full of noise and tumult . . . the

population appears denser and worse off than in Liverpool'.

His unfavourable impressions of Manchester did not stop him from losing any time in arranging an exhibition. The results were disappointing; few people came and those who did showed little interest. He was wined and dined, but not on the Liverpool scale. What astonished him was the general ignorance about America. 'The principal conversation about it always turns to Indians and their ways, as if the land produced nothing else.' He noticed that every young lady drew in watercolours, many of them far better than he could ever do, but on very rare occasions could they be prevailed upon to produce them. To get away from the city, he walked four miles out of town, but 'the funnels raised from the manufactories to carry off the smoke appear in hundreds in every direction ... and the whirring sound of machinery is constantly in your ears'.

Audubon returned dispirited to Liverpool to ask his friends what he should do next. He had just opened a subscription book, in which the Rathbones were naturally the first to enter

View of Manchester in the early nineteenth century. At that time the largest industrial city in the world, its filth and squalid living conditions depressed Audubon.

their names. Both they and H. G. Bohn, the well-known London publisher and bookseller, were against Audubon's plan that his drawings be published life-size. Bohn adduced familiar 'marketing' arguments about the enormous expense of engraving and hand-colouring such plates and the unwieldiness of the finished product. He would be restricting his market to a few institutions and rich noblemen. As a size he recommended a 'double Wilson', that is, twice the size of a normal book, but not as large as what Audubon had in mind. Bohn further suggested that he should abandon exhibitions and go to London where he could meet the leading naturalists and through them see the best engravers, colourists, printers and paper merchants, thus obtaining some comparative costs. He should go to Paris, Brussels and Berlin; Paris, Bohn thought, would be the best place to publish the book – he could have 250 copies printed there, with title pages in English and in the 'double Wilson' format issued to the people of England as an English publication. But this respectable 'co-edition' struck Audubon as immoral. '*This I will not do*; no work of mine shall be other than true metal – if copper, copper, if gold, gold, but not copper gilded.'

When Bohn saw the drawings in Manchester, he withdrew his objections on account of the size. He was 'at first simply surprised, then became enthusiastic, and finally said they must be published the full size of life, and that he was *sure* they would pay'. He advised Audubon to leave Manchester at once and make for London. Instead Audubon went off in the opposite direction, to Edinburgh, arriving there on 25 October 1826.

Before leaving Manchester, 'much poorer than I was when I entered it,' Audubon visited the village of Bakewell, near Matlock in Derbyshire. 'I am at last, my Lucy, at the spot which has been honoured with thy ancestor's name.' His great plan, and how best to realize it, was now rapidly taking shape in his mind. *The Birds of America* was to be a subscription book and the illustrations were to be life-size; nothing, not even the reasoned arguments of his English well-wishers, would dissuade him from that. His instinct was right; his subsequent fame rested on

the heroic proportions and exuberant vitality of what is known as the 'Double Elephant Folio'. The later small octavo editions of the work sold well because they were touched by the mystique and glamour of the original. When in England Audubon showed, for the first time, that he had an exceptional flair for publicity. His large-as-life illustrations became in his mind inseparably bound up with his own flamboyant personality. To suggest that his book be reduced was tantamount to cutting its author down to size. He discovered after being in Liverpool only a few hours that what the English liked was novelty, and novelty he would give them in a double 'package' of book and author – both as large as, or larger than, life. Wilson's *American Ornithology* was by now well established in England and other important bird books, in particular Selby's *Illustrations of British Ornithology*, were about to appear on the market.

In England the hot-tempered, artist-vagabond spendthrift, of dubious morality, becomes, as if by magic, the 'American woodsman', the artist-naturalist imparting the 'truths' of his frontier philosophy to touchingly receptive provincial audiences. His success seems to have had a beneficent effect upon his own character. He became, at long last, more mature, sensible and thoughtful, while his energies were canalized into one all-absorbing purpose.

Audubon's instinct told him that he should visit the major provincial cities before undertaking a conquest of the metropolis. This is why he decided to disregard Bohn's advice and go to Edinburgh in search of subscribers and a printer. After an uncertain start, his drawings and his personality began to intrigue a few important people and within a few days he was famous. He called on Dr Knox, the anatomist and surgeon, who left the operating theatre to greet him, his hands covered in blood. He met the engraver William Home Lizars, who was engraving the plates for Selby's bird book. He took Lizars to his lodgings in George Street; with his 'heart like a stone' he undid his portfolio and brought out the drawings one by one. Lizars was stupefied. He had never seen such pictures in his life. 'Mr Audubon', he said, 'the people here don't know who you are at

In October 1826 Audubon arrived in Edinburgh to seek subscribers, a printer and publicity.

all, but depend upon it, they *shall* know.' He could not make up his mind which drawing he liked best – the mocking-birds attacked by a rattlesnake, the hawk pouncing on seventeen partridges or the whooping crane eating newly born alligators. Finally he stopped at the great-footed hawks 'with bloody rags at their beaks' ends and cruel delight in their daring eyes', and said he would start by engraving this (Plate XVI). He then changed his mind and engraved instead the wild turkey cock (Plate I), presenting Audubon with the engraved, hand-coloured plate on 28 November 1826.

Audubon now outlined his publication plans in his journal. He would

publish one number [that is, five plates] at my own expense and risk, and with it under my arm, make my way. If I can procure three hundred good substantial names of persons or associations or institutions, I cannot fail doing well for my family; but, to do this, I must abandon my life to its success, and undergo many sad perplexities, and perhaps never again – certainly not for some years – see my beloved America. The work, from what I have seen of Mr Lizars' execution, will be equal to anything in the world at present, and of the rest the world must judge for itself. I shall superintend both

126

engraving and colouring personally, and I pray my courage will not fail; my industry, I know, will not.... It is true the work will be procured only at great expense, but then, a number of years must elapse before it is completed, so that renders the payment an easier task. This is what I will *try*; if I do not succeed I can return to my woods and there in peace and quiet live and die. I am sorry that some of my friends are against the pictures being the size of life, and I must acknowledge it renders the work rather bulky, but my heart was always bent on it, and I cannot refrain from attempting it.

Audubon's original plan was to publish four hundred illustrations in eighty parts of five plates each, the subscribers paying two guineas for each part. To give the subscribers value for their money, each number was to consist of one full-page, two medium-sized and two small illustrations. In the end, the work consisted of 435 illustrations and eighty-seven parts. As each number came off the press, Audubon was expected, out of his subscription sales, to pay Lizars's expenses. The die was now cast; Audubon had found an engraver-printer about to invest a lot of money in his scheme and the days were over when he could wander from one town to another, exhibiting his drawings and hoping for favourable reactions. The complexities of the aquatint process, and the freedom of the engraver and hand-colourists to depart from the original drawing, if they so wished, made it essential for Audubon to stay in Edinburgh and supervise the production of the early plates.

Audubon soon became famous in Edinburgh society, but some people held different views of the 'American woodsman'.

Lizars and Audubon were in agreement on the importance of publicity both for the author and for the drawings. Audubon's enforced stay in Edinburgh enabled them to make careful and elaborate plans for the social and artistic conquest of this beautiful city, which the Prince Regent, now King George IV, had made so fashionable. A meeting with Sir Walter Scott was, after getting *The Birds of America* published, Audubon's most fervent wish. Scott was now at the height of his prestige, and Audubon claimed that reading his novels had given him many hours of happiness.

Lizars believed strongly in the importance of an exhibition of

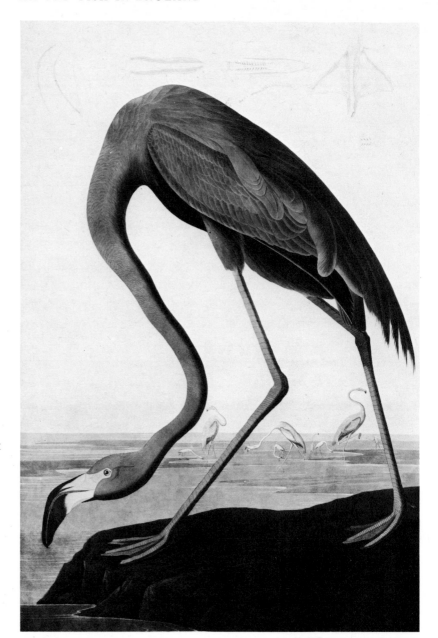

RIGHT American flamingo, Plate CCCCXXXI from *The Birds of America*. Audubon's original watercolour, made in 1838 after repeated attempts to obtain specimens, is shown (OPPOSITE) in colour.

FOLLOWING PAGES LEFT Portrait of Audubon painted by his son, John Woodhouse Audubon, on his return from the Missouri River expedition, *c.* 1843. RIGHT Great white heron, watercolour executed in 1832 for Plate CCLXXXI in *The Birds of America*.

Audubon's drawings as an essential piece of publicity. He also insisted that he be painted by John Syme in a wolfskin coat – the handsome woodsman with his curly chestnut hair falling to his shoulders. This picture, which Lizars engraved, and the drawings which were exhibited at the Edinburgh Royal

128

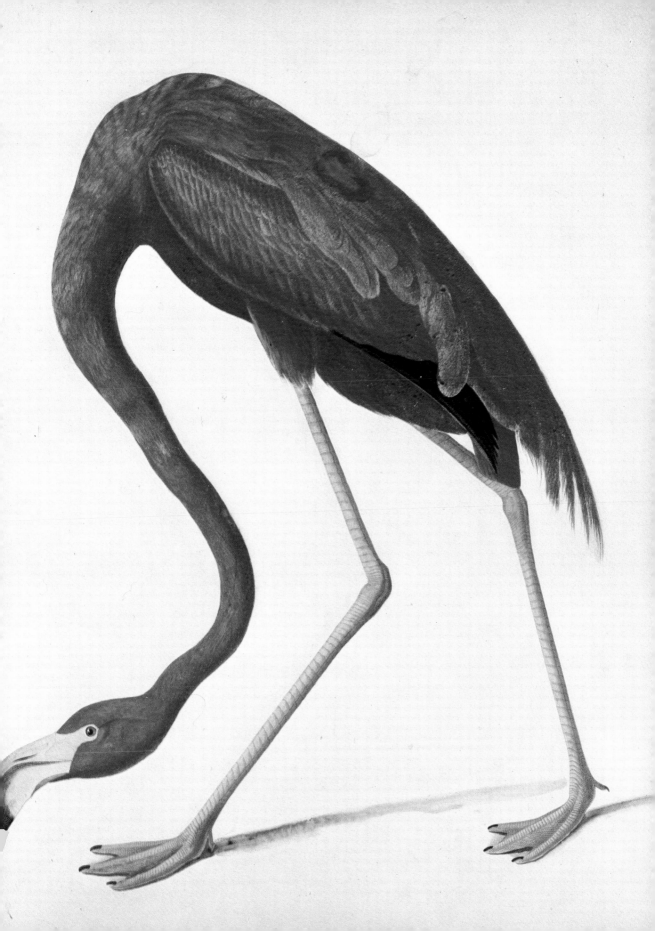

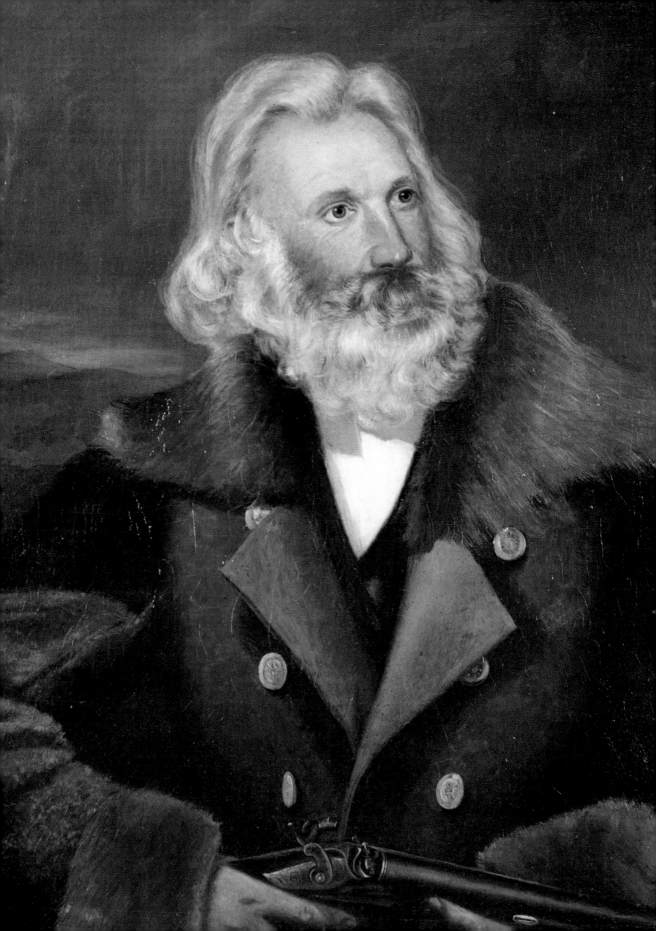

Institution, swept Edinburgh off its feet. 'I am fêted, feasted, elected honorary member of societies, making money by my exhibition and by my painting. . . .It is Mr Audubon here, and Mr Audubon there; I only hope they will not make a conceited fool of Mr Audubon at last.' For those who came to the exhibition, the man and his drawings brought to the Old World a new poetic vision of America in all its wild abundance. They became the talk of the town. Sir Walter Scott, to his later regret, refused to go to the exhibition. 'I wish I had gone to see his drawings; but I had heard so much about them that I resolved not to see them. . . .'

A French journalist had this to say about the Edinburgh exhibition:

A magic power transported us into the forests trodden for so many years by this man of genius. . . . Imagine a landscape wholly American . . . on twigs, branches, on the shore, copied by the brush with the strictest fidelity, sport the Feathered Races of the New World, each in the size of life . . . it is a real and palpable vision of the New World with its imposing vegetation and its tribes not yet knowing the yoke of man . . . this realization of an entire hemisphere, this picture of a nature so lusty and strong, is due to the brush of a single man; such an unheard of triumph of patience and genius!

One institution after the other fell before the charisma of the 'American woodsman'. He was elected an honorary member of several learned societies; a cast was made of his head by the phrenologist George Combe; he contributed articles to Scottish scientific journals and dined out every night with persons of consequence.

I seem, in a measure, to have gone back to my early days of society and fine dressing, silk stockings and pumps, and all the finery with which I made a popinjay of myself in my youth. . . . I go to dine at six, seven or even eight o'clock in the evening, and it is often one or two when the party breaks up; then painting all day, with my correspondence, which increases daily, makes my head feel like an immense hornet's nest, and my body wearied beyond all calculation; yet it has to be done; those who have my best interests at heart tell me I must *not refuse* a single invitation!

OPPOSITE Herring gull, watercolour dated 1831 for Plate CCXCI in *The Birds of America.* The view of the entrance to St Augustine harbour is by Lehmann, as is the standing gull in the foreground, the only figure subject definitely attributable to him.

133

In January 1827 Audubon achieved his ambition of an introduction to the novelist Sir Walter Scott. 'I watched his movements', wrote the fascinated Audubon, 'as I would those of a celestial being. . . .'

In January 1827 Audubon's dream of meeting Sir Walter Scott came true. He called on him at his house.

My eyes feasted on his countenance. I watched his movements as I would those of a celestial being; his long, heavy, white eyebrows struck me forcibly. His little room was tidy, although it partook a good deal of the character of a laboratory. He was wrapped in a quilted morning-gown of light purple silk; he had been at work writing on the 'life of Napoleon'. He writes close lines, rather curved as they go from left to right, and puts an immense deal on very little paper. . . . I talked little, but, believe me, I listened and observed.

Of Audubon, Scott wrote that he had studied ornithology,

by many a long wandering in the American forests. He is an American by naturalization, a Frenchman by birth; but less of a Frenchman than I have ever seen – no dash, or glimmer, or shine about him, but great simplicity of manners and behaviour; slight in person, and plainly dressed; wears long hair, which time has not yet tinged; his countenance acute, handsome and interesting, but still simplicity is the predominant characteristic!

A couple of days later, Audubon called on Scott again, this time bringing with him a portfolio of his drawings. Scott regarded them as 'of the finest order' and had a few more comments to make. 'This sojourner in the desert has been in the woods for months together. He preferred associating with the Indians to the company of the Black Settlers; very justly, I daresay, for a civilized man of the lower order – that is, the dregs of civilization – when thrust back on the savage state becomes worse than a savage. . . .'

By February Lizars had printed the first batch of his plates. They were the wild turkey (*Meleagris gallopavo*); yellow-billed cuckoo (*Coccyzus americanus*); prothonotary warbler (*Protonotaria citrea*), purple finch (*Carpodacus purpureus*); and the Canada warbler (*Wilsonia canadensis*), later renamed 'Bonaparte's fly-catcher', in honour of Napoleon's nephew (Plates I–V). The wild turkey, to which Audubon assigned the place of honour, is one of the most famous of his plates; in it the 'great American cock' strides majestically through the cane

which is a feature of the riverbanks and swamps of the southern states. 'The great size and beauty of the Wild Turkey, its value as a delicate and highly prized article of food, and the circumstances of its being the origin of the domestic race now generally dispersed over both continents, renders it one of the most interesting of the birds indigenous to the United States of America.' He was not alone in admiring this excellent bird; Benjamin Franklin had regretted that the turkey, 'withal a true original Native of America', was not chosen as the country's national symbol rather than the bald eagle (Plate xxxi), 'a Bird of bad moral character'. Audubon's notes of his bald eagle, which he shot at a distance of 150 yards as he sailed down the Mississippi in 1820, were rather more grandiloquent. 'The figure of this noble bird is well known throughout the civilized world, emblazoned as it is on our national standard, which waves in the breeze of every clime, bearing to distant lands the remembrance of a great people living in a state of peaceful freedom.'

Audubon's choice of plates for the first number was admirable. He might have been tempted to choose some of his more savage and stylized drawings to get the series off to a lively start. He resisted this temptation and he offered his first subscribers a delightful choice of exquisitely painted, unassuming birds and vegetation. The plates owed, in fact, almost as much to Joseph Mason as to Audubon, whose sullen refusal to accord his young pupil any form of acknowledgment is all the more reprehensible. Without the fruit and leaves of the pawpaw tree, the yellow-billed cuckoos would have looked unimpressive; the same could be said of the prothonotary warbler without the branches and berries of the rare Louisiana cane-vine, and of the Canada warbler without Mason's beautifully drawn leaves and ripe seed-pod of the *Magnolia grandiflora*.

There was now nothing further to detain Audubon in Edinburgh. He was ready to leave for London with the first number, to test his product in the world's richest, most sophisticated city, less likely to be impressed by stunts, gimmicks and novelties than the sensation-starved provinces. Before he left

135

Edinburgh at the beginning of April 1827 he read to scientific societies some more papers on alligators, rattlesnakes and passenger pigeons, all ingeniously related to his drawings. This blend of fact and fantasy pleased Edinburgh audiences but was later to arouse the wrath of his enemies in Philadelphia.

Many writers have described the great flights of the passenger pigeons – how they literally blackened the sky for days on end with their astronomical numbers, how the air was filled with the deafening thunder of their wings and how sturdy trees collapsed under their accumulated weight. The last passenger pigeon in the world died in the Cincinnati Zoo on 1 September 1914 at 1 pm. How could the sky be black with their numbers – Audubon calculated that, in 1813 in Kentucky, more than one billion birds passed over in a three-hour flight – and the bird be extinct within a century? In one of the most celebrated passages in his Episodes, Audubon describes scenes of such carnage which, if repeated indefinitely, could and did lead to the destruction of the species. His own charming drawing of a male passenger pigeon being fed by his mate (Plate LXII) was made in Pittsburgh in 1824. 'The air was literally filled with Pigeons; the light on noon-day was obscured as by an eclipse; the dung fell in spots, not unlike melting flakes of snow; and the continual buzz of wings had a tendency to lull my senses to repose.' This was in 1813, when he was on one of his many business trips from Henderson to Louisville. The passenger pigeons found a roosting place on the banks of the Green River in Kentucky. Farmers travelled hundreds of miles to be ready for the slaughter after the pigeons had landed; many drove ahead of them thousands of hogs to be fattened on the slaughtered pigeons. Camps were pitched on the edge of the forest; they were packed with wagons and horses, guns and ammunition.

As the time of the arrival of the passenger pigeons approached, their foes anxiously prepared to receive them. Some persons were ready with iron pots containing sulphur, others with torches of pine knots; many had poles, and the rest, guns. . . . Everything was ready and all eyes were fixed on the clear sky which could be glimpsed amid

OPPOSITE Passenger pigeon, Plate LXII from *The Birds of America*. Audubon's account of the butchering of these birds is, to the modern reader, one of the most horrifying passages in his writings.

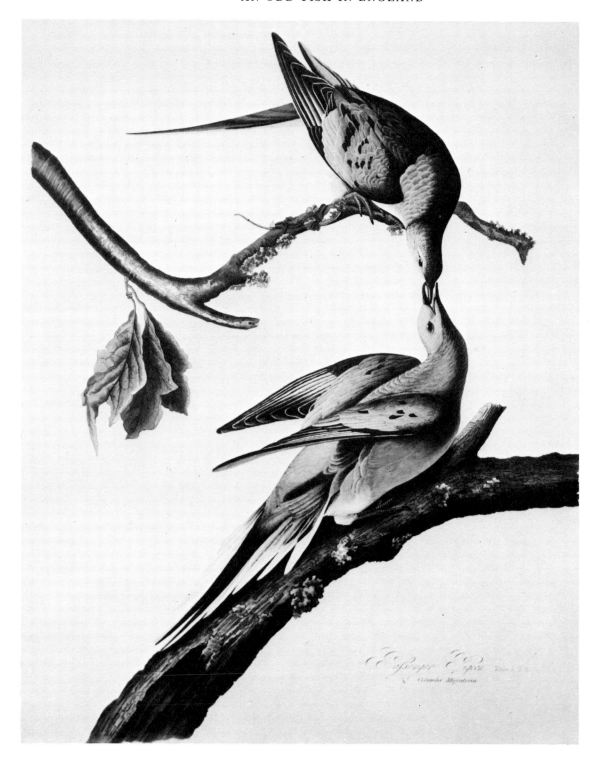

the tall tree-tops. . . . Suddenly a general cry burst forth, 'Here they come!' The noise they made, even though still distant, reminded me of a hard gale at sea, passing through the rigging of a close-reefed vessel. As the birds arrived and passed over me, I felt a current of air that surprised me. Thousands of the pigeons were soon knocked down by the polemen, whilst more continued to pour in. The fires were lighted, then a magnificent, wonderful, almost terrifying sight presented itself. The pigeons, arriving by the thousands, alighted everywhere, one above another, until solid masses were formed on the branches all around. Here and there the perches gave way with a crack under the weight, and fell to the ground, destroying hundreds of birds beneath, and forcing down the dense groups of them with which every stick was loaded. The scene was one of uproar and confusion. I found it quite useless to speak or even to shout, to those persons nearest to me. Even the gun reports were seldom heard, and I was made aware of the firing only by seeing the shooters reloading.

No one dared venture nearer the devastation. Meanwhile, the hogs had been penned up. The picking up of the dead and wounded birds was put off till morning. The pigeons were constantly coming, and it was past midnight before I noticed any decrease in the number of those arriving. The uproar continued the whole night. I was anxious to know how far this sound could be heard, so I sent off a man used to roaming the forest, who returned in two hours with the information that he had heard it distinctly three miles from the roosting place.

Towards the approach of day, the noise somewhat subsided. Long before I could distinguish them plainly, the pigeons began to move off in a direction quite different from the one in which they flew when they arrived in the evening before. By sunrise all that were able to fly had disappeared. The howling of the wolves now reached our ears, and the foxes, the lynxes, cougars, bears, racoons, opossums and polecats were sneaking off. Eagles and hawks, accompanied by a crowd of vultures, took their place and enjoyed their share of the spoils. Then the author of all this devastation began to move among the dead, the dying and the mangled, picking up the pigeons and piling them in heaps. When each man had as many as he could possibly dispose of, the hogs were let loose to feed on the remainder.

How strange and exciting such a story must have sounded to an Edinburgh audience. It has, for once, the ring of authenticity.

In March 1827, as Lizars was working on the second number of *The Birds of America*, Audubon boldly issued his *Prospectus*; it announced that the work would appear in parts of five plates each, at two guineas a part, five parts a year. He thereupon proceeded to London – not directly, but taking in Newcastle, York, Leeds, Manchester and Liverpool. The production of the book was in good hands; all he had to do was to sell it. In each town he hired a hotel room on arrival, large enough for him to be able to exhibit his drawings and the printed plates of the first number, and then walked briskly around the town delivering his letters of introduction and inviting their recipients to visit his hotel and inspect his drawings and plates. He arrived in London at the end of May. He felt that he was entering 'the mouth of an immense monster, guarded by millions of sharp-edged teeth, from which, if I escaped unhurt, it must be called a miracle'.

Soon after he arrived in London, Audubon received from Lizars the grievous news that his colourists had gone on strike. Production on *The Birds of America* had come to a complete standstill and Lizars would not, for the time being, be able to fulfil any more orders. All he could do would be to send Audubon some black-and-white engravings for him to have hand-coloured in London. Audubon was in despair; the series had been launched and he would not now be able to honour his undertaking to supply his subscribers with a new number every two months. The news came as 'quite a shock to my nerves'. Audubon then made one of the great discoveries of his life, in the person of Robert Havell Jr. The Havells, a Berkshire family, had for several generations practised the art of engraving. They had a shop called the Zoological Gallery in Newman Street, just north of Oxford Street, where they sold engravings, books, artists' materials and every possible kind of natural history specimen.

Robert Havell Jr became in no time Audubon's indispensable collaborator. It is only necessary to compare some of Audubon's original watercolours and their perfunctorily sketched-in backgrounds with the resultant highly finished

Robert Havell, without whom Audubon would never have published *The Birds of America*.

139

engravings to appreciate the immense importance of Havell in this undertaking. Their historic partnership came to an end on 20 June 1838 when the final number of *The Birds of America* was published. It is the plates engraved by Havell, and not his own paintings, which established Audubon's later reputation. 'The work, comprising four hundred and thirty-five plates, and one thousand and sixty-five figures was finished on the 20th June 1838 without the continuity of its execution having been broken for a single day, and the numbers having been delivered with examplary regularity; for all which I am indebted to my friend and Engraver, Mr ROBERT HAVELL.'

Audubon soon forgot William Lizars; he never, it is unfortunate to recall, appreciated Lizars's great act of faith in engraving and colouring the early plates, nor the social, moral and financial help he had given him during the uncertain early days in Edinburgh. He even had Lizars's name removed from the first few plates. Audubon was like that; he could be unreliable in his friendships and loyalties. In London he had no time to cultivate such niceties as gratitude. The news from Lizars had come as a dreadful shock. Now he had to keep Havell supplied with cash if the engraving and colouring were to proceed without interruption. His main means of raising the money was by painting in oils. He painted day and night (he did seven copies of the otter caught in a trap), and hawked his pictures around London.

At that time I painted all day, and sold my work during the dusky hours of evening. As I walked through the Strand and other streets where Jews reigned; popping in and out of Jew-shops or any other, and never refusing the offer made me for the pictures I carried fresh from the easel. Startling as this may seem, it is nevertheless true, and one of the curious events of my extraordinary life.

Audubon had arrived in London at the wrong time of the year. The summer season had started and all persons of consequence would soon be leaving the capital. His efforts to find subscribers for *The Birds of America* met with disappointment. He had brought with him a formidable number of letters of

introduction to big names in science, society and the arts, but though he wandered all over London in search of subscribers, he did not find a single person at home. 'I have many times longed to see London, and now I am here I feel a desire beyond words to be in my beloved woods.' His mood changed for the better, though only temporarily, after meeting various scientists and being introduced to the Linnean and to other learned societies. He went to Covent Garden Theatre and heard Madame Vestris ('she sings middling well') and he also met Sir Thomas Lawrence, head of the Royal Academy and the favourite painter of the Court and of fashionable society. Lawrence helped him at a moment when he might perhaps have been sent to prison for debt. In the summer of 1827 Audubon was very short of money and Havell was demanding an immediate payment of £60 for work done. Lawrence took his friends to Audubon's lodgings in Great Russell Street to see his drawings and oil paintings, several of which they bought. 'I was then not only not worth a penny, but had actually borrowed five pounds a few days before to purchase materials for my pictures. But these pictures which Sir Thomas sold for me enabled me to pay my borrowed money, and to appear full-handed when Mr Havell called. Thus I passed the Rubicon!'

Audubon did not care for painting in oils: 'I can draw, but I shall never paint well.' One day in London, when he was walking 'I know not whither', he bumped into Joseph Bartholomew Kidd, a young Scottish landscape artist whom he had met in Edinburgh. He asked Kidd to come and paint in his lodgings. 'His youth, simplicity and cleverness have attached me to him very much,' he wrote. He taught Kidd how to draw birds and Kidd, in his turn, helped him with some of the landscape backgrounds to *The Birds of America*, a subject which always caused Audubon a certain amount of difficulty. He noticed how much more the public was prepared to pay for paintings in oil than for watercolours, and he regretted all the more, at this low point in his financial fortunes, that he was not more gifted in this medium. 'My friends cry against my painting in oil – and *now I do declare to thee* [the pages of his journal]

that I will not spoil any more canvas, but will draw in my usual old, untaught way, which is what God meant me to do.' In Liverpool Mrs Rathbone had wanted him to teach her how to paint in oils. 'Now is it not too bad that I cannot do so, for want of talent? My birds in *water-colours* have plumage and soft colours, but in oils – alas!'

Audubon hit upon the idea of having an itinerant natural history gallery of oil paintings; he was convinced that they would sell very well, not only in London, but in Paris, Berlin and St Petersburg. Kidd, whom he admired so much, would paint them. He would copy in oils the drawings for the first hundred plates of *The Birds of America* and put in his own backgrounds. The two artists would divide the proceeds. The arrangement got off to a good start and Kidd's paintings were highly praised. 'In the execution of such as these as Mr Kidd has finished, he has not only preserved the vivacious character of the originals, but he has greatly heightened their beauty, by the general tone and appropriate feeling which he has pre-served and carried throughout his pictures,' wrote Captain Thomas Brown in the *Caledonian Mercury*. In spite of the success of these paintings, a booming ornithological gallery did not result. Audubon blamed Kidd's laziness for the failure of the scheme; it is not known how many paintings were done by Kidd in all – thirty-six is a commonly accepted figure – nor is it certain which were by Kidd and which were by Audubon. This shows that Audubon, despite all his moaning, was turning into quite a competent oil painter.

'I do anything for money now a days,' he wrote to Lucy in August 1827. He was longing for her to join him in London, but he knew that he still had a long way to go before he could persuade her that it would not mean a repetition of the pri-vations of Henderson, Cincinnati and New Orleans. He wrote to his son Victor, 'Your Mamma alone is all that I may expect to see and she is not willing to come over untill I have acquired a *great fortune*. How long then I may be without her is quite unknown and I feel perplexed the oftener I think of it.' He knew that London was the town where a fortune could be made and

OPPOSITE Purple grackle (common grackle), Plate VII from *The Birds of America*.

142

PLATE VII

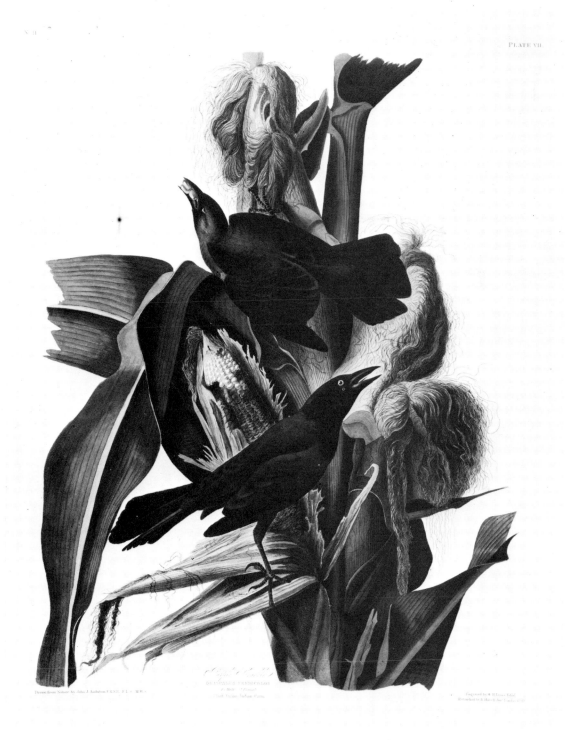

he knew that his only hope of doing so quickly was by painting in oils. This thought led to renewed lamentations about his inadequacy in this medium:

I have painted several pieces in oil, of course *attempts*, but my hand does not manage the oil brush properly – neither the composition nor the effect are good, and disgusted myself, I care not about finishing any of them although I am perfectly confident that the delineations are correct to perfection ... the pictures I sell are only purchased by my friends, and my heart and natural pride revolt at this, therefore, I am very likely to abandon this style for ever.

The other thing that bothered him was London itself. It must have been a frighteningly large, wealthy and sophisticated city for the 'American woodsman'. Everything about London awed and dazzled him, while London was not fascinated by Audubon as a glamorous frontier phenomenon. He had to work hard to ward off the spectre of a second bankruptcy. It must be remembered that, in addition to turning out paintings for sale, and working over his watercolours for Havell to engrave, he was supervising the vast work of engraving and colouring, soliciting all the subscriptions, chasing up bad payers and was personally responsible for financing this mammoth publishing project. It is not surprising that he had bouts of depression; these were often brought on by Lucy's long silences. He could not forgive London for making him feel lonely, uncouth and unsuccessful, despite the many kindnesses which he received. This was probably why he yearned more for the presence of Lucy in London than in the more manageable provincial cities of Liverpool and Edinburgh, where he felt quite important. London cut him down to size, a fact which he resented. He tried to explain to Lucy why success did not come so easily in London as in other places. He was working on

2 very large Pictures of Peacocks, and Turkeys, for the Spring London exhibition so as to have my name cracked up here as well as in Edinburgh – but Dearest Wife thou must know that Edinburgh is a Mere village compared with this Vasty Capital – the Duke of Bedford owns several streets himself that would cover Louisville entirely.... I hate it, yes, I cordially hate London, and yet cannot

Swamp sparrow, Plate LXIV from *The Birds of America*. The plate bears the unexpected legend, 'Drawn from Nature by Lucy Audubon', but it is unlikely that Lucy did more than one or two · leaves.

escape from it. I can neither write my Journal here, nor draw well, and if I walk to the fields around, the very voice of the sweet birds I hear has no longer any charm for me, the pleasure being too much mingled with the idea that in another hour all will again be bustle, filth and smoke.

In his dislike of London he found a kindred spirit in the American envoy *extraordinaire* Gallatin. 'He detests the English, and spoke in no measured terms of London as the most disagreeable place in Europe.'

The members of the nobility, his most likely subscribers, also had him trembling with subservience. 'The Critical Politique State of Affairs here certainly was a great means of deterring many persons of Rank from seeing my Work ... It is quite out

Pierre Joseph Redouté,
the famous painter of
roses, arranged
introductions for
Audubon in France.
Rosa indica, or *rosier du
Bengale*, by Redouté.

of the question for thee to imagine the *brilliant superfluities* that
ornamented the Countesses and other *Ladies*. They fairly shine
with rich decorations and trinkets.' He reacted to the con-
temptuous indifference of the English to events in America. 'I
would be glad to know,' he wrote to his son Victor, 'the
sentiments of the Americans *generally*, respecting the election of
Gl Jackson [Andrew] – here where everything that is Yankee is

146

ridiculed it appears to make a sensation, but I dare say like everything else in London it will live but one week!' The young Earl of Kinnoul, a subscriber to *The Birds of America*, summoned Audubon to his house and roundly abused him because all his birds '*were alike*, and he considered my work a swindle'. Audubon listened patiently to the expostulating earl, 'a small man with a face like the caricature of an owl', and then left 'the rudest man I have ever met in this land'.

'Whenever I am in this London all is alike indifferent to me, and I in turn indifferent.' Audubon was relieved to leave it for Paris in September 1828. The Bourbon Charles x was still on the throne but the day was not far off when he would be overthrown by the July Revolution and succeeded by his cousin Louis-Philippe, Duc d'Orléans. Audubon travelled to Paris with that vain, testy, irascible naturalist William Swainson, who knew a lot about birds and insects but was difficult to get on with. Swainson had some work to do in the Jardin des Plantes and Audubon wanted to find some subscribers.

After reaching Calais, they dined after surrendering their passports: 'Our still sickly bodies were glad to rest.' When his passport was returned to him, Audubon was amused to read on the accompanying form that his complexion was '*copper red*' – 'As the Monsieur at the office had never seen me, I suppose the word American suggested that all the natives of our country were aborigines.' Audubon brought with him many letters of introduction to influential Frenchmen. He was less intimidated by Paris than by London. Writing to his son Victor after his return to England, he said,

France is not rich, it is a *beautifull waste*. Paris alone has a few wealthy personages but nothing to compare with the number or the style of those in this most extraordinary Island. I saw all the Court of France and spent more than one hour with the Dukes of Orleans and Chartres, two extremely fine men – the first is the wealthiest man in France and twenty years ago he gave lessons of French and Drawing in America at a Dollar a lesson – He is a great admirer of all that is American.

Pierre Joseph Redouté, the great flower painter, arranged for

Audubon to show his drawings and his early plates of *The Birds of America* to the Duc d'Orléans. Redouté had been struck by the animation of Audubon's drawings and thought there was a good chance of both Duc and Duchesse taking out separate subscriptions. After walking past many footmen and through many corridors and ante-chambers Audubon finally met the Duc d'Orléans. 'Lucy – Kentucky, Tennessee and Alabama have furnished the finest men in the world, as regards physical beauty; I have also seen many a noble-looking Osage chief; but I do not recollect a finer-looking man, in form, deportment, and manners, than this Duc d'Orléans.' The Duc d'Orléans, later King Louis-Philippe, examined carefully the contents of Audubon's portfolio, and when he saw the plate of the Baltimore orioles with the nest swinging amongst the twigs of the yellow poplar, he exclaimed that this had surpassed anything he had ever seen: 'I am not astonished now at the eulogiums of M. Redouté.' The Duc and Duchesse, as Redouté had guessed, both entered their names for a subscription.

Baron Cuvier, the 'dictator of biology', was another illustrious person whom Audubon met in Paris. Cuvier was one of the greatest naturalists and palaeontologists of his age; like Buffon, he enjoyed overwhelming social and scientific prestige and his inveterate hostility to any form of evolutionary teaching was one reason why the doctrine of evolution was so slow in establishing itself in France. He received Audubon at the Museum of Natural History with the greatest affability: 'He was polite and kind to me, though my name had never reached his ears.' Audubon described him to Lucy as a '*new species of man* (separately created rather than evolved, as the evolutionary heretics would have it).... Age about sixty-five; size corpulent, five feet five ... face wrinkled and brownish ... nose aquiline, large and red; mouth large with good lips; teeth few, blunted by age, excepting one on the lower jaw, measuring nearly three-quarters of an inch'. Cuvier invited Audubon to dine with him at his home. 'There was not the show of opulence at this dinner that is seen in the same rank of life in England, no, not by far ... the dinner finished, the Baroness rose, and we

all followed her into the library. I liked this much; I cannot bear the *drinking matches* of wine at the English tables.'

Cuvier arranged for Audubon's work to be shown to the members of the Académie Royale des Sciences. A footman carried his portfolio and placed it on a table before the members, and Audubon occupied a seat of honour. 'Poor Audubon! here thou art, a simple woodsman, among a crowd of talented men, yet kindly received by all – so are the works of God as shown in His birds loved by them.' The members admired the plates, exclaiming *'Quel ouvrage! quel prix!'* None of them could afford to buy it. 'Poor France! thy fine climate, thy rich vineyards, and the wishes of the learned avail nothing; thou art a destitute beggar.'

The mixture of social success and sales resistance which was Audubon's lot in Paris induced him to communicate to his journal the most extraordinary effusions in which he hinted about his exalted birth and how he was really born 'to command all'. These have been seized on by the protagonists of the Dauphin theory. Apart from the Duc d'Orléans, Audubon had little or no intercourse with royalty during his two months in Paris. At least he saw King Charles x on horseback reviewing his troops, and he also saw his library. 'The King seldom reads, but he shoots well. Napoleon read, or was read to, constantly, and hardly knew how to hold a gun.' At the review of the troops he stood very near the king. 'As a Kentuckian would say, I could have "closed his eyes with a rifle bullet."' None of the ladies in the king's entourage were 'connections of Venus, except most distantly'.

Audubon was not displeased with the results of his stay in France. 'I was kindly received by the greatest men there and procured 14 subscribers.' What he wanted with ever greater urgency was for his wife to come to England. He never tired of telling her how comfortably they would live on the sales of a mere hundred subscriptions; the expenses ('coppers', paper, colouring, printing) for five numbers would be £550 and the proceeds £1,050, which left a profit of £500. But Lucy was slow to persuade.

8

The Biographer
of Birds

fter an absence of exactly three years in Europe, Audubon returned to America in April 1829. He sailed from Portsmouth in the packet-ship *Columbus*. 'I chose the ship on account of her name and paid thirty pounds for my passage.' At first he had thought of travelling incognito under the simple name of John James. 'Only 3 or 4 friends in England will know *positively* where I have gone, my Subscribers and the *World* will think me on the European Continent after more Patronage – this is absolutely necessary for the safe keeping of my present subscribers, most all of which would become alarmed and would expect the work to fall through.'

Audubon had two reasons for going to America at this critical stage of his undertaking. He wanted to see Lucy again and to persuade her to return to England with him. He sensed that this was his last chance of being reunited with her. He wanted also to gather as much new material as possible for future numbers of *The Birds of America*; about fifty of his earlier drawings needed re-doing and he hoped to shoot, draw and preserve the skins of a large number of birds.

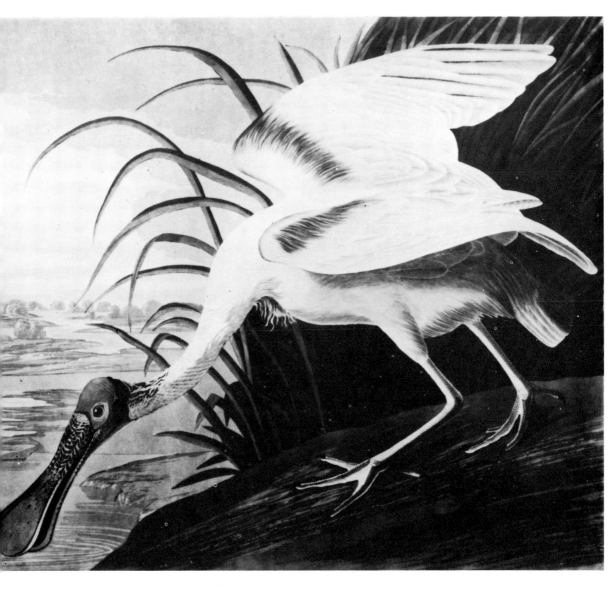

Roseate spoonbill, Plate
CCCXXI from *The Birds of
America*. The background
is Lehman's, and it is
possible that the bird is
by his hand, too.

Before leaving England he had entrusted the general supervision of his business to John George Children, a physicist and naturalist, and secretary of the Royal Society. It was he who had taken Audubon along to the Linnean Society to show the Fellows the first number of *The Birds of America*. 'All those present pronounced my work *unrivalled* and warmly wished me success.' Children was one of the few good and helpful friends that Audubon made in London. He had also arranged for the King to be shown the first number of *The Birds of America*. 'His Majesty was pleased to call it fine, permitted me to publish it under his particular patronage, approbation and protection, became a subscriber on the usual terms, not as kings generally do, but as a gentleman. . . .' Children tried, unsuccessfully, to persuade the British Museum to take out a subscription to *The Birds of America*; '£200 per annum was all that was allowed for the purchase of natural curiosities.'

Now that his publication was to be in the competent hands of John G. Children, Audubon dropped his plan of travelling to America incognito. 'When I reach the shore I will have my arrival published in the News Papers there.' Havell was provided with all the drawings needed for the rest of 1829 and for the first issue of 1830; he also kept a certain number of Audubon's oil paintings to offer for sale in his shop. The rest of Audubon's material was deposited by Children at the British Museum. The work had now been in publication for two years (the first ten parts appeared in 1827–8) and was, on the whole, paying its way. A constant danger was that of subscribers cancelling their subscriptions; this had indeed happened on several occasions.

Audubon travelled to America not as a celebrity but not as a tramp. He had £190 in his pocket through the sale of his paintings in England; he had an important publication to his credit and had gained a reputation as an ornithologist and animal artist. In New York, even if his arrival was not reported in the 'News Papers', he was treated respectfully by the customs officials who waived the payment of duty on his books and his guns. The sight of land touched off the spark of his immi-

grant patriotism and he addressed his book and his country in these words:

I have brought thee, my English book, all the way across the Atlantic, too sea-sick to hold any converse with thee – sea-sick all the way, until this morning I saw my dear native land. . . . I clasped my hands and fell on my knees, and raising my eyes to Heaven – that happy land above – I offered my thanks to our God, that he had preserved and prospered me in my long absence, and once more permitted me to approach these shores so dear to me, and which hold my heart's best earthly treasures.

Having delivered himself of these effusions, he wrote Lucy a tough letter warning her of the consequences if she persisted in her refusal. Should she refuse 'to join her husband and go to Europe with him; to enliven his spirits and assist him with her kind advices', then, 'I *shall never put the question again* and *we probably* never will meet again'. He dared not go to Louisiana for fear of not receiving vital regular news from London. 'Probably for ever my eyes will not rest on the Magnolia Woods or see the mocking thrush gaily gambling full of melody amongst the big trees of the South.'

In New York Audubon exhibited his drawings and the finished plates at the Lyceum of Natural History. From there he went on to Philadelphia to see Dr Richard Harlan and the painter Thomas Sully, about the only persons well disposed towards him in that city. Feeling 'a dampening chill run through me as I walked along its fine streets', Aubudon made for Camden, New Jersey, where he hunted and painted and studied the habits of the migratory warblers, then arriving from the south for the breeding season. From Camden he went to Great Egg Harbour, where he lived in a fisherman's hut by the sea. The harbour was famous for its number and variety of land and water birds. Here Audubon made the original drawings for several of the plates of *The Birds of America* – the bay-winged bunting, yellow-breasted chat, warbling flycatcher, golden-crowned thrush, small green-crested flycatcher and rough-legged falcon.

On returning to Philadelphia he found a terse, cool letter

RIGHT Loggerhead shrike, watercolour executed from *c.* 1825 for Plate LVII in *The Birds of America*. Audubon showed both male and female, 'in order to show the quarrelsome disposition of these birds even when united by the hymeneal band'.

OPPOSITE Indigo-bird (indigo bunting), a watercolour done in several stages, the earliest being the spider of 1821. The painting became Plate LXXIV in *The Birds of America*.

from Lucy. She accused him of showing a lack of affection in not coming to Louisiana, and said that she could not, or would not, go north to Louisville. He tried to use his elder son Victor as an intermediary, explaining to him the reasons why he could not go 'west of the Mountains'. Audubon complained that he had never once had a letter from Lucy giving the facts of her situation; she had never told him how much or how little she

No. 15. Plate 74.

Published
1829.

Indigo-bird.
Fringilla cyanea
Plant. Schisandra coccinea
Vulg. Sarsaparilla.

earned. Victor was meant to pass these arguments on to his mother. Meanwhile Audubon set off for Mauch Chunk in the Great Pine Swamp in Northampton county, Pennsylvania, his only luggage being 'a wooden box containing a small stock of Linin, drawing-paper, my journal, colours and pencils, together with twenty pounds of shot, several flints, a due quantum of cash, my gun "Tear Jacket", and a heart as true to nature as ever'.

Audubon's stay in the Great Pine Swamp is the subject of one of his Episodes. When there to obtain new birds he stayed in the cabin of a lumberman, Jedediah Irish. The romantic sensibilities of his English readers were particularly affected by his description of the idyllic scene.

Reader, to describe to you the qualities of that excellent man were vain; you should know him, as I do, to estimate the value of such men in our sequestered forests. . . . The long walks and long talks we had together I never can forget, or the many beautiful birds which we pursued, shot and admired. The juicy venison, excellent bear flesh, and delightful trout that daily formed our food, methinks I can still enjoy. And then, what pleasure I had in listening to him as he read his favourite poem of BURNS, whilst my pencil was occupied in smoothing and softening the drawing of the bird before me! Was this not enough to recall to my mind the early impression that had been made upon me by the description of the golden age, which I had found realized?

Audubon spent at least two months in the Great Pine Swamp; he collected and drew many of the smaller land birds such as finches, warblers and flycatchers. Some of the warblers which he drew at this time, the originals of the plates later engraved by Havell, were the black poll, pine swamp and black and yellow warblers. Freed from the hateful restraints of London life, he was his old self again:

I am at work and have done much, but I wish I had eight pairs of hands and another body to shoot the specimens; still I am delighted at what I have accomplished in drawing this season; Forty-two drawings in four months, eleven large, eleven middle-size, and twenty-two small, comprising ninety-five birds, from Eagles

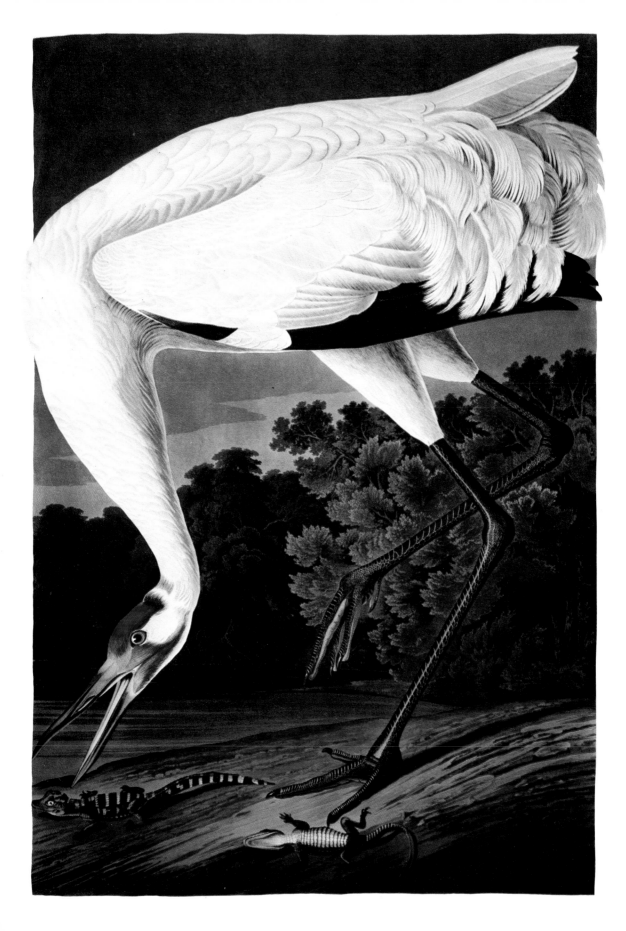

合衆國育名の禽學者奧度棒あり時

旅行して多年思慮を殫して摸寫芳

諸本を箱ニ入て親戚ニ托し置き數月はて

家ニ帰り箱を開き見ると鼠其内ニ巣

くひ圖圖ハ悉くく齧まみて碎片となれり

奧度棒ハ是を見て大ニ心を傷まして

數日の間恍惚として失忘せる者の如く

既ふして又舊の如くに銃を手ふして記簿鉛筆を

携へ林ふ入て禽鳥を捕へ其形狀を摸寫せして三年ふ

をらすして画又箱ふ満ち摸寫ち前時より更ふ好きを覚えしとて

No 10.
Plate 49
(119)

Yellow throated Vireo. ———— Male
Vireo flavifrons. —
Plant vulgo Swamp Snow ball.
Hydrangea quercifolia

Drawn from Nature by John J. Audubon
Louisa Bayou y Plantation Louisiana July 11th 1835

downwards, with plants, nests, flowers, and sixty different kinds of eggs. I live alone, see scarcely anyone, besides those belonging to the house where I lodge. I rise long before day and work until nightfall, when I take a walk and then to bed. I returned yesterday from Mauch Chunk; after all, there is nothing perfect but *primitiveness*, and my efforts at copying nature, like all other things attempted by us mortals fell far short of the originals. Few better than myself can appreciate this with more despondency than I do.

At this time Audubon intended to reproduce the eggs of American birds full-size in the final sections of *The Birds of America*; they had, however, to be squeezed out in favour of new birds. The strain of collecting birds, drawing and skinning them, painting the appropriate floral foregrounds and backgrounds, and dealing with his European correspondence was becoming more than he could manage. In Philadelphia he took on a Swiss artist called George Lehman, whom he had once met in Pittsburgh in 1824. Lehman's task was to help him draw the flowers and plants in his new bird portraits. Lehman is sometimes described as the artist responsible for the scenes in the second of the three phases into which *The Birds of America* may be divided. The first, up to Plate CL, is exuberant and occasionally overdone. The second, up to Plate CCCLXX, shows the artist confident in the possession of the necessary techniques. The third, up to Plate CDXXXV, reveals the pressure of the timetable and his efforts to cram in all the new species he had collected – hence the overcrowding and repetitive backgrounds. Lehman sometimes went in for backgrounds of fussy little farms and seaside towns. He later accompanied Audubon on his 1831–2 Florida trip.

In Philadelphia Audubon received his answer from Lucy to his arguments made via Victor. If he wanted to see her again he must come to Louisiana. Audubon gave way; he made for the magnolia woods of the Feliciana country by way of Pittsburgh and Louisville, where he saw his two sons again. He hardly recognized them. Both were working in Louisville, Victor for Nicholas Berthoud and John for Thomas W. Bakewell. Audubon sailed down the Ohio in a steamboat; nine years

OPPOSITE
Yellow-breasted vireo (yellow-throated vireo), watercolour painted at Oakley in 1821. The background of 'Swamp Snow-ball' is by Joseph Mason.

American snipe (common snipe), Plate CCXLIII from *The Birds of America*. The South Carolina plantation landscape is by Lehman.

earlier, humiliated and penniless, he had drifted down the same river in a flatboat. Yellow fever was raging when he arrived. He borrowed a horse and galloped to Lucy's house.

It was so dark that I soon lost my way, but I cared not, I was about to rejoin my wife, I was in the woods, the woods of Louisiana, my heart was bursting with joy! The first glimpse of dawn set me on my road, at six o'clock I was at Mr Johnson's house [where Lucy was teaching]; a servant took the horse, I went at once to my wife's apartment; her door was ajar, already she was dressed and sitting by her piano, on which a young lady was playing. I pronounced her name gently, she saw me, and the next moment I held her in my arms. Her emotion was so great, I feared I had acted rashly, but tears relieved our hearts, once more we were together.

Audubon stayed in Louisiana until the end of 1829. He spent his time killing and drawing birds of prey and also various species of squirrels, which abounded in the Feliciana woods. On New Year's Day 1830 Audubon and Lucy bade farewell for ever to the magnolia woods of Feliciana. They left for New

Orleans, taking with them three slaves 'yet belonging to us, namely Cecelia and her two sons Ruben and Lewis'. They sold them before boarding the steamboat *Philadelphia* for Louisville. This was the first time he had made this trip with Lucy. In *Audubon: an Intimate Life of the American Woodsman*, Stanley Clisby Arthur described the journey:

Again John James Audubon travelled the Mississippi river, the same stream that had seen him floating down its surface nine years before, in rags and tatters, unknown and low in spirit. Now he was making the trip famous, admired, and with gold coins jingling in his pockets. The same long hair hung over his ears (he had not had it cut again since Edinburgh) and curled on his shoulders, his eyes were as blue and as light and as piercing, his nose as patricianly patterned and his Gallic accent as pronounced. He was dreaming this cold day of January 1830 as he had done in January 1821, when the keelboat in which he was drifting reached New Orleans. A portfolio of bird drawings was his prized piece of luggage then as now. Audubon the dreamer had arrived at the portal of his dream.

After spending a couple of months with the Berthouds in Louisville and stuffing birds at the Falls of the Ohio, Audubon and Lucy travelled to Washington, the nation's capital. There they were befriended by the distinguished Bostonian Edward Everett, then leader of the House of Representatives, who arranged both for Audubon's drawings and plates to be shown to members of Congress and for the Library of Congress to become a subscriber to *The Birds of America*. Andrew Jackson, recently elected President, entertained him and Lucy at the White House. Audubon had cheered 'Old Hickory' in the streets of New Orleans in April 1821; later, in New York, he had sat as a model for a portrait of Andrew Jackson by the painter John Vanderlyn 'since my figure considerably resembled that of the General, more than any he had ever seen'. Audubon had donned Jackson's blue uniform and boots and, grasping the hilt of his unsheathed sword, adopted the old warrior's martial pose at the Battle of New Orleans. The portrait of 'Old Hickory' from the shoulders up and Audubon from the shoulders down was hung in the New York City Hall.

Andrew Jackson – 'Old Hickory' – the famous general who became President of the United States, entertained the Audubons at the White House.

On 1 April 1830 the Audubons sailed for Liverpool in the packet-ship *Pacific*, arriving there twenty-five days later. Lucy stayed with her sister and Audubon made straight for London, where he found that many of his subscribers had drifted away in his absence. As his granddaughter put it, 'Finding many subscribers had not paid, and others had lapsed, he again painted numerous pictures for sale, and journeyed hither and yon for new subscribers.' A better piece of news was that he had been elected a Fellow of the Royal Society. This pleased him, although, as he modestly confided to his journal: 'I felt my self that I had not the qualifications to entitle me to such an honour.' He paid the £50 entrance fee and took his seat in that august body in May.

One of the sound pieces of advice that Children had given

Audubon was to desist from writing articles for learned journals, which would only invite barbed, pedantic comments from the 'scientific' naturalists, but to concentrate on his own 'bird biographies'. Audubon had, indeed, been anxious for some time to write a text to accompany *The Birds of America* and had made one or two crude attempts as early as 1821. He knew that such a task was beyond his own unaided technical and linguistic knowledge.

I know that I am a poor writer, that I scarcely can manage to scribble a tolerable English letter, and not a much better one in French, though that is easier for me. I know I am not a scholar, but meantime I am aware that no man living has studied them as much as I have done, and with the assistance of my old journals and memorandum-books which were written on the spot, I can at least

The north of England in the 1830s – the opening of the Liverpool and Manchester Railway in September 1830.

THE OPENING OF THE LIVERPOOL & MANCHESTER RAILWAY SEPR. 15TH 1830, WITH THE MOORISH ARCH AT EDGE HILL AS IT APPEARED ON THAT DAY.

165

put down plain truths, which may be useful and perhaps interesting, so I shall set to at once. I cannot, however, give *scientific* descriptions and here must have assistance.

Audubon had earlier asked William Swainson, who delighted in the niceties of technical ornithology, to help him with the scientific text of his bird biographies. He had written asking Swainson to '*Bear a hand* in the text of my work – by my furnishing you with the ideas and observations which I have and you to add *the science which I have not*!' Audubon suggested that he and Lucy come and live with the Swainsons, as paying guests, while the work was in progress:

My first volume will comprise an introduction and *one hundred letters addressed to the Reader* referring to the 100 plates forming the first volume of my illustrations. I will enter even on local descriptions of the country – adventures and anecdotes, speak of the trees and the flowers the reptiles or the fishes or insects as far as I know – I wish . . . to make it a *pleasing* book as well as an *instructive* one. In the event of my living with you we will furnish our own wines, porter or ale.

Swainson was much taken by this proposition and replied affirmatively, saying he would charge five shillings to seven shillings and sixpence a sheet. 'It would of course be understood that my name stands in the title-page as responsible for such portion as concerns me.' It was on this stipulation that the negotiations broke down; Audubon was unwilling to share with anyone the credit for his book. He then went with Lucy to Edinburgh and stayed again at Mrs Dickie's 'boarding residence' in George Street. Edinburgh had been the birthplace of *The Birds of America* and might well become the birthplace of their biographies. In fact, it did. He found in October an admirable young Scottish naturalist and anatomist, William MacGillivray. 'I made known my business, and the bargain was soon struck. He agreed to assist me and correct my manuscripts for two guineas per sheet of sixteen pages, and that day I began to write the first volume.'

MacGillivray turned out to be an ideal assistant. This sensible thirty-four-year-old Scot from Aberdeen, later author of

the distinguished five-volume *History of British Birds* (1837–52), did not, unlike the vain and touchy Swainson, covet the distinction of his name appearing on the title-page. He recognized Audubon as a great bird man and great artist and was only too happy to smooth out his text – removing capricious capital letters, turning 'Willson' into 'Wilson' and 'watter' into 'water' – and to contribute most of the technical details. In his prefaces to the various volumes of the *Ornithological Biography* Audubon acknowledges MacGillivray's assistance; this was apparently not good enough for certain hecklers, the most persistent of whom was that extraordinary genius and crackpot naturalist Charles Waterton, the eccentric squire of Walton Hall in Yorkshire. Waterton, a friend of the dour George Ord in Philadelphia, published about twenty polemical articles against Audubon, that 'foreigner' and 'stranger', whom he regarded as a dangerous charlatan. These two curious men were a match for each other. Waterton considered it his duty to inform the world that Audubon was a phoney; he was one of the most vociferous critics of the rattlesnake and other 'scientific' articles. When the volumes of *Ornithological Biography* (1831–9) began to appear, competently written and with no misspellings, Waterton eagerly smelt a rat. 'I request the English reader to weigh well in his own mind what I have stated, and I flatter myself that he will agree with me, when I affirm that the correct and elegant style of composition which appears through the *whole of the Biography of Birds* cannot possibly be that of him whose name it bears.'

The writing of *Ornithological Biography* was a *tour de force* on the part of Audubon and MacGillivray. They had to write fast to beat the competition – all of a sudden it had been announced that two new editions, each with different editors, of Wilson's *American Ornithology* were about to be published. Audubon was not unduly worried; Wilson's book had had its day. 'I have studied the character of Englishmen as carefully as I have studied the birds in America, and I know full well that in England novelty is always in demand, and that if a thing is well known it will not get much support.'

ABOVE Florida cormorant (double-crested cormorant), Plate CCLII from *The Birds of America*, with (OPPOSITE) the original watercolour painted in 1832, showing how Audubon's roughly sketched-in background has been developed by Havell in the engraving.

Nevertheless, Audubon and MacGillivray took the news seriously. Audubon spent the winter of 1830 writing furiously in Edinburgh. He was at his desk by four every morning and he wrote uninterruptedly until ten or eleven every night. Mac-Gillivray started the day at ten, but continued until two the following morning. Audubon wrote:

So full was my mind of birds and their habits that in my sleep I continually dreamed of birds. I found MacGillivray equally industrious, for although he did not rise so early in the morning as I did, he wrote much later at night (this I am told is a characteristic of all great writers); and so the manuscript went on increasing in bulk, like the rising of a steam after abundant rains.

After three months of writing the first volume was ready for

168

the printers. The valiant Lucy had, in the meantime, copied out the entire manuscript for it to be deposited in the United States, thus, it was thought, securing the American copyright. Later Audubon discovered that 'the copy-right law authorizes any citizen of the United States to take out a copy-right of his work, on depositing a *printed copy* of the title page in the office of the District Court.'

On 9 April 1831 the *London Literary Gazette* announced: 'This day is published, price 25s. in royal octavo, cloth, Ornithological Biography. . . .' As no Edinburgh publisher could be prevailed upon to take the book, Audubon decided to publish it at his own expense. He found a printer, Patrick Neill, a friend from his first Edinburgh visit, who had put him in touch with Lizars. In the end, the title-page of the first volume carried the

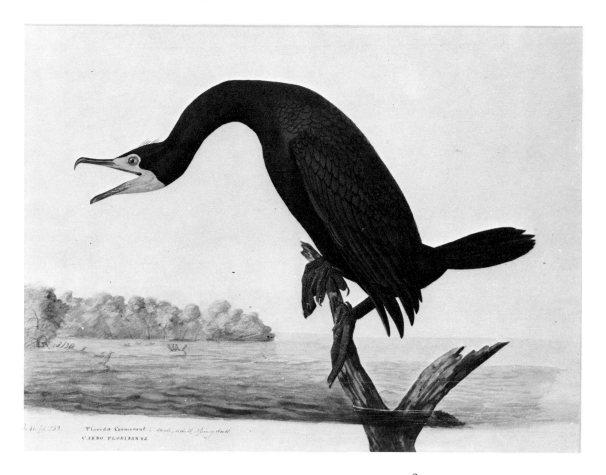

PLATE 83

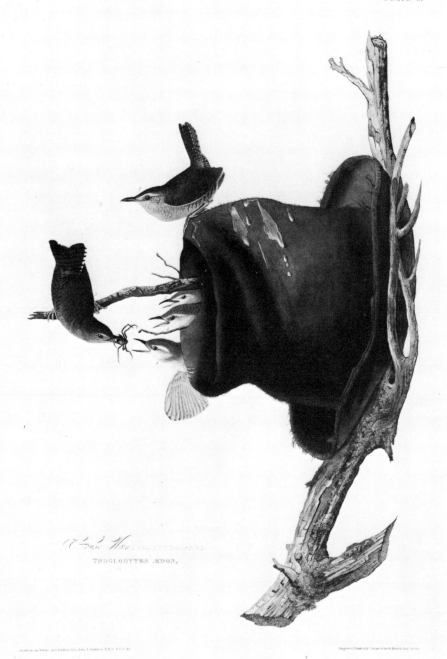

House Wren.

TROGLODYTES ÆDON,

Drawn from Nature, and Published by John J. Audubon, F.R.S. F.L.S. &c.

Engraved, Printed & Coloured by R. Havell, Junr London.

imprint of the bookseller Adam Black – Audubon had found an official publisher, but carried the risk himself. The reviews were very satisfactory; the easy, informal, personalized style was welcomed by a public accustomed to the aridities of natural history writing.

The first volume of the text now published, Audubon summarized the situation in the early summer of 1831.

> I have balanced my accounts with Birds of America and the whole business is really wonderful; forty thousand dollars have passed through my hands for the completion on the first volume (i.e. 100 plates or twenty numbers). Who would believe that a lonely individual, who landed in England without a friend in the whole country, and with only sufficient pecuniary means to travel through it as a visitor, could have accomplished such a task as this publication?

He was fond of asking himself these rhetorical questions. In spite of all his efforts, he had lost fifty subscribers, representing a sum of $56,000, and his subscription list was down from 180 to 130 names. Both England and France were in a state of political upheaval; in England it was feared that the movement for extending the suffrage would dangerously increase the pretensions of the lower orders, and in France the Citizen King Louis-Philippe (Audubon's first French subscriber) had been swept on to the throne by the July Revolution. Many people did not consider the times propitious for investing $1,000 or £168 in this magnificent and costly work. Furthermore, there had been several complaints about the indifferent quality of many of the plates; Havell had not examined each number with sufficient care before despatching to a subscriber. In the summer of 1831 Audubon decided that the time had come to return to the United States to collect more birds and more subscribers.

OPPOSITE House wren, Plate LXXXIII from *The Birds of America*. 'Look at the little creatures', Audubon wrote of these charming birds nesting in an old hat, 'anxiously peeping out or hanging to the side of the hat, to meet their mother. . . .'

9

The Wild Coasts
of Labrador

udubon had a triumphant return to the United States in 1831. Edward Everett had been doing his utmost to promote his cause – that 'of science and of America' – in various ways; he had arranged public exhibitions of the plates in the Library of Congress and in the Boston Athenaeum. In the former they attracted 'great attention and unqualified admiration' and in the latter 'the entire satisfaction and delight of those who saw them'. Everett tried to get Congress to pass a bill to give *The Birds of America* a duty-free passage to their native land, but this was held up by an impeachment proceeding. He nominated Audubon for a fellowship of the American Academy of Arts and Sciences and he distributed his prospectuses, regretting that he had not been able to enlist more subscribers.

Audubon experienced the pleasant sensation of finding himself famous in his own country. 'The papers and scientific journals (we have not many) are singing the praises of my work, and, God willing, I may yet come out at the broad end of the horn; at all events, I will either *break it or make a spoon*.' He

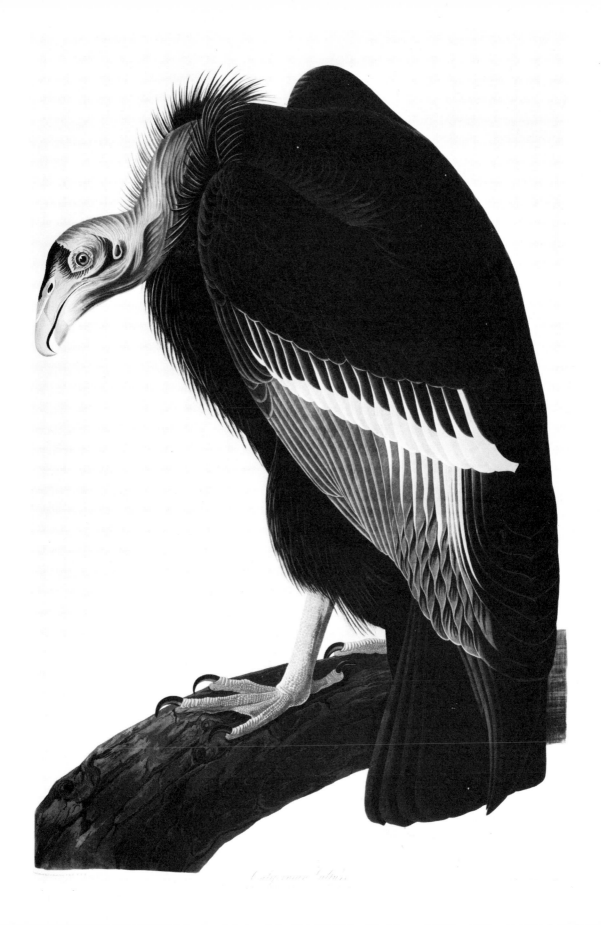

learned in Philadelphia that the American Philosophical Society and John Wetherill of Mill Grove had become subscribers.

Lucy and Audubon now separated, she making for Louisville to see her sons, and he for Florida, taking with him George Lehman and Henry Ward, a taxidermist who had come with them from England. 'My young man is busily engaged in skinning' (the birds which Audubon shot during the crossing), 'and killed a bag-full of warblers yesterday', he wrote. A pleasant and fruitful period now began for Audubon. During the years 1831–4 (he returned to England in April 1834) he was to meet his great friend and collaborator John Bachman of Charleston; and to go on fascinating expeditions with his sons and his loyal friend Edward Harris of Morristown, New Jersey – to the dunes and lagoons of the Texas coast, to the palmetto groves of Florida, and to the wild coast of Labrador.

Audubon's expeditions began to assume the character of national scientific progresses. The *Monthly American Journal of Geology and Natural Science* announced that the scientific world would be kept regularly informed through its pages of Audubon's activities. 'We anticipate the most interesting reconnaisances, both geological[!] and zoological, from this enterprising naturalist, who is accompanied by Mr Lehman, as an assistant draughtsman, and by an assistant collector who came with him from Europe.' Audubon and his two companions left Philadelphia by steamer for Norfolk and Richmond, Virginia, where he collected letters of introduction from the governor. From Richmond they travelled via Fayetteville in North Carolina to Charleston, South Carolina.

Charleston was the home of the Rev. John Bachman, a Lutheran minister and amateur naturalist. No sooner had he heard that Audubon and his two colleagues were in town than he insisted that they all come and stay with him. Thus started the most delightful and valuable friendship of Audubon's remaining years. His personality and the fervour of his passion for birds enthralled Bachman. For a month he sat at Audubon's feet as he skinned, wrote and talked about birds.

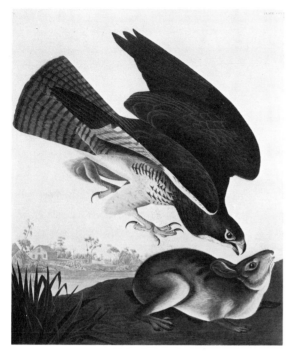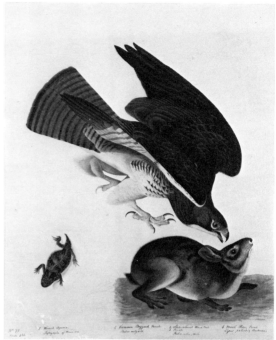

We were engaged in talking about Ornithology, in collecting birds, in seeing them prepared, and in laying plans for the accomplishment of that great work which he has undertaken ... there seems quite a blank in my house since he has gone, for we looked on him as one of our family. He taught my sister [actually sister-in-law] Maria to draw birds; and she now has such a passion for it, that whilst I am writing, she is drawing a Bittern, put up for her at daylight by Mr Audubon.

In 1849 Bachman was to marry, as his second wife, his sister-in-law Maria Martin who, after 1832, painted many of the flowers and insects to accompany Audubon's drawings of birds. Sometimes the plants in the finished plates were more striking than the birds. Audubon would draw the bird or birds on a sheet of bare white paper, and afterwards George Lehman or Maria Martin would paint in the sky or a landscape background. Maria Martin tended to restrict herself to exquisitely drawn and coloured flowers, butterflies and insects. A typical Lehman background is that of the fort and town of St Augustine, Florida in Plate CCLXIX. Audubon's medium was

Common buzzard (Swainson's hawk), in the original watercolour of 1836–7 (ABOVE RIGHT), and as it appeared as Plate CCCLXXII of *The Birds of America* (ABOVE LEFT). The hawk is by Audubon, the marsh hare perhaps by his son John. The horned lizard, probably drawn by Maria Martin, was used by Havell in his engraving of Plate CCCLXXXVI, illustrated on page 216.

175

invariably watercolour worked over with pastel. The flowers, trees and plants which he chose to embellish his drawings were not always in the bird's habitat (for example, Plate CVII), since they were often selected to enhance the colour values and shapes and to emphasize the habits of certain birds; in Plate XXXII, for instance, the blossom of the *Magnolia grandiflora* was deliberately chosen to harmonize with the tobacco-brown of the black-billed cuckoo. Audubon himself was quite capable of being his own botanical artist; none of his assistants excelled him in his drawings of magnolias, pines, larches, hemlocks and cedars, with the birds, painted in complementary colours, pecking at the cones, fluttering over them or perching on the branches.

In Charleston, using Bachman's house as their head-quarters, Audubon and his two assistants skinned about three hundred birds. The Charlestonians competed with each other in showering him with attentions; he was given a New-foundland dog, a collection of shells and a silver snuffbox. He found himself caught up in a whirl of social engagements. This would have been all very well had he been content with collecting specimens in the Carolinas. . . . 'But my mind was among the birds farther south: the Floridas, Red River, the Arkansas, that almost unknown country, California, and the Pacific Ocean. I felt myself drawn to the untried scenes of those countries, and it was necessary to tear myself away from the kindest friends.' Audubon's ambitious hope of exploring the continent were never realized. The farthest west he ever got was to Galveston in Texas in 1837 and to Fort Union in North Dakota in 1843.

In April 1832 Audubon started exploring the east coast of Florida. He began in St Augustine in the far north, and was not very impressed by it:

Oranges and plenty of good fish seem to contribute the wealth of the place. Sands, poor pine forests, and impenetrable thickets of cactus and palmettos form the undergrowth. Birds are rare and very shy; and with all our exertions, we have not collected one hundred skins in a fortnight that we have been here. . . . I have drawn

seventeen species, among which one *mongrel vulture*, which I think will prove new.

Audubon and Lehman took a short walk before daybreak and drew uninterruptedly until nightfall, while Ward went out with his gun and dog looking for specimens. At night Audubon wrote up his journals and went to bed early.

When we have nothing on hand to draw, the guns are cleaned over night, a basket of bread and cheese, a bottle with old whiskey, and some water, is prepared. We get into a boat, and after an hour of hard rowing, we find ourselves in the middle of most extensive marshes, as far as the eye can reach. The boat is anchored and we go wading through mud and water, amid myriads of sand-flies and mosquitoes, shooting here and there a bird, or squatting down on our hams for half an hour, to observe the ways of the beautiful beings we are in pursuit of. This is the way in which we spend the day. At the approach of evening the cranes, herons, pelicans, curlews, and the trains of blackbirds are passing high over our heads, to their roosting places; then we also return to ours. If some species are to draw the next day, and the weather is warm, they are outlined that same evening, to save them from incipient putridity. I have ascertained that *feathers* lose their brilliancy almost as rapidly as flesh or skin itself, and am of the opinion that a bird alive is 75 per cent more rich in colours than twenty-four hours after its death; we therefore skin those first which have been first killed, and the same evening. All this, added to our other avocations, brings us into the night pretty well fatigued.

At the beginning of 1832 Audubon moved forty miles south to the plantation of a young man, John Bulow of Bulowville. Since the trip had started, he had skinned 550 birds and made twenty-nine drawings. He was, however, anxious to acquire more new species. With this object in view, he planned two journeys – one up the St John's River, which ran more or less parallel to the coast, and the other to the Florida Keys. A government schooner, the *Spark*, was put at his disposal for the journey up the St John's River, and another schooner, the *Marion*, for the exploration of the southern coast. These two expeditions provided occasions for some repulsive scenes of

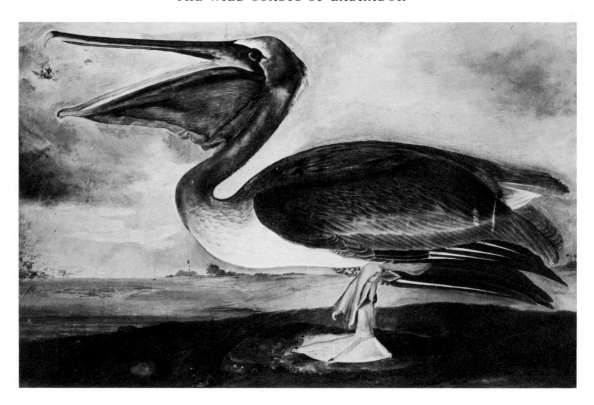

Brown pelican, watercolour of 1821 for Plate CCCCXXI in *The Birds of America*. The landscape, in oils, was added later, possibly by Audubon's son Victor. 'I really believe I would have shot one hundred of there reverend sirs,' wrote Audubon, 'had not a mistake taken place in the reloading of my gun.'

butchery which Audubon gleefully and gloatingly describes in his Episodes. He set out at sunrise one morning with four Negro servants 'in search of birds and adventures'. He wanted to kill twenty-five brown pelicans in order to draw a single male bird. Why he should have needed so many birds for a single drawing is curious. It was partly the fun of killing them at a time when people's thoughts had not turned towards conservation and partly for the sake of giving accurate anatomical descriptions of the species and their individual variations. His friends in England, MacGillivray in particular, were clamouring for as many specimens as possible.

In a thick shrubbery of mangrove Audubon came across several hundred pelicans,

seated in comfortable harmony, as near each other as the strength of the boughs would allow. . . . I waded to the shore under cover of the rushes along it, saw the pelicans fast asleep, examined their countenances and deportment well and leisurely, and after all, levelled,

fired my piece, and dropped two of the finest specimens I ever saw. I really believe I would have shot one hundred of there reverend sirs, had not a mistake taken place in the reloading of my gun.

On another occasion the pelicans were less fortunate: 'A discharge of artillery seldom produced more effect; the dead, the dying and the wounded, fell from the trees upon the water, while those unscathed flew screaming through the air in terror and dismay.' For Audubon birds were few in number if he shot less than a hundred per day.

He was particularly fascinated by the alligators and blazed away at them from the deck of the schooner for want of anything much better to shoot at.

I have been deceived most shamefully about the Floridas – scarcely a bird to be seen and those of the most common sort – I look to the leaving of it as a Happy event – I am now truly speaking in a *Wild* and *dreary* and desolate part of the World – No-one in the Eastern States has any *true* idea of this Peninsula – *My account* of what I have or shall see of the Floridas will be far, very far from corroborating the *flowery sayings* of Mr Barton the Botanist.

They had, however, a certain amount of fun killing alligators; the brains of one leaped out of its head and exploded in mid-air.

In the *Marion* Audubon visited all the coastal islands from St Augustine to Key West, as well as the Tortugas, where he killed and drew a new bird, the great white heron, Lehman putting in as a background the island town of Key West. Many new drawings were made, a thousand specimens secured and two new finds discovered on the two Florida expeditions. For Audubon they were 'rather unprofitable'. He returned to Charleston bearded and in tatters. Bachman wrote later, 'As I saw you ... when you came from Florida ... your beard, two months old, was as gray as a Badger's. I think a grizzly bear, forty-seven years old, would have claimed you as *par nobile fratum*.'

In the spring of 1832 Audubon left Charleston for Philadelphia where he was joined by Lucy and their two sons. His friends had noticed that he was becoming more and more vain

and touchy, although still buoyantly good-natured. His foul and intemperate language shocked the pious Dr Bachman, who asked him to keep to his resolutions not to swear and not to work on Sunday. As for swearing, said Bachman, it was 'a vulgar practice for one who is conversant with the most beautiful of God's works – the feathered race'. He was for sixty years the pastor of St John's Lutheran Church in Charleston. Lehman and Ward were the butts of Audubon's expletives in Florida; he discharged them both when the expeditions were over, not all that graciously. As it was, he could not have afforded to have kept them on much longer, although his resources now more or less sufficed for the essential needs of his family and he no longer had to paint his way out of debt. Since he had returned to the United States there had been several American subscriptions, which were to be dramatically increased in Boston in the summer of 1832. 'There are moments,' he said, 'and they are not far between, when, thinking of my present enormous undertaking, I wonder how I have been able to support the extraordinary amount of monies paid for the work alone, without taking cognizance of my family and my expeditions, which ever and anon travelling as we are from place to place and country to country are also very great.' Ward got a job in the Charleston Natural History Museum and later claimed as his own property many of the specimens which he had skinned in Florida.

The Birds of America was now becoming a family concern. From the year 1832 until Audubon's death, he and his two sons formed an impressive business trio. Victor was sent to England to superintend the engraving and colouring of the plates and to deal with financial and administrative matters such as the processing of subscriptions. John accompanied his father in the field, both collecting and drawing birds and backgrounds. Robert Havell was not a very efficient businessman and he could be careless in the preparation of the plates. The magnitude of Havell's task was such that it was essential for Audubon or one of his representatives to be present in the Havell establishment. It is sometimes forgotten that aquatint

was a relatively new and complex process and that *The Birds of America* was the most sumptuous work to which aquatint engraving had been applied. Aquatint was, in fact, an etching rather than a true engraving process; it consisted of areas of tone, not line, and the drawings were bitten into the copper plate by the action of acid through porous ground.

Audubon was sensible of the fact that accuracy in engraving and colouring was more important than ever for the new American subscribers. He bombarded Havell with reminders of this fact. '*Americans* are *excellent judges* of work particularly of such as are drawn from their country's soil – they are proud of everything that is connected with America, and feel mortified when ever anything is done that does not come up to their sanguine expectations.' As important as the careful colouring of the plates was the need for fresh supplies of birds. By the spring of 1833 there were fifty-five American subscribers; this made about 180 subscribers in all. They expected to receive over a period of seven to eight years some 400 plates, delivered in parts every two months, each part containing five plates. There was an urgent need for Audubon to keep Havell supplied with drawings; if he failed to do this the publishing rhythm would be broken and the whole enterprise would grind to a halt.

These considerations led Audubon to decide to spend another year in the United States collecting and drawing birds. As Victor was managing very well in England, he could be trusted to supervise the production of the plates. In the spring of 1833 Audubon wrote to Havell,

My youngest son and I are going on a long and tedious journey this spring and summer. I intend to visit the whole coast of Labrador into Hudson's Bay to reach Quebec by returning over land. No White Man has ever tramped the country I am about to visit, and I hope the result will prove satisfactory to all concerned ... there are *no Post Offices in this wilderness before us* – I therefore ask of you to do your best and consult my Son who is my Right Arm and hand in everything connected with the Publication.

An expedition to the shores of Labrador was something that

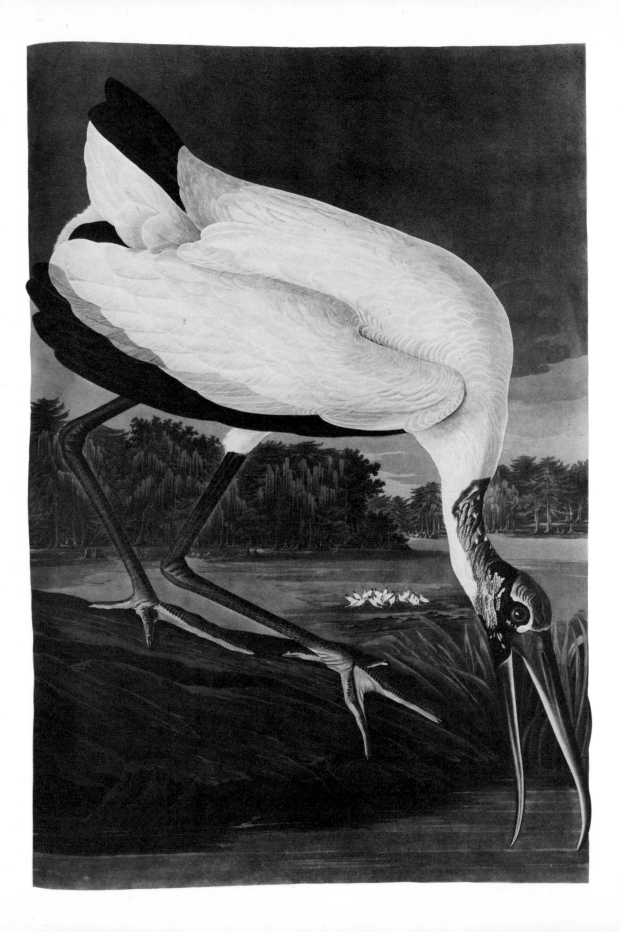

Audubon had long wanted to undertake. The object was the usual one – to procure birds and make drawings of them for the continuation of *The Birds of America*. He hoped not only to discover new birds, but also to study the summer plumage and breeding habits of water birds who spent the mild months on that wild, forbidding coast. Audubon chartered a schooner, the *Ripley*, at Eastport, Maine, and at the beginning of June he set off for Labrador taking with him a group of enthusiastic young naturalists including his son John. As usual, he was 'shockingly sea-sick, crossing that worst of all dreadful bays, the Bay of Fundy'. They sailed along the coast of Nova Scotia, to the famous Bird Rock covered with gannets which rose in clouds from the rock. 'I rubbed my eyes, took my spy-glass, and in an instant the strangest picture stood before me.' He had thought that the rock was covered with several feet of snow. 'They were birds we saw – a mass of birds of such a size as I never before cast my eyes on. The whole of my party stood astounded and amazed, and all came to the conclusion that such a sight was of itself sufficient to invite any one to come across the Gulf to view it at this season.'

After Bird Rock they passed Anticosti Island and on 18 June they reached the shores of Labrador. Audubon rose at three o'clock every morning and worked for seventeen hours on his drawings. He encouraged his son John to acquire the habit of rising early by waking him every morning at four. The party visited various little islands inhabited by puffins, razor-billed auks, guillemots and black-headed gulls, many of which Audubon put on paper. He made twenty-three large drawings on this trip, whose chief features were the cold and the mosquitoes; they had collected about two hundred bird skins and a few small mammals, but very few new species of birds: 'Seldom in my life have I left a country with as little regret as I do Labrador.' However, he wrote in his Episodes some splendid descriptions of the 'wonderful dreariness' of the country.

Thus ended Audubon's trip to Labrador. The long hours spent drawing caused at times a kind of paralysis to creep into his neck, shoulders and fingers. 'The young men think my

Wood ibis, Plate CCXVI from *The Birds of America*. The landscape is that of the West Feliciana area. 'Through the dim light your eye catches a glimpse of the white-plumaged birds,' wrote Audubon, 'moving rapidly like spectres....'

183

fatigue is added to by the fact that I often work in wet clothes, but I have done that all my life with no ill effects. No! no! it is that I am no longer young [he was forty-eight].' The 'young men' apparently enjoyed the experience more than he had. Audubon was gradually turning into a national institution; government schooners had been placed at his disposal and his journeys began to take on the character of scientific voyages of discovery for the greater glory of America. The newspapers of Philadelphia and Boston were pleased to speak of him as a returning hero, and the *Boston Patriot* said:

We believe that there is no one who will not be gratified to learn the progress of his arduous and unremitted labours in a branch of science which he has made peculiarly his own; and he has kindly favoured us with information on the subject of his recent tour, which we are glad to lay before our readers; regretting only that we are unable to present it in his own rich and animated language, and to invest it with the attractions which it would derive from his own descriptive powers.

The aspect of science which Audubon had made 'peculiarly his own' was a whimsical, semi-literate way of writing about nature; so steeped was his whole being in the phenomena of the outdoor world, that animal similes and metaphors were scattered throughout his letters and diaries. The frail Earl of Morton, whose large carriage lined with purple morocco had conveyed Audubon from his Edinburgh lodgings to the great house at Dalmahoy, was 'weaker than a newly hatched Partridge'; in London he felt 'dull as a beetle'; in Oxford, Dr John Kidd, Professor of Chemistry and Medicine, helped him look for subscribers: 'He and I ran after each other all day like the Red-headed Woodpeckers in the spring.' As he waited in Liverpool for the Rathbones to pronounce on the merits of his drawings, he was 'panting like a winged pheasant'. His writings abound in such vivid similes.

In the *Ornithological Biography* MacGillivray managed to rid Audubon's text of much hyperbole and rhetoric and yet to bring out, probably better than Audubon could himself, the freshness and immediacy of its appeal. Many passages from the

URIA BRÜNNICHII

Episodes have found their way into anthologies of American prose. Henry Thoreau, philosopher-countryman, mystic and author of *Walden*, found books of natural history the best form of winter reading. In 1842 he wrote:

> I read in Audubon with a thrill of delight when the snow covers the ground, of the magnolia, and the Florida keys, and their warm sea-breezes; of the fence-rail, and the cotton tree, and the migrations of the rice bird; of the breaking-up of winter in Labrador, and the melting of the snow on the forts of the Missouri, and owe an accession of health to these reminiscences of luxuriant nature.

The Labrador expedition over, Audubon made his way to Charleston to see his friend John Bachman. He spent the winter of 1833–4 as his guest. 'Here under the roof of our good Friend John Bachman we are all comfortable and employed in writing, drawing, music, reading, and conversing from the moment we raise in the morning until we retire to rest.' They

Brünnich's murre (thick-billed murre), Plate CCXLV from *The Birds of America*. Audubon was sent this specimen packed in ice, which perhaps explains its unusually stiff and un-lifelike posture.

185

conducted experiments to support Audubon's contention, under attack by 'Watterton' and Ord, that the turkey buzzard and carrion crow are led to their food by sight rather than by smell. The smelling powers of the vulture were threatening to become as vexed a question as the tree-climbing powers of the rattlesnake. Audubon wrote to Victor in London, saying that,

the moment is at hand when these Scoundrels will be glad to find some hiding place to resort to, and to wait for time to obliterate their obvious Jealousy and falsehoods ... depend upon it, from next Wednesday the American World will know that – Turkey Buzzards are first gregarious as well as the Carrion Crows – that they eat fresh meat in preference to Putrid stuff – that they eat birds newly killed, either plucked or not, *even of their own Species* – that they suck Birds' eggs and devour their callow young – that they come to their food by

ABOVE Tufted auk (tufted puffin), Plate CCXLIX from *The Birds of America*. The original watercolour was executed in Britain in 1834 or 1835.

OPPOSITE Arctic tern, Plate CCL from *The Birds of America*. Audubon made the original painting for this plate on his way to Labrador in 1833.

187

their sense of sight and not by that of smell – and lastly that they cannot discover by any sense of smell, the most putrid of matters, even when this putrid substance is within a few feet from them and *out of their bright eyes*!

Charleston was at this period one of the most vigorous and enlightened centres of natural history in the United States. From the middle of the eighteenth century, when this exquisite coastal town was Mark Catesby's base for the preparation of his great book *Natural History of Carolina*, Charleston was the home of many physician-naturalists at a time when the study of natural history, particularly botany, was intimately linked to that of medicine. Bachman was a friend of all the Charleston physicians and naturalists, and all, in their turn, gave unstinted support to Audubon. He and Bachman were, in their joint publication *Viviparous Quadrupeds of North America* (1845–8), to add another classic to the important books on natural history appearing in Charleston at this time. (Viviparous means bringing forth young in a live state.) Some of the others were on snakes, fungi and fishes. Audubon said, 'It is impossible to do justice to the generous feelings of the Charlestonians, or to their extreme kindness towards me.' As an expression of his gratitude he had the plate of the long-billed curlew (Plate CCXXXI) adorned with a view of Charleston and Fort Sumter. (See title-page).

In May 1834 Audubon was back in England. In London he saw Victor once more. He was delighted with his son, who had managed things admirably in his absence and who 'speaks now French, German, Spanish and English. – Paints pretty well and adds can *scrape* God bless the King on the Violin. – On the Piano he executed well several years ago and has not given up studying. – With all this his whole expenses per annum do not exceed one thousand Dollars! If he is not a man fit for any fair maid my name is not John J.A.!'

In Charleston Audubon had made considerable progress with the text of the second volume of *Ornithological Biography*. He continued in the chatty, personal, idiosyncratic style of the first volume, taking his readers into his confidence about the

OPPOSITE
American crow (common crow), Plate CLVI from *The Birds of America*. Lehman and Audubon collaborated on the background – a black walnut tree with, below, a humming-bird's nest.

vicissitudes of his life. He described in the introduction his arduous efforts to find subscribers in the chief cities of the country and his sadness in leaving Edinburgh. 'The fair city gradually faded from my sight, and, as I crossed the dreary heaths of the Lammermoor, the mental prospect became clouded.' He disliked the lonely trudge from town to town, opening up his portfolio to sceptical and indifferent eyes – but,

I waged war against my feelings, and welcomed all, who, from love of science, from taste, or from generosity, manifested an interest in the 'American Woodsman'. See him, reader, in a room crowded by visitors, holding at arm's length each of his large drawings, listening to the varied observations of the lookers on, and feel, as he now and then did, the pleasure which he experienced when some one placed his sign manual on the list.

He told them about his first and second return to the United States. 'With what pleasure did I gaze on each setting sun, as it sunk into the far distant west! With what delight did I mark the first wandering American bird that hovered over the waters!'

Least water hen (black rail), Plate CCCXLIX from *The Birds of America*.

He told them about John Bachman in Charleston and 'the lovely and interesting group that composed his family ... servants, carriages, horses, and dogs, were all at our command, and friends accompanied us to the woods and plantations, and formed parties for water excursions. Before I left Charleston, I was truly sensible of the noble and generous spirit of the hospitable Carolinians'. As for Boston, 'who that has visited that fair city, has not admired her site, her universities, her churches, her harbours, the pure morals of her people, the beautiful country around her, gladdened by the glimpses of villas, each vying with another in neatness and elegance?' All this was another way of saying that he had found several Bostonian subscribers.

Audubon also announced that he was, in consequence of many letters from his 'patrons', planning to include water birds in his third volume; the fourth volume would contain all the remaining land birds as yet discovered, although this would mean cramming several drawings on a page. In September 1834 he went to Edinburgh to continue his work with Mac-Gillivray. This dry, factual ornithologist understood precisely the nature of Audubon's appeal to the general public and he indulged in flights of promotional and editorial fantasy. He had wanted the first volume of text to be interspersed with woodcuts *à la* Bewick; if this were done,

it would spread over the land like a flock of migratory pigeons. Even without these embellishments it would fly, but were you to give it those additional wings, it would sweep along in beautiful curves, like the nighthawk or the purplebreasted swallow ... I have often thought that your stories would sell very well by themselves, and I am sure that with your celebrity, knowledge and enthusiasm, you have it in your power to become more *popular* than your glorious pictures can ever make you of themselves, they being too aristocratic and exclusive.

Waterton, Audubon's irresponsible enemy, had, as we have seen, started a little campaign to show that the illiterate Audubon could not possibly have been the author of a book distinguished by such elegance of style. MacGillivray saw his task

as that of transcribing, correcting and revising a mass of material – in Audubon's own words, 'smoothing down the asperities'. He never claimed to have done much more than this and he seemed to be perfectly satisfied with Audubon's printed acknowledgments, which, in a preface to a later volume, also referred to his execution of the anatomical descriptions and the accompanying sketches. An example of MacGillivray's 'editing' may be taken from a passage on the ruby-throated humming-bird. Audubon writes,

No sooner has the vivifying orb began to warn of spring once more the season, and caused millions of plants to spread the beauties of its benefiting rays, than the little humming bird is seen advancing on fairy wings, visiting carefully every opening calix and like an anxious florist, remove from each of them the injurious Insects that otherwise would ere long cause their beautious petals to droop and decay. – the little bird poised in the air is observed peeping cautiously and with a brilliant eye into their innermost recesses whilst the etheral motions of its pinions so rapid and so light appears to fan and cool the flower without any detriment to its once fragile texture, producing merely a delightful murmuring sound well adapted to lull the Insects to repose –

After MacGillivray's editing the passage reads,

No sooner has the returning sun again introduced the vernal season, and caused millions of plants to expand their leaves and blossoms to his genial beams, than the little Humming-bird is seen advancing on fairy wings, carefully visiting each opening flower-cup, and, like a curious florist, removing from each the injurious insects that otherwise would ere long cause their beauteous petals to droop and decay. Poised in the air, it is observed peeping cautiously, and with sparkling eye, into their innermost recesses, whilst the ethereal motions of its pinions, so rapid and so light, appear to fan and cool the flower, without injuring its fragile texture, and produce a delightful murmuring sound, well adapted for lulling the insects to repose.

OPPOSITE Ruby-throated humming-bird, Plate XLVII from *The Birds of America*. The species does not normally congregate in such large numbers, but Audubon chose to do them like that to satisfy European curiosity about these birds.

If this is a typical example of MacGillivray's 're-writing', Waterton was being unjust in denying Audubon the credit for the book's elegance of style.

PLATE 47

Ruby-throated Humming Birds. Male 1. F. 2. Young 3.
TROCHILUS COLUBRIS.
Plant Bignonia radicans
Vulgo, Trumpet Flower

Drawn from Nature and Published by John J. Audubon F.R.S.E. F.L.S. M.W.S.

Engraved by R. Havell. Junr Printed & Coloured by R. Havell Augt London

Black guillemot, Plate
CCXIX from *The Birds of
America*. The original
watercolour was painted
in Maine in 1833.

The third volume of *Ornithological Biography*, dealing with water birds, was published towards the end of 1835, almost ten years since the appearance of the first number of *The Birds of America*. Audubon expressed his satisfaction with the superior engraving and colouring of the plates in this volume and he described how much harder it was to become acquainted with the habits of water birds than with those on the land.

He who follows the feathered inhabitants of the forests and plains, however rough or tangled the paths may be, seldom fails to obtain the objects of his pursuit, provided he be of due enthusiasm and perseverance. The Land Bird flits from bush to bush, runs before you, and seldom extends its flight beyond the range of your vision. It is very different with the Water Bird, which sweeps afar over the wide ocean, hovers above the surges, or betakes itself for refuge to the inaccessible rocks on the shore. There, on the smooth sea-beach, you see the lively and active Sandpiper; on that rugged promontory the Dusky Cormorant; under the dark shade of yon cypress the Ibis and Heron; above you in the still air floats the Pelican or the Swan; while far over the angry billows scour the Fulmar and the Frigate bird. If you endeavour to approach these birds in their haunts, they betake themselves to flight, and speed to places where they are secure from your intrusion.

Audubon announced his plan to bring out both the last number of *The Birds of America* and the last volume of the text by the end of 1838. In the meantime he would undertake, with his son John, a journey into the southern and western parts of the United States 'with the view of obtaining a more accurate knowledge of the birds of those remote and scarcely inhabited regions'.

10

America, My Country

 have laboured like a cart Horse for the last thirty years on a Single Work, have been successful amost to a miracle in its publication so far, and am now thought a-a-a- (I dislike to write it, but no matter, here goes) a Great Naturalist!!!' So wrote Audubon to John Bachman. Unfortunately, many fickle English subscribers, with their restless taste for novelty, were allowing their subscriptions to lapse. 'The taste is passing for Birds like a flitting shadow – Insects, reptiles and fishes are now the rage, and these fly, swim or crawl on pages innumerable in every Bookseller's window.' Audubon was unimpressed by most of the new English publications on birds, generally because they were 'not from nature'. He was particularly contemptuous of Sir William Jardine's great compendium of natural history, *The Naturalist's Miscellany*, now prized for its hundreds of little hand-coloured plates. 'Sir Wam Jardine is published an enormous quantity of trash all compilation, and takes the undue liberty of giving *figures* from my Work and those of all others who may best suit his views. . . . You could not pass a Bookseller's shop from the extreme West

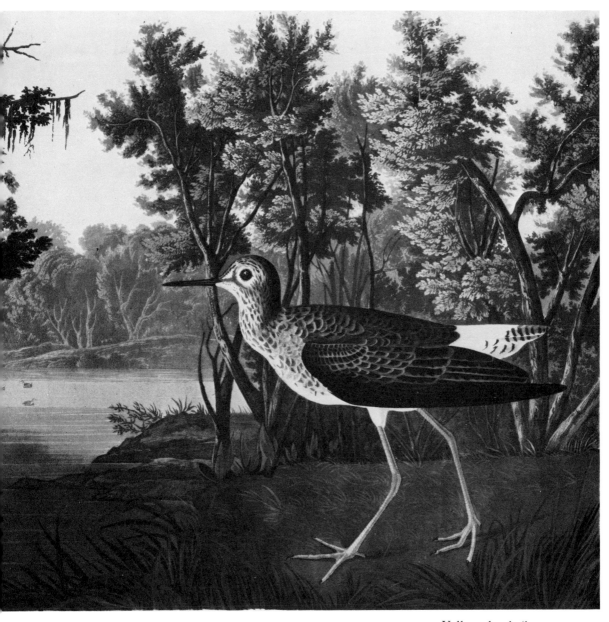

Yellow shank (lesser
yellowlegs), Plate
CCLXXXVIII from *The Birds
of America*. The South
Carolina landscape is one of
Lehman's finest; he may have
painted all of the original
watercolour in 1832.

One of a number of letters Audubon wrote to Havell, complaining about his work.

End to Wapping without seeing New books on Zoology in every window – and "at most reduced prices!" '

Before he sailed for New York in August 1836, Audubon travelled extensively in England, doing what he could to strengthen the nerves of faltering subscribers. One of these was the Marchioness of Hereford, 'who you know has had the whole of the first volume cut out and pasted on the walls of one of her Superb Rooms!' He found, understandably, the writing of his five volumes of text a tedious and unrewarding affair. Sometimes he 'swelled up' and had to put down his pen for a

198

few days. 'God preserve you,' he wrote to Bachman, 'and save you the trouble of ever publishing Books on Natural Science! For my part I would rather go without a shirt or any inexpressibles through the whole of the florida swamps in mosquito time than labour as I have hitherto done with the pen.' The reviewers were, he said, all agog for his next volume, hoping for some diatribes against Waterton and Ord. 'What shocking disappointment! Not a word is there in the whole book even in allusion to these beetles of darkness!'

'I am almost mad with the desire of publishing my 3d Vol this year – I am growing old fast and must work at a double quick time now.' This Audubon did; the third volume came out in December 1835. The effort had 'rendered me *puffy* I could scarcely breath – my appetite was gone – My digestion bad – in other Words I was attacked with dispesia as bad as ever'. As a change of activity, he took to drawing and in no time finished thirty-three drawings of American birds for the third volume of *The Birds of America*; what was more, they contained fifty-seven species not given by Wilson. He renewed his attacks on contemporary English bird books, sparing only John Gould. 'Works on the Birds of *all the World* are innumerable – Cheap as dirt and more dirty than dirt – Sir William Jardine will encumber the whole of God's creation with stuff as little like the objects of the Creator's formation as the moon is unto cheese', a simile which reminds one of his complaint to Havell of the quality of the plate of the Baltimore orioles, whose hanging nest was 'no more like my Drawing than a Chimney Sweep is to your beautiful wife'.

In London the prevailing passion for insects had brought the value of mounted birds and bird skins crashing down; at an auction Audubon bought for the equivalent of 25 cents a snowy owl which had sold for over 20 dollars a couple of months earlier. 'And all this because the World is all agog – for what? for *Bugs* the size of *Water Melons*. . . . I almost wish I could be turned into a *Beetle* myself!'

Audubon was an indefatigable correspondent and he minded very much when his letters were not answered. Bachman was

the main offender in this respect. 'Between *you* and I and the *Post* I think you extremely Lazy! Frightful – horrible – Disgraceful!' In one letter after the other he had entreated him to send some heads of Negroes and alligators (for Mac-Gillivray's purposes) and to preserve as many species of birds as possible in barrels of 'Common Whiskey'; he had kept him informed of the details of his English life – how his son John had been paid for fifty portraits and was turning out copies of Raeburns and Murillos at a furious rate; how he was going to ask Louis-Philippe, in the event of war breaking out between France and England, to issue special passports for 'Men of Science'; how Gould, the only ornithological author he tolerated ('His *Wife* makes his drawings on stone – she is a plain fine woman, and although these works are not quite up to Nature, both deserve great credit.') had sent him (Bachman) a pedigree dog; how Swainson and Bonaparte had dropped him (Audubon); how he liked to pay bills promptly, thus emulating his hero Napoleon who 'would never suffer a debt to stand unpaid, *provided* the means were snug within his exchecker'. Audubon asked him to 'procure Me if you possibly can *every Species* to be found within Twenty Miles of Charleston *in the flesh* and in Spirits . . . have Barrells or Jars, or gallipots prepared of all sorts and sizes, and in these place the specimens and then have them covered to the brim with Common Whiskey or Rum. In this manner you will procure in a fortnight of exertion *all* that South Carolina can afford'.

Audubon planned to take back with him an assorted collection of starlings, larks, wild pigeons and jays, 260 in number, with a view to their release and subsequent propagation in the United States. In addition, Lord Derby had given him two pointers and a 'Retrever' and Lord Ravensworth had promised him two 'Cockers'. Most of the birds – but not the dogs – died during the crossing. He and his son John sailed from Ports-mouth in the *Gladiator* on 2 August 1836 and arrived in New York thirty-three days later. Havell had by this time engraved half the plates for the fourth and last volume of *The Birds of America*. Audubon wanted the remaining odd fifty plates to

show some of the hitherto undiscovered species from the Far West. The ornithologists Nuttall and Townsend were looking for new birds on the west coast; they had explored the Columbia River in California and sent from there new specimens to the Philadelphia Academy of Natural Sciences. Audubon was most anxious to look at these birds and then portray them. Knowing the members of that body, he wrote to Bachman saying that he had some doubts whether 'these Gents will allow me to do so'. His fears were justified. The Academy permitted him a brief look at the birds, but he was refused permission to draw them. This was tantalizing; he now felt too old and tired to undertake an expedition to the west, which was in any case no longer necessary, as the birds had come east. After seeing them, he reported to Bachman that the collection consisted of 'about forty new species of birds, and its value cannot be described'.

Audubon did not, as he might have done in the past, lose his

John Gould painted many exotic birds of the Far East, but always from stuffed specimens which lacked the lifelike qualities of Audubon's freshly killed and expertly wired models.

201

temper at the Academy's refusal to let him draw the Nuttall and Townsend specimens. In Boston he met Thomas Nuttall himself, who had returned from his Californian expedition, leaving Townsend behind him. Nuttall, a Yorkshireman, had emigrated to the United States as a young man; he became noted for his botanical explorations in various parts of America and he was the author of several excellent works on trees and plants. He sympathized with Audubon in his difficulties with 'the *soi-disant* friends of science, who objected to my seeing, much less portraying and describing those valuable relics of birds, many of which had not been introduced into our Fauna'. In the end it was settled that Audubon should buy duplicates of these specimens, as we learn from a jubilant letter to Bachman.

Now Good Friend open your Eyes! aye open them tight!! Nay place specks on your probosis if you chuse! Read aloud!! quite aloud!!! – I have purchased *Ninety Three Bird* Skins! Yes 93 Bird Skins! Well what are they? Why nought less than 93 Bird Skins sent from the Rocky Mountains and the Columbia River by Nuttall and Townsend! – Cheap as Dirt too – only one hundred and Eighty Four Dollars for the whole of these, and hang me if you do not echo my saying so when *you see them*!! Such beauties! such rarities! Such novelties! Ah my Worthy Friend how we will laugh and talk over them!

Having got all the skins he wanted, Audubon turned his thoughts towards his next American tour. He went to Washington to discuss with government officials what assistance he might expect for an expedition which would take him along the west coast of Florida and the Gulf of Mexico, as far as Galveston in Texas. 'My objects in view are to procure the use of a Revenue Cutter, (Robt Day Commander) to navigate us along the Gulph of Mexico, and ransack its different Bays, Bayous and Harbours.' Unfortunately, the war then raging between the Seminole Indians and the citizens of Florida was claiming every cutter; no government ships would be available until the war was over. In Washington Audubon lunched with Andrew Jackson, whose second term as President was about to come to an end. 'I sat close to him; we spoke of olden times, and

touched slightly on politics. . . . The dinner was what might be called plain and substantial in England; I dined from a fine young turkey shot within twenty miles of Washington. The general drank no wine, but his health was drunk by us more than once; and he ate very moderately, his last dish consisting of bread and milk.'

It was arranged that a boat would be sent to Charleston to pick up Audubon and his party, of which Edward Harris was to be a member, when the crisis in Florida was over. He therefore returned to Charleston, where he spent the winter of 1836–7 drawing the famous Nuttall–Townsend specimens and planning with Bachman their joint book on American quadrupeds. Audubon did not live to see the completion of this important and standard work on American mammalogy, which was to occupy most of his energy when his labours on *The Birds of America* and *Ornithological Biography* came to an end in 1838–9. Of the one hundred and fifty-five plates, about half were from drawings by Audubon himself and the rest by his son John Woodhouse Audubon.

By the spring of 1837 the government vessel had not arrived at Charleston. Audubon, therefore, with Edward Harris and John, went overland to New Orleans. They travelled by rail as far as Augusta, Georgia, a novel form of transportation which much appealed to Audubon. The Florida War ended with the surrender of Osseola (Rising Sun) and his final three hundred warriors and at Pensacola, on the Mexican Gulf, Audubon learned that the revenue cutter *Campbell* was at his disposal in New Orleans. At the beginning of April 1837 they sailed from New Orleans accompanied by the *Crusader*, a twelve-ton government schooner with four guns or 'grunters' – to protect them against any interference from Mexican ships. The expedition was provisioned for two months.

On the way to New Orleans Audubon had seen some of the grim consequences of the government victory over the Florida Indians. He saw a hundred Creek warriors

confined in Irons, preparatory to leaving for ever the Land of their

PLATE CCCCXXIV

Drawn from Nature by J. J. Audubon F.R.S. F.L.S.

Engraved, Printed and Coloured by Robt. Havell, 1838

Lazuli Finch.
FRINGILLA AMŒNA, Say.
1. Female

Crimson necked Bull finch.
PYRRHULA FRONTALIS, Bonap.
2. Male

Grey crowned Linnet.
LINARIA TEPHROCOTIS, Swains.
3. Male

Cow pen Bird.
ICTERUS PECORIS, Bonap.
4. Young Male

Evening Grosbeak.
FRINGILLA VESPERTINA, Cooper.
5. Female. 6. Young Male

Brown Longspur.
PLECTROPHANES TOWNSENDI, Aud.
7. Female

births! Some miles onward we overtook about two thousand of these once free owners of the Forest, marching towards this place under an escort of Rangers, and militia mounted Men, destined for distant lands, unknown to them, and where alas, their future and latter days must be spent in the deepest of Sorrows, afliction and perhaps even phisical want. This view produced on my mind an aflicting series of reflections more powerfully felt than easy of description – the numerous groups of Warriors, of half clad females and of naked babes, trudging through the mire under the residue of their every scanty stock of Camp furniture, and household utensiles – The evident regret expressed in the marked countenance of some and the tears of others – the howlings of their numerous dogs, and the cool demeanour of the chiefs, – all formed such a Picture as I hope I will never again witness in reality – had Victor been with us, ample would have been his means to paint Indians in sorrow –

The expedition arrived at Galveston Bay in the infant Republic of Texas at the end of April 1837. The President of Texas, General Sam Houston, had won its independence not many weeks earlier by defeating the Mexican general, Santa Ana, at San Jacinto. Audubon and his companions had spent most of their time fishing, shooting, skinning birds and animals and dropping them into barrels of rum – now, in his view, the best preservative. He wrote to MacGillivray,

Ah, my dear friend, would that you were here just now to see the Snipes innumerable, the Blackbirds, the Gallinules, and the Curlews that surround us; – that you could listen as I now do, to the delightful notes of the Mocking-bird, pouring forth his soul in melody as the glorious orb of day is fast descending towards the western horizon; – that you could gaze on the Great Herons which, after spreading their broad wings, croak aloud as if doubtful regarding the purpose of our visit to these shores!

After a couple of days spent exploring Galveston Island for birds and animals, they left for Houston, the temporary capital of the short-lived republic. Sam Houston had agreed to receive them in the President's mansion, a two-room log hut. Audubon had earlier seen him, a tall, strong man wearing a large grey hat, walk from the Capitol, as yet without a roof, to his

Plate CCCCXXIV from *The Birds of America*, one of the late, composite plates, showing a variety of finches and buntings. The top figure, a male house finch, was based on a specimen that belonged to John Gould.

205

mansion: 'I observed a scowl in the expression of his eyes that was forbidding and disagreeable.' Houston received them cordially; he wore a fancy velvet coat and trousers trimmed in broad gold lace. They drank grog together and Audubon toasted the new republic.

Thus ended Audubon's third American tour. He had found it very exhausting and had lost twelve pounds in weight. He was reasonably satisfied with the results; they found no new species but learned much about the habits of birds west of the Mississippi: 'I feel myself now tolerably competent to give an essay on the geographical distribution of the feathered tribes of our dear country.'

On returning to Charleston, John Woodhouse married Maria Rebecca, the eldest of the nine Bachman children. His brother Victor was, two years later, to marry Eliza, another daughter. Both wives were delicate and died shortly after their marriages. Neither husband, however, pined for long and each found a new wife after a few months of widowhood.

Audubon returned to England in the summer of 1837. 'London is Just as I left it, a Vast Artificial area, as well covered with humbug, as are our Pine Lands and old fields with Broom grass.' MacGillivray had just published the first volume of his book on British birds; the critics attacked his 'misplaced quaintness of expression', attributing it to an attempt to imitate the styles of Izaak Walton and Audubon which 'being extremely peculiar, can only be relished in the originals'. MacGillivray was obviously hopelessly enmeshed in the seductive coils of Audubonian prose.

Audubon learned that more English subscriptions had been discontinued in his absence and that many of those who were still receiving their numbers of *The Birds of America* did not wish the series to exceed the eighty numbers originally announced in his prospectus. What was he to do? A second collection of new birds had arrived from Townsend, despite the protestations of certain 'enlightened' persons in Philadelphia. 'What! said I, shall the last volume of the *Birds of America* be now closed, at a time when new species are in my hands? No!' In spite of

cramming several different kinds of birds on to composite plates and omitting eggs, which he had hoped to include, Audubon was compelled to add seven further parts, bringing the number of plates up to 435, representing 489 different species of American birds. When the eightieth number of *The Birds of America* appeared at the end of 1837, many important birds – duck, swans, terns, flamingos, grouse, warblers and woodpeckers – had not been included, for want of official recognition. Hence the need to introduce thirty-five composite plates.

The glorious work was completed on 20 June 1838, the year after Queen Victoria's accession to the throne. On that day the last plate of *The Birds of America* was printed. 'An immediate weight from off my shoulders,' wrote Audubon, 'and a great relief to my ever fidgety and anxious mind respecting this immense undertaking.' Audubon's moment of triumph had arrived, even if the number of subscribers was far below that which he had at first envisaged. When he published, in May 1839, the fifth and final volume of *Ornithological Biography*, the American subscribers exceeded the European ones (he did not include those who had dropped out); there were eighty-two of the former and seventy-nine of the latter – 161 in all. Since the autumn of 1826, when the first plates of *The Birds of America* were in the press, to the summer of 1838, Audubon had spent $115,640 (£28,910) on the publication. 'I doubt if any other *Family* with our pecuniary means will ever raise for themselves such a *Monument* as "the Birds of America" is over their tomb!', wrote Audubon.

Robert Havell's work was now done. He had made up his mind some time before that he would emigrate to the United States. His many years of collaboration with the 'American woodsman' must have had their effect on him. He now decided to dispose of his stock and break up his successful printing and engraving establishment. Audubon, knowing his occasional carelessness in practical matters, was most concerned about the fate of what he called 'the coppers' – the original copper plates of *The Birds of America*, which were also to cross the

Atlantic; and not only the 'coppers', but also his prints, drawings and books. Havell, for all his brilliance as an aquatinter and colourist, sometimes slipped up severely on the routine business side; on several occasions his 'idle rascals' sent subscribers a number containing five copies of the same plate. Havell put off his departure for the United States so often that Audubon wrote him saying, 'I should not be surprised if my Work on the quadrupeds of America, published in my own country may not be out and finished before I meet with you fishing or shooting or resting beneath the shade of some lofty tree in my Native Land.'

Havell finally set off for America, landing in New York towards the end of 1839. He was forty-six and looking for new outlets for his undoubted talents as craftsman and artist. He lived at first at Ossining and later at Tarrytown, both small towns north of New York on the Hudson River, which he loved and sketched and painted. He painted many views of this broad, majestic river and, in 1878, aged eighty-five, he died propped up in bed gazing at it.

The completion of *The Birds of America* did not have the same

View of the Hudson from Tarrytown Heights, by Robert Havell.

liberating effect upon Audubon. He still had the fourth and fifth volumes of *Ornithological Biography* to bring out before he could consider returning to his 'native country'. With the publication of the fifth volume in May 1839 his European life and labours came to an end. His final preface abounded with quaintness, exuberance and intimacies about his life: 'How often, Good Reader, have I longed to see the day on which my labours should be brought to an end!' He told how, as he lay in the deepest recesses of the western forests, he had had hallucinations of danger, sickness and poverty and he was at times tempted to throw away his pencils and his drawings, abandon his journals and return to the world.

At other times, the Red Indian, erect and bold, tortured my ears with horrible yells, and threatened to put an end to my existence; or white-skinned murderers aimed their rifles at me. Snakes, loathsome and venomous, entwined my limbs, while vultures, lean and ravenous, looked on with impatience. Once, too, I dreamed, when asleep on a sand-bar on one of the Florida Keys, that a huge shark had me in his jaws, and was dragging me into the deep.

Later he went on to say, 'You may well imagine how happy I am at this moment, when . . . I find my journeys all finished, my anxieties vanished, my mission accomplished.'

His great work accomplished, Audubon returned to the United States in the summer of 1839. He was fifty-four years old. He had hardly arrived in New York before he issued a Prospectus of two new ventures: a 'miniature' or octavo edition of *The Birds of America*, and the *Quadrupeds of North America*. Shortly before he left Edinburgh, an optician, Dr David Brewster, had told him that the *camera lucida* would save much time and work in the drawing and outlining of birds; by means of a prism, it reduced in size the pictures of the original edition and projected them on to a flat surface, on which they could be traced. Audubon adopted this method for the 'miniature' edition.

The 'miniature' edition was a bestseller; it surpassed all records in the sale of books on natural history. Both the author and his Double Elephant Folio had passed into the realm of

Minnie's Land, the house on the Hudson River which Audubon bought when he had become famous.

legend and there was a stampede to buy a book containing all the famous original illustrations, although reduced in size, and the text of *Ornithological Biography* which, to many of Audubon's admirers, read like a thrilling adventure tale. The new edition was issued in a hundred parts, of five plates each, to be bound in seven volumes; the parts appeared on the first and fifteenth of every month and cost one dollar. The complete work cost therefore $100 – which was 10 per cent of the cost of the Double Elephant Folio.

Audubon's success in finding subscribers was such that he feared the profit would have a corrupting effect on his children. Lucy was talking about sales of five thousand rather than of two thousand, which was Audubon's target. 'It would prove too much for the sake of our Dearest beloved Children, all of whom I ever will Wish to be Industrious and Honest, and not Droves wallowing in Wealth and useless to their own kind if not so to their own Family Circles. No, no! 2000 subscribers for Instance, provided they are all good and true will suffice for us all. . . .'

With his new wealth Audubon bought about thirty-five acres of land on the Hudson River in Carmansville, later known as Washington Heights and now part of New York City. It extended from the present 155th to 158th Streets and reached, on the eastern side, what is now Amsterdam Avenue. The property was bought in the name of Lucy and it became known as Minnie's Land, since her sons always called her by the Scottish 'Minnie', for mother. On this land Audubon built a simple, spacious wooden house with a high portico running the length of the side which faced the Hudson River; it stood in a group of elms and oaks and, difficult as it is to believe nowadays, the encircling wood resounded with the song of birds. Deer, elk, moose, bears, wolves, foxes and smaller animals were kept in special enclosures. Audubon was becoming quadruped-minded; the incomparable bird artist was turning to the portrayal of American animals. His style, and that of his sons, was to be cramped by the need to draw so many different species of small rodents. In dozens of letters which he wrote in

1841 and 1842 he entreated correspondents to send him speci-
mens, preserved in 'good Yankee rum', of bats, wood rats,
mice, moles, weasels, shrews, squirrels, hares and rabbits.
Before immersing them, 'the larger kinds can be skinned,
preserving the skull entire, and also the legbone and the
clavicles. One fore and one hind foot ought to be pinned on a
board or cork until perfectly dried, and actual measurements
and weights forwarded with the specimens ... young and old
are wanted.'

In his new home on Minnie's Land Audubon worked four-
teen hours a day on the *Quadrupeds*; wherever possible he drew
the weasels, shrews, field mice and other small mammals life-
size. When visitors called, he received them in his work-room;
its walls were covered with elks' antlers, part of the floor with
the skin of an American panther; in one corner was an easel; on
the chimneypiece were many stuffed birds and across one end
of the room ran a long table covered with folios, sketches and
artist's materials. In the year 1842 Audubon, aged fifty-seven,
had white locks which fell in clusters about his shoulders; his
eyes were now dark grey and restless and his aquiline nose and
tightly shut mouth gave the impression of an imperial eagle.

The Viviparous Quadrupeds of North America (1845–8) was issued
to subscribers in thirty parts of five plates each, at $10 a part or
$300 in all. These were to be bound into two volumes; unlike
The Birds of America, the plates of *Quadrupeds* were printed by
lithography and later coloured by hand; their size was 22×28
inches (Imperial Folio). It is thought that seventy-six of the
original drawings were by Audubon and the remaining
seventy-four by his son John Woodhouse, assisted by Victor
Gifford. (The size of the plates of *The Birds of America* was
$29\frac{1}{2}$×$39\frac{1}{2}$ inches.)

John Bachman, who was to write the text of *Quadrupeds*, did
not think Audubon had given enough attention to the prob-
lems posed by this new publication. He feared that, after the
triumphant completion of *The Birds of America*, he felt confident
enough to tackle a work about quadrupeds without bothering
to study them individually. 'Don't flatter yourself that the

quadrupeds will be child's play. I have studied them all my life. The skulls and the teeth must be studied, and colour is as variable as the wind; down, down in the earth they grovel, while we, in digging and studying, may grow old and cross. Our work must be thorough.' Bachman warned Audubon that he would find few books to help him and that he would have to undertake long journeys in search of quadrupeds. 'You will be bothered with the Wolves and the Foxes, to begin with ... the Western Deer are no joke, and the ever varying Squirrels seem sent by Satan himself, to puzzle the Naturalist.'

These warnings had a mildly chastening effect. Audubon agreed that the publication would be

fraught with difficulties innumerable, but I *trust* not insurmountable, provided We Join our Names together, and you push your able and broad shoulders to the Wheel, I promise to you that I will give the very best figures of all our quadrupeds that ever have been thought of or expected, and that you and I can relate the greatest amount of *Truths* that to this time has appeared connected with their dark and hitherto misunderstood histories! ... Only think of the quadrupeds of America being presented to the World of Science, by Audubon and Bachman; ... one of the very best D.D.'s and ... the only American living F.R.S.L.! [Fellow of the Royal Society of London].

In March 1843 Audubon obeyed Bachman's injunction to 'undertake a long journey'. He started on his eight-month journey up the Missouri River with his old friend Edward Harris; Isaac Sprague, a young artist following in the steps of Mason and Lehman; John G. Bell, a taxidermist; and Lewis Squires, a general factotum. The expedition was, Audubon pointed out, 'undertaken solely for the sake of our work on the Quadrupeds of North America'. His *Missouri River Journals* were discovered by his granddaughters in the back of an old secretaire in 1896. He had done his very best to persuade his young disciple Spencer Fullerton Baird, later the greatest American ornithologist of his time, to join the Missouri expedition. But this was not to be. Baird followed the progress of the expedition from accounts in the newspapers. Audubon was quickly on his way to becoming, in his somewhat premature

OPPOSITE ABOVE Polar bear, a plate from *Quadrupeds* after a watercolour by John Woodhouse Audubon.

OPPOSITE BELOW Prairie dog, one of the selection of small mammals which Audubon himself produced for *Quadrupeds*.

On Stone by Wm E. Hitchcock

Drawn from Nature by J W Audubon

Polar Bear

Lith Printed & Col.d by J T Bowen, Phil.a

On Stone by Wm E Hitchcock

Drawn from Nature by J.J Audubon. F.R.S.F.L.S

Prairie Dog. Prairie Marmot Squirrel

Lith Printed & Col.d by J T Bowen, Phil.a

An old photograph of Audubon's granddaughters, with John Woodhouse Audubon's famous portrait of his father over the mantelpiece.

old age, the adviser to young scientists and a revered and adored sage.

Although Lucy and his sons thought him too old for this arduous journey (his family believed him to be thirteen years older than he really was), Audubon's heart was set on going farther west; his only direct knowledge of bird life in and beyond the Rocky Mountains was based on the Nuttall–Townsend skins. Apart from collecting quadrupeds, he wanted to find new species for the additional plates in the 'miniature' edition of *The Birds of America*. In September 1842 he had been on a quick canvassing tour of Canada, visiting, amongst other places, Montreal and Quebec, and covering 1,500 miles. The comforts of Minnie's Land, its varied bird and animal life and the expanding orchard – Audubon had planted two hundred fruit trees, which included pears, 'aples', quinces, apricots, vines and nectarines – were unable to detain the restless

214

naturalist, who appeared to have a premonition that this would be his last important journey.

The party travelled to St Louis in a steamer belonging to the American Fur Company, 'the very filthiest of all filthy old rat-traps I ever travelled in'. He described his *compagnons de voyage*, a motley crowd of trappers of different nationalities, as 'Buckeyes, Wolverines, Suckers, Hoosiers, and gamblers, with drunkards of each and every denomination, their ladies and babies of the same nature, and specifically the dirtiest of the dirty'. The detailed journal which he kept during these eight months abounded in vivid and fascinating descriptions of life in military outposts and pioneers' settlements, and of game animals in the wilderness – the noblest being, of course, the buffalo. His first experience of 'Buffalo country' was at the mouth of the James River (Jacques, as he called it), the largest river entering the Missouri and coming from the north through South Dakota. A herd of fifty galloped away upon seeing the steamboat; the prairies had been thoroughly trampled by them and the trees and bushes were covered with their hair. He thought the buffaloes looked poor and shabby and he regretted not staying longer on shore to 'make havoc' with them – 'but we shall have enough of that sport ere long'. They were soon drawing, skinning and pickling the heads of buffalo calves. He gave horrifying accounts of the ravages caused by smallpox amongst the Indian tribes of the Riccarees, Mandans, Sioux and Blackfeet. Chiefs, dressed in all their finery, stepped into their graves, rather than let their bodies be seen disintegrating. Before doing so, they often killed their wives and children.

Audubon's opinion of the Indians changed for the worse during this trip. He was put off by seeing them eat the putrid flesh of drowned buffaloes. He ridiculed George Catlin, the famous painter and panegyrist of Indian life, for his romantic accounts of Indians, 'How very different they must have been from any that I have seen!' In the old days in Kentucky Audubon delighted to dwell on the good looks and noble bearing of the Indians. But no longer; the ones he now came

Lucy Audubon in old age.

Oil painting of an Indian, *Keokuk*, by George Catlin.

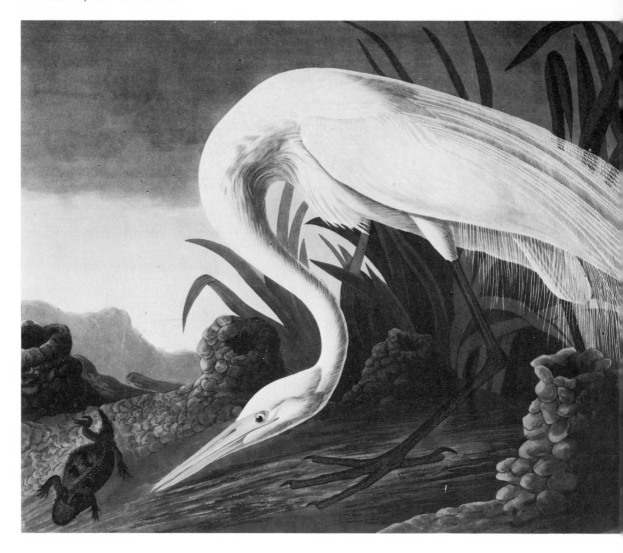

White heron (common
egret), Plate CCCLXXXVI
from *The Birds of America*.

across were 'miserably poor, filthy beyond description, and
their black faces and foully smelling Buffalo robes made them
appear to be like so many devils'.

It was not long before Audubon was able to 'make havoc'
with buffaloes; he took part in a buffalo hunt. This experience
brought about in him a change of heart. After killing his first
bull, he cut off the brush of the tail and stuck it in his hat. Other
members of the party broke open the head of Audubon's bull
and ate the brains, raw and warm. He began to be shocked
by the wantonness of the buffalo slaughter. 'What a terrible

destruction of life, as it were for nothing, or next to it, as the tongues only were brought in, and the flesh of these fine animals was left to beasts and birds of prey, or to rot on the spots where they fell.' He saw that the senseless destruction of buffaloes could lead to their extinction. 'Immense numbers are murdered almost daily on these boundless wastes called prairies. . . . This cannot last . . . before many years the Buffalo, like the Great Auk, will have disappeared; surely this should not be permitted.' But these grave thoughts did not deter him from hunting buffaloes. He described the noisiness of the prairies: 'Wolves howling and bulls roaring, just like the long continued roll of a hundred drums . . . thousands upon thousands of Buffaloes; the roaring of these animals ressembles the grunting of hogs, with a rolling sound from the throat . . . buffaloes all over the bars and prairies, and many swimming; the roaring can be heard for miles!'

In November 1843 Audubon was back at Minnie's Land, having grown a long, patriarchal, white beard. Some of the enormous number of animals which they had killed were brought back in barrels of 'Common rum' – prairie dogs and wolves, grizzly bears, marmots, foxes, elks, calabashes, otters, mountain rams and antelopes. They also had seventeen species of birds for the 'miniature' edition of *The Birds of America*. He had still not attained his goal, the Rocky Mountains, but he had thoroughly explored the region of the Upper Missouri and Yellowstone Rivers, then little known.

In 1848 Audubon's powers began to fail. He had spent the two previous years drawing the specimens which he had collected on the Missouri River expedition. Some of the parts, each with five large plates, had come out as early as 1842. Audubon only lived to see the first three volumes of text (1846–54). The 'miniature', composite edition of *Quadrupeds* was published by his son Victor in 1854. Bachman said later, 'I wrote every line which composed the latter volumes of the *Quadrupeds*.' This is not strictly true; the last two volumes owe a great deal to John Woodhouse and to all the papers and memoranda which Audubon left behind. At the end of 1845

Engraving of Audubon which accompanied an obituary of him in a French newspaper.

Bachman nearly despaired of Audubon as a collaborator, and was on the point of giving up work on *Quadrupeds*. He complained that Audubon had kept none of his promises to supply him with material (skins and notes) for the text descriptions. All that interested him was getting the plates engraved. 'On many of the Quadrupeds,' Bachman wrote, 'he has not sent me one line and on others he has omitted even the geographical range – I know nothing of what he did in the West having never received his journal and not twenty lines on the subject. I am to write a book without the information he promised to give – without books of reference and above all what is a *sine qua non* to me without specimens.' After these remonstrances, Audubon kept him better supplied.

Bachman would have preferred Audubon to have brought back from the Missouri expedition fewer parts of buffaloes, elk and bighorn and more 'little Marmots, Squirrels and Jumping Mice'. But when Bachman saw, in the spring of 1844, Audubon's new lithographs, his disappointment vanished: 'They are most beautiful and perfect specimens of the art. I doubt whether there is anything in the world of Natural History like them. I do not believe that there is any man living that can equal them.' If Audubon's prose was sometimes full of blarney, his brush, said Bachman, was always 'a truth teller'. In the *Quadrupeds* Audubon concentrated on drawing small rodents – rabbits, marmots, squirrels and so on – and he left the larger mammals to his son John. It is difficult to tell which of these charming drawings, which capture both the animation and the stillness of the animals in the wild, are by father and which by son.

In 1847 Audubon's mind began to fail. Bachman called one day. 'Alas, my poor friend Audubon! The outlines of his beautiful face and form are there, but his noble mind is all in ruins. It is indescribably sad.' He could no longer draw or paint, although his far sight was as good as ever. People saw a tall figure with snow-white hair wandering along the banks of the Hudson – sometimes alone, sometimes led by a servant. He died on 27 January 1851.

218

BIBLIOGRAPHY

AUDUBON, John James. *The Birds of America*. Double elephant folio, London, 1827–38.
 Orithological Biography. 5 volumes, royal octavo, Edinburgh, 1831–9.
 The Birds of America. 'Miniature' edition, 7 volumes, royal octavo, New York and Philadelphia, 1840–4.
and BACHMAN, Rev. John. *The Viviparous Quadrupeds of North America*. 2 volumes of 150 plates, imperial folio, New York, 1845–8.
 The Vivaparous Quadrupeds of North America. 3 volumes (text only), New York, 1846–54.
 The Quadrupeds of North America. 'Miniature' edition, 3 volumes, royal octavo, New York, 1854.

ADAMS, A. B. *John James Audubon*. London, 1967.
ARTHUR, S. C. *Audubon: an Intimate Life of the American Woodsman*. New Orleans, 1937.
AUDUBON, MARIA. *Audubon and his Journals*. 2 vols, London, 1898.
BUCHANAN, R. W. *The Life and Adventures of John James Audubon*. London, 1868.
CORNING, HOWARD (editor). *Letters of John James Audubon 1826–1840*. 2 vols, Boston, 1930.
—— *Journal of John James Audubon made during his Trip to New Orleans in 1820–1821*. Boston, 1929.
FRIES, W. *The Double Elephant Folio*. Chicago, 1973.
HERRICK, F. H. *Audubon the Naturalist*. New York, 1938.
ST JOHN, MRS HORACE. *Audubon, the Naturalist of the New World*. Boston, 1856.

ACKNOWLEDGMENTS

The illustrations in this book appear by kind permission of the following museums, agencies and individuals. References to colour illustrations are printed in *italics*.

American Museum of Natural History, New York: 6, 9, 29, 36–7, 39, *51*, 75 left, 76, 87, 100 above, 118, 121, *129*, 214
Photographed from *Audubon by Himself*, published by the American Museum of Natural History: 91 (reproduced by courtesy of Charles Scribner's Sons), 100 below, 116–17 (Smithsonian Institution)
Photographed from *Audubon the Naturalist* by Francis H. Herrick: 12–13, 72, 75 right, 86, 116
British Museum, London (Natural History): 4, 46, 57, 64–5, 83, 102, 128, 137, 143, 145, 151, 162, 168, 170, 173, 175 right, 182, 185, 186, 187, 188, 190, 193, 197, 204, 216–17, endpapers
Christie, Manson and Wood, London: 2–3, 23, 68, 99, 198, 201
Cooper-Bridgeman Library, London: *158*, 213 above, 213 below
Mary Evans Picture Library, London: 20, 58, 94, 95, 126, 164
Historical Society of Pennsylvania: 38
Collections of the Library of Congress: 17
Mansell Collection, London: 84, 120, 127, 218
Maryland Historical Society: 15
Montgomery County Tourist Bureau, Court House, Norristown, Pennsylvania: 24
Musée des Beaux Arts, Rheims: 31
Musée Carnavalet, Paris: 25
Museum of Fine Arts, Boston (M. and M. Karolik Collection): 42, 107
National Gallery of Art, Washington DC: 69
New York Historical Society: 11, 34–5, *49*, *50*, *52*, 54, 62, 77, *78–9*, *80*, 109, 112, *130*, *131*, *132*, 139, 154, 155, *158*, *160*, 169, 175 left, 178, 194–5, 208, 210, 215 above
Science Museum, London: 165
The George Walter Vincent Smith Art Museum, Springfield, Massachusetts: 44–5
Smithsonian Institution: 215 below (United States National Museum, on deposit with the National Collection of Fine Arts)
Victoria and Albert Museum, London: 115 (Cooper-Bridgeman Library), 146, *159 above* (Cooper-Bridgeman Library), *159 below* (Cooper-Bridgeman Library)
Weidenfeld and Nicolson Archive: 14, 101, 123, 134
Worcester Art Museum, Massachusetts: 92–3

Picture research by Julia Brown

The author and publisher have taken all possible care to trace and acknowledge the sources of illustrations used in this book. If by chance we have made an incorrect attribution we will be pleased to correct it in future reprints, provided that we receive notification.

INDEX

Page numbers in *italics* refer to the illustrations

Académie Royale des
Sciences, 149
Academy of Natural
Sciences, 111, 113
alligators, 179, 200; *157*
(colour)
American Academy of
Arts and Sciences, 172
American crow (common
crow; Plate CLVI), *188*
American flamingo
(Plate CCCCXXXI), *128*;
(watercolour, 1838), *129*
(colour)
American Fur Company,
215
American Philosophical
Society, 174
American snipe (common
snipe; Plate CCXLIII),
162
American white pelican
(Plate CCCXI), *23*
Les Amis des Noirs, 21
antelopes, *120*
Anticosti Island, 183
Antonio, Father, 105
Arctic tern (Plate CCL),
186
Arkansas, 86
Arthur, Stanley Clisby,
Audubon, 163
Audubon, Anne Moynet,
14, 16, 17, 27–9, 34, 104
Audubon, Jean, 10,
13–19, 21, 22–30, 34,
38, 43–4; *14*
Audubon, John James,
birth and early life,
10–13, 26–9; *12–13*;
character, 12, 125;
ashamed of his
illegitimacy, 19–21;
Dauphin theory, 19–20,
25; studies under
David, 30; early
drawings, 32–4;
technique, 32; goes to
America, 34, 37–43;
meets Lucy, 39–41;
relationship with Lucy,
28, 40, 66, 81; 'banding'
experiments, 41;
returns to France,
43–4; returns to

America, 44–5; works
for Benjamin Bakewell,
47; in Louisville,
48–55, 63; marriage,
53; meets Alexander
Wilson, 56–8, 61–3;
moves to Henderson,
63–7; travels up
Mississippi, 67–71;
ends partnership with
Rozier, 71; partnership
with Thomas
Woodhouse Bakewell,
71–3; returns to
Henderson, 71, 73, 74;
sawmill and gristmill at
Henderson, 74–81; *75*;
bankruptcy, 30, 81,
82–4; appearance, 82,
211; portraiture, 84–6,
96–7, 105, 108; *86*;
taxidermist at the
Western Museum, 85;
journey across America,
86–96; as the American
woodsman, 92–5; in
New Orleans, 96–7, 98,
104–5; tutor to Eliza
Pirrie, 98–104; goes to
Natchez, 105–6, 108; in
Philadelphia, 110–13;
European tour, 113,
114–49; publishes *The
Birds of America*, 123–7,
134–5, 139–41, 150,
152; oil paintings, 140,
141–4; returns to
America, 150, 152–3;
rift with Lucy, 153–6,
161; reunited with
Lucy, 162–3; returns to
England, 164; Florida
expeditions, 174,
176–9, 202–6;
collaborators, 175–6;
bad temper, 180;
Labrador expedition,
181–3; Missouri River
expedition, 212–17;
death, 218; portraits of,
6, *51* (colour), *84*, *91*,
118, *127*, *130* (colour),
157 (colour), *214*, *218*;
hunting equipment, *87*
Audubon, John

Woodhouse, 195; *159*,
175; birth, 81; artistic
career, 86, 200;
collaborates on *The
Birds of America*, 180;
Labrador expedition,
183; *The Viviparous
Quadrupeds of North
America*, 203, 211, 217,
218; *158* (colour), *213*;
Florida expedition, 203;
marriage, 206; portraits
of Audubon, *51*
(colour), *130* (colour),
214
Audubon, Lucy, 73, 96,
97, 110, 113, 114, 124,
179, 214; *145*; meets
Audubon, 39–41;
relationship with
Audubon, 28, 40, 66,
81; in Louisville, 53,
55, 85–6; marriage, 53;
dowry, 55, 63; in
Henderson, 66–7; and
Audubon's bankruptcy,
81, 82–4; stays in
Cincinnati, 87–8; joins
Audubon in New
Orleans, 105; school at
Beech Wood, 107–9;
refuses to join Audubon
in London, 142, 144–5,
153; Audubon's letters
to, 148–9, 153; rift with
Audubon, 153–6, 161;
reunited with Audubon,
162–3; goes to
England, 164, 166;
copies *Ornithological
Biography*, 169; returns
to Louisville, 174;
Minnie's Land, 210;
portraits of, *62*, *215*
Audubon, Maria, 12–13,
19, 66, 164
Audubon, Rosa
(daughter), 82
Audubon, Rosa (sister),
18, 29
Audubon, Victor Gifford,
66, 73; birth, 53; travels
with Audubon, 108,
110; Audubon's letters
to, 119, 142, 146–7,

187–9; intermediary
between Audubon and
Lucy, 154–6, 161;
works on *The Birds of
America*, 180, 181, 189;
178; marriage, 206;
works on *The Viviparous
Quadrupeds of North
America*, 211, 217
Audubon & Bakewell, 73,
74
Augusta, Georgia, 203
Aumack, Jacob, 88

Bachman, Eliza, 206
Bachman, Rev. John, 176,
179, 180, 191;
friendship with
Audubon, 174–5, 185;
Audubon's letters to,
196, 199–200, 201, 202;
*The Viviparous
Quadrupeds of North
America*, 189, 203,
211–12, 217–18
Bachman, Maria
Rebecca, 206
Baird, Spencer Fullerton,
212
Bakewell, Benjamin, 40,
43, 47, 48, 53
Bakewell, Eliza, 28
Bakewell, Lucy, *see*
Audubon, Lucy
Bakewell, Thomas
Woodhouse, 40, 71–3,
161
Bakewell, William
(Lucy's brother), 47–8
Bakewell, William
(Lucy's father), 39–40,
43, 55
Bakewell, Derbyshire, 124
Baltimore orioles, 148,
199
barn owl (Plate CLXXI), *99*
barn swallow (Plate
CLXXIII), *57*
barred owl (Plate LXVI), *4*
Barton, 179
Bartram, John, 60
Bartram, William, 60–1,
106
Baton Rouge, 108
bay-winged bunting, 153

Bayou Sara, 95, 98–104, 107, 113, 162
Beech Woods, 107–8
Bell, John G., 212
Benedict, Jennett, *86*
Berlin, 124, 142
Berthoud family, 82, 110, 163
Berthoud, Nicholas, 82, 95, 98, 161
Bewick, Thomas, 101–3, 191; *101*; *History of British Birds*, 101
Bird Banding Society of the United States, 41
Bird Rock, 183
The Birds of America, 12, 32, 62, 163, 183; Audubon plans, 86; Mason paints backgrounds to, 87; publication, 123–7, 134–5, 139–41, 150, 152, 180–1; size, 124–5, 211; eggs excluded from, 161; Lehman's contribution to, 161, 175, 179; text, 165–7; finances, 171, 172; English subscriptions lapse, 196, 198; third volume, 199; fourth volume, 195, 200–1; completion of, 206–7; copper plates, 207–8; miniature edition, 209–10, 214, 217; *see also Ornithological Biography*
bison, *see* buffalo
Black, Adam, 171
black warbler, 156
black-billed cuckoo (Plate XXXII), 176
black guillemot (Plate CCXIX), *194–5*
black-headed gull, 183
black poll warbler, 156
Blackfeet Indians, 215
boat-tailed grackle (watercolour, 1832), 111; *112*
Bohn, H. G., 124, 125
Bonaparte, Charles Lucien, 111, 113, 134, 200; *American Ornithology not given by Wilson*, 111
Bonaparte, Joseph, King of Spain, 111
Bonaparte, Lucien, 111

Boone, Daniel, 90–1
Boston, 180, 191
Boston, Athenaeum, 172
Boston Patriot, 184
Bouffard, Catherine, 18
Bowen, 81
Brand family, 105
Brawne, Fanny, 75
Brewster, Dr David, 209
British Museum, 152
Brown, Captain Thomas, 142
brown pelican (watercolour, 1821), 178–9; *178*
Brünnich's murre (thick-tailed murre; Plate CCXLV), *185*
Brussels, 124
Buffalo, 113
buffalo, 215, 216–17; *159* (colour)
Buffon, Comte de, 30–2, 59–60, 148; *Histoire naturelle des oiseaux*, 32
Bulow, John, 177
buntings (Plate CCCCXXIV), *204*
Burns, Robert, 59

Calais, 147
Caledonian Mercury, 142
California, 201
Californian vulture (California condor; Plate CCCCXXVI), *173*
Camden, New Jersey, 153
Canada, 214
Canada warbler (Bonaparte's fly-catcher; Plate V), 134, 135
Carmansville, 210
Carolina parakeet (Plate XXVI), *115*
Carrier, Jean, 26
carrion crow, 187–9
Cash Creek, 67–8
Catesby, Mark, *Natural History of Carolina*, 189
catfish, 67; *64–5*
Catlin, George, 215; *Keokuk*, *215*
Catskills, *44–5*
Les Cayes, 10, 13, 17, 18, 21
Charette, 25
Charles X, King of France, 147, 149
Charleston, 174–6, 179, 180, 185, 189, 191, 203; *2–3*

Charleston Natural History Museum, 180
Chartres, Duke of, 147
Children, John George, 152, 164–5
Christie's, 8
Church, F. E., *In the Catskills*, *44–5*
Cincinnati, 85, 86, 87–8, 113; *92–3*
Cincinnati College, 85
Cohoes Falls, *endpapers*
Coirond Frères, 17
Cole, Thomas, *Sunny Morning on the Hudson River*, *42–3*
Columbia River, 201
Combe, George, 133
common buzzard (Swainson's hawk; Plate CCCLXXII), *175*; (watercolour, 1836–7), *175*
Cornwallis, 1st Marquis, 17; *17*
Couëron, 13, 26, 27–8, 30, 43–4; *29*
Creek Indians, 203–5
Cruikshank, F., portrait of Audubon, *84*
Cummings, Captain, 89
Cuvier, Baron, 12, 148–9

Dacosta, Francis, 43, 44, 45
Darwin, Charles, 28
Darwin, Erasmus, 40
David, Jacques Louis, 30, 32, 44; *The Death of Marat*, *31*
Day, Robert, 202
Derby, 14th Earl of, 120, 200
Dickie, Mrs, 166
d'Orbigny, Alcide Charles, 28
d'Orbigny, Charles, 28, 32
Drake, Dr Daniel, 85, 88–9
Du Puigaudeau, Gabriel, 29
dusky cormorant, 195

eagles, 32
Edinburgh, 124, 125–38, 144, 166, 190; *126*
Edinburgh Royal Institution, 128–33
Embargo Act, 1807, 53

English Pheasants Surprised by a Spanish Dog, *121*
Everett, Edward, 163, 172

Fatland Ford, 39, 40, 45, 53, 55, 66, 73; *39*
Fayetteville, 174
finches (Plate CCCCXXIV), *204*
fish, *116*
Fisher, Miers, 37, 38, 43
Florida, 12, 86, 113, 161, 174, 176–9, 202–3
Florida cormorant (double-crested cormorant; Plate CCLII), *168*; (watercolour, 1832), *169*
Florida War, 202–3
Fort Sumter, 189
Fort Union, 176
foxes, 121
Franklin, Benjamin, 135
French Revolution, 17–18, 24–6
frigate bird, 195
fulmar, 195

Gallatin, 145
Galveston, 176, 202, 205
George IV, King of England, 127, 152
La Gerbetière, 26, 27–8, 104; *29*
Giroux, C., *Cotton Plantation*, *107*
golden-crowned thrush, 153
goosander (common merganser; Plate CCCCXXXI), *endpapers*
Gordon, Anne, 119
Gould, John, 199, 200; *201*
Grasse, Comte de, 17; *16*
Gray's Ferry, 60
great black-backed gull (watercolour, 1832), *11*
Great Egg Harbour, 153
great-footed hawk, 126
Great Pine Swamp, 156–61
great white heron (watercolour, 1832), 179; *131* (colour)
Green Bank, 117, 118
Green River, 136
Greenwich, Connecticut, 37
guillemot, 183

hares, *36–7*
Harlan, Dr Richard, 153
Harris, Edward, 113, 174, 203, 212
Havell family, 139
Havell, Robert Jr, 199; importance of to Audubon's fame, 139–40; works on *The Birds of America*, 139–40, 141, 144, 152, 156, 171, 180–1, 200; portrait of, *139*; Audubon's letters to, *198*; emigrates to America, 207–8; *View of Hudson River, Toppan Bay, near Sing Sing, 78–9* (colour); *View of the Hudson from Tarrytown Heights, 208*
hawk owl (watercolour, 1836–7), *54*
hawks, 126
Henderson, 63–7, 71, 73, 74–81, 88; *75*
Hereford, Marchioness of, 198
hermit thrush, 89
herons, 195
Herrick, Francis H., 119; *Audubon the Naturalist*, 13
herring gull (watercolour, 1831), *132* (colour)
Hot Springs, 86
house wren (Plate LXXXIII), *170*
Houston, General Sam, 205–6
Houston, Texas, 205
Hudson River, 210; *42–3, 78–9* (colour)

ibis, 195
indigo-bird (indigo bunting; watercolour, from 1821), *155*
Irish, Jedediah, 156

Jackson, 108
Jackson, Andrew, 146, 163, 202–3; *164*
James River, 215
Jardine, Sir William, 199; *The Naturalist's Miscellany*, 196
jays, 200
Jefferson, Thomas, 37, 53
Josephine, Empress, 19
Journals, 12, 87–9, 212; *116–17*
Juniata River, 73

Keats, George, 74–81, 86
Keats, Georgiana, 75
Keats, John, 74, 75–81, 86
Kentucky, 55, 67, 91, 136, 215
Key West, 179
Kidd, Dr John, 184
Kidd, Joseph Bartholomew, 141, 142
Kinnoul, Earl of, 147
Knowsley, 120; *120*
Knox, Dr, 125

Labrador, 12, 174, 181–3
Lamarck, 30
larks, 200
Latrobe, Benjamin Henry, *Overseer Doing his Duty, 15*
Lavater, Johann Kaspar, 100
Lawrence, Sir Thomas, 141
Lawson, Alexander, 60, 63, 111
least water hen (black rail; Plate CCCXLIX), *190*
Leeds, 139
Lehman, George, 174, 177, 180; backgrounds to Audubon's paintings, 161, 175, 179; *2–3, 46, 52* (colour), *112, 132* (colour), *151, 162, 188, 196–7*
Library of Congress, 163, 172
Linnaeus, *Systema Naturae*, 61
Linnean Society, 141, 152
Liverpool, 71, 114–22, 123, 125, 139, 144, 164
Liverpool and Manchester Railway, *165*
Lizars, William Home, 125–6, 127–8, 134, 139, 140, 169
loggerhead shrike (watercolour, *c.* 1825), *154*
London, 139–47, 164, 189, 206
London Literary Gazette, 169
long-billed curlew (Plate CCXXXI), 175, 189; *2–3*
Louis XV, King of France, 14
Louis XVI, King of France, 19, 21
Louis XVII, King of France, 19

Louis-Philippe, King of France, 147, 148, 149, 171, 200
Louisburg, 14
Louisiana, 71, 100, 161–2
Louisiana heron (watercolour, 1832), *52* (colour)
Louisville, 30, 48–55, 61, 63, 81, 82–6, 110, 161, 163, 174
Lyceum of Natural History, New York, 153

MacGillivray, William, 178, 200; works on *Ornithological Biography*, 12, 89, 166–8, 184, 191–2; Audubon's letters to, 205; book on British birds, 206
Madison, James, 100
Manchester, 122–3, 124, 139; *123*
Mandan Indians, 215
Mandeville de Marigny, Marquis de, 12–13
Marat, Jean-Paul, *31*
Marie Antoinette, Queen of France, 19
marmots, 218
marsh hare, *175*
Martin, Maria, 175; *175*
Martinet, F. N., 32
Mason, Joseph, 86–7, 97, 100, 104, 105, 106; backgrounds to Audubon's paintings, 87, 101, 106, 135; *49* (colour), *160* (colour)
Mason, Samuel, 91
Mauch Chunk, 156
Maysville, 73
meadow lark (eastern meadowlark; Plate CXXXVI), *46*
Mexico, 106
Mexico, Gulf of, 202
Mill Grove, 22–4, 37, 38–9, 41–3, 44–5, 48, 110; *24, 50* (colour)
Minnie's Land, 210, 211; *210*
Mississippi River, 12, 67–71, 86, 90, 163, 206
Missouri River, 113, 212–17
Mitchell, Dr Samuel L., 47, 48
mocking-bird (Plate XXI), 103, 126; *102*

Monthly American Journal of Geology and Natural Science, 174
Montreal, 214
Morristown, 37
Mortimer, Rev. Dr, 53
Morton, Earl of, 184
Moynet, Anne, *see* Audubon, Anne Moynet
Myself, J. J. Audubon, 10, 89

Nantes, 24–6, 30, 53
Napoleon I, Emperor of the French, 14, 34, 44, 111, 149, 200
Natchez, 95–6, 105–6, 108, 110; *94*
National Audubon Society, 8, 39
Neill, Patrick, 169
New Haven, 40
New Orleans, 71–3, 81, 86, 95, 96–7, 98, 104–5, 163, 203; *95*
New York, 47, 55, 113, 152–3, 208, 210; *34–5*
Newcastle, 113
Newcastle, Duke of, 14
Niagara, 113
Nolte, Vincent, 73–4, 114; *Fifty Years in Both Hemispheres*, 73
Norfolk, Virginia, 174
North Dakota, 176
Northampton County, 156–61
Nova Scotia, 183
Nuttall, Thomas, 201–2, 203, 214

Oakley, 100, 103–4; *100*
Ohio, 55
Ohio River, 48, 53, 67–8, 86, 90, 161–2
Ord, George, 60, 113, 167, 187, 199
Orléans, Duc d', *see* Louis-Philippe, King of France
Orléans, Duchesse d', 148
Ornithological Biography, 12, 32–4, 62, 89–95, 189–95, 210; MacGillivray's contribution to, 12, 89, 167–71, 184, 191–2; third volume, 199; fourth volume, 209; fifth volume, 207, 209
Osseola, 203

Ossining, 208
otters, 117

Paris, 124, 142, 147–9
partridges, 126
passenger pigeon (Plate LXII), 8, 136–8; *137*
Peale, Titian R., 111
Pears, 74
peewees, 41
pelicans, 195
Penn, John, 24
Penn, William, 37
Pennsylvania, 55, 159–61
Percy, Mrs, 107, 108, 109–10, 113
Percy, Captain Robert, 107
Perkioming Creek, 41, 43
Philadelphia, 22, 37, 43, 45, 55, 110–13, 136, 153, 161, 179, 184; *38*
Philadelphia Academy of Natural Sciences, 201–2
pigeons, 200
pileated woodpecker (Plate CXI), *83*
pine swamp warbler, 156
Pirrie, Eliza, 98–104, 108; *100*
Pirrie, James, 100
Pirrie, Mrs James, 98, 103
Pitt, William, 14
Pittsburgh, 53, 113, 161
polar bear, *213*
Pope, Nathaniel Wells, 66, 67, 70
Pope, Mrs Nathaniel Wells, *Reminiscences*, 82
Portchartrain, 12–13
prairie dog, *213*
Prévost, Henry Augustus, 22
Priestley, Joseph, 40
prothonotary warbler (Plate III), 134, 135
puffins, 183
purple finch (Plate IV), 134
purple grackle (common grackle; Plate VII), *143*

Quebec, 214

rabbits, 218
Rabin, Mlle, 13, 18–19, 21
Rankin, Dr Adam, 67
Rathbone family, 117–20, 123–4, 184
Rathbone, Mrs, 117, 142

Rathbone, Richard, 114–17
rattlesnakes, 103; *102*
Ravensworth, Lord, 200
razor-billed auks, 183
Redouté, Pierre Joseph, 147–8; *Rosa indica*, *146*
Riccaree Indians, 215
Richmond, Virginia, 174
Rochefort, 29, 30
Rocky Mountains, 214, 217
Rollinson, William, *New York from Long Island*, *34–5*
Roscoe family, 117, 122
Roscoe, William, 114, 118
roseate spoonbill (Plate CCCXXI), *151*
rough-legged falcon, 153
Rousseau, Jean-Jacques, *Rêveries du promeneur solitaire*, 30
Royal Institution, Liverpool, 118–19
Royal Society, 164
Rozier, Ferdinand, 47, 61, 73, 110; *72*, *75*; partnership with Audubon, 44–5, 48–53, 55, 63, 66, 67; travels up Mississippi, 67–71; ends partnership with Audubon, 71
ruby-throated humming-bird (Plate XLVII), 192; *193*
rump yellow warbler, 88

Les Sables d'Olonne, 14, 15
St Augustine, 175, 176–7, 179; *132* (colour)
St Francisville, 107
Ste Geneviève, 71, 91; *75*
St John's River, 177
St Louis, 215
St Petersburg, 142
San Domingo, 13, 15–16, 17–18, 21, 27, 34
sandpipers, 195
Santa Ana, General, 205
Schuylkill River, 43, 60
Scott, Sir Walter, 7, 127, 133, 134; *134*
Scribner's Magazine, 10
sea otter, *159* (colour)
Selby, *Illustrations of British Ornithology*, 125
Seminole Indians, 202
Sharpe, Macijah, 91
Shippingport, 30, 82, 110

Sioux Indians, 215
small green-crested flycatcher, 153
Smiles, Samuel, *Self-Help*, 90
snowy owl (copper plate for Plate CXXI), 76; (watercolour, 1829), 199; *77* (colour)
song thrush, 59–60
Sprague, Isaac, 212
Squires, Lewis, 212
squirrels, 218; *4*, *99*
Stanley, Lord, *see* Derby, 14th Earl of
starlings, 200
Stein, John, 106, 108
Sully, Thomas, 153
summer red bird (summer tanager; watercolour, 1821), *49* (colour)
Swainson, William, 147, 166, 167, 200
swamp sparrow (Plate LXIV), *145*
swans, 70, 195
Syme, John, 128

Tarrytown, 208; *208*
Tawapatee Bottom, 70
Texas, 12, 174, 176, 202, 205
Thomas, William, 39
Thoreau, Henry, 185
Toppan Bay, *78–9* (colour)
Tortugas, 179
Toussaint l'Ouverture, Pierre Dominique, 21, 34; *20*
Townsend, 201–2, 203, 206, 214
Townsend's hares, *36–7*
Transylvania Company, 74
trumpeter swan (Plate CCCLXXVI), *68*
trumpeter swan (Plate CCCCVI), *80* (colour)
tufted auk (tufted puffin; Plate CCXLIX), *187*
turkey buzzard, 187–9
turkey vulture, 41
Turton, William, *A General System of Nature*, 61

US Congress, 163, 172

Vanderlyn, John, 163
Vestris, Madame, 141

Victoria, Queen of England, 207
The Viviparous Quadrupeds of North America, 189, 203, 209, 211–12, 217–18

Walton, Izaak, 206
warbling fly-catcher, 153
Ward, Henry, 174, 177, 180
Washington, D.C., 163, 202–3
Washington, Mississippi, 105
Washington, George, 43
Washington Heights, 210
Waterton, Charles, 103, 167, 187, 191, 192, 199
West Feliciana, 98–103, 107–8, 161–2; *182*
Western Museum, 85
Wetherill, John, 174
white-crowned sparrow (watercolour, 1814), *109*
white-headed eagle (bald eagle; Plate XXXI), 67, 135; *64–5*
white heron (common egret; Plate CCCLXXXVI), *216–17*
Whittredge, Worthington, *View of Cincinnati*, *92–3*
whooping crane (Plate CCXXVI), 126; *157* (colour)
wild turkey (Plate I), 126, 134–5
Wilson, Alexander, 86, 88; *58*; *American Ornithology*, 56–63, 96, 101, 104, 111, 113, 125, 167, 199
wood ibis (Plate CCXVI), *182*

yellow-billed cuckoo (Plate II), 134, 135
yellow-breasted chat, 153
yellow-breasted vireo (yellow-throated vireo; watercolour, 1821), *160* (colour)
yellow shank (lesser yellowlegs; Plate CCLXXXVIII), *196–7*
yellow warbler, 156
Yellowstone River, 217
Yorktown, 17; *17*

Zoological Gallery, 139

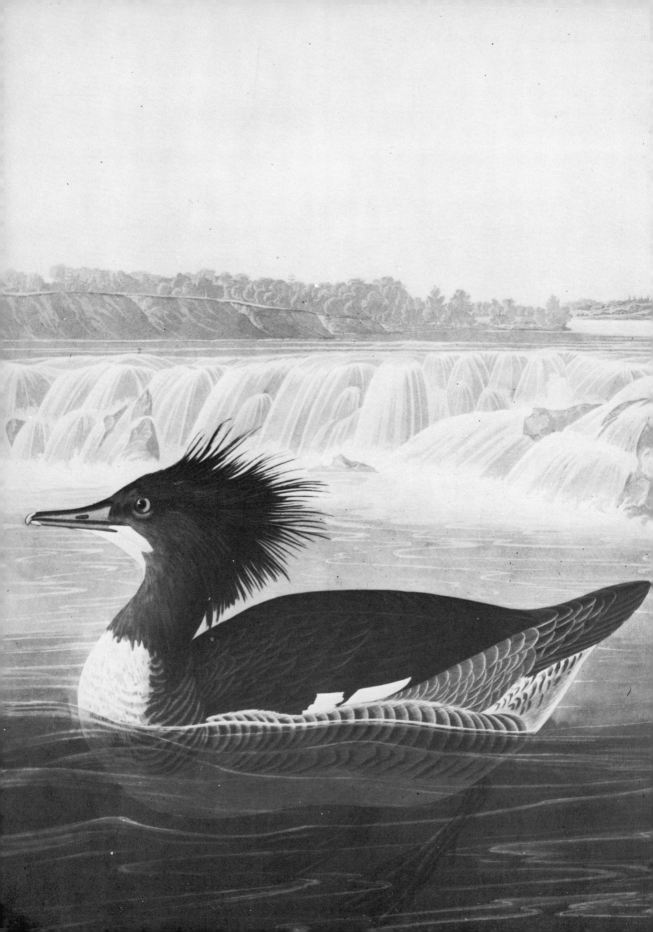